NieR:Automata World Guide

[CITY RUINS SURVEY REPORT]

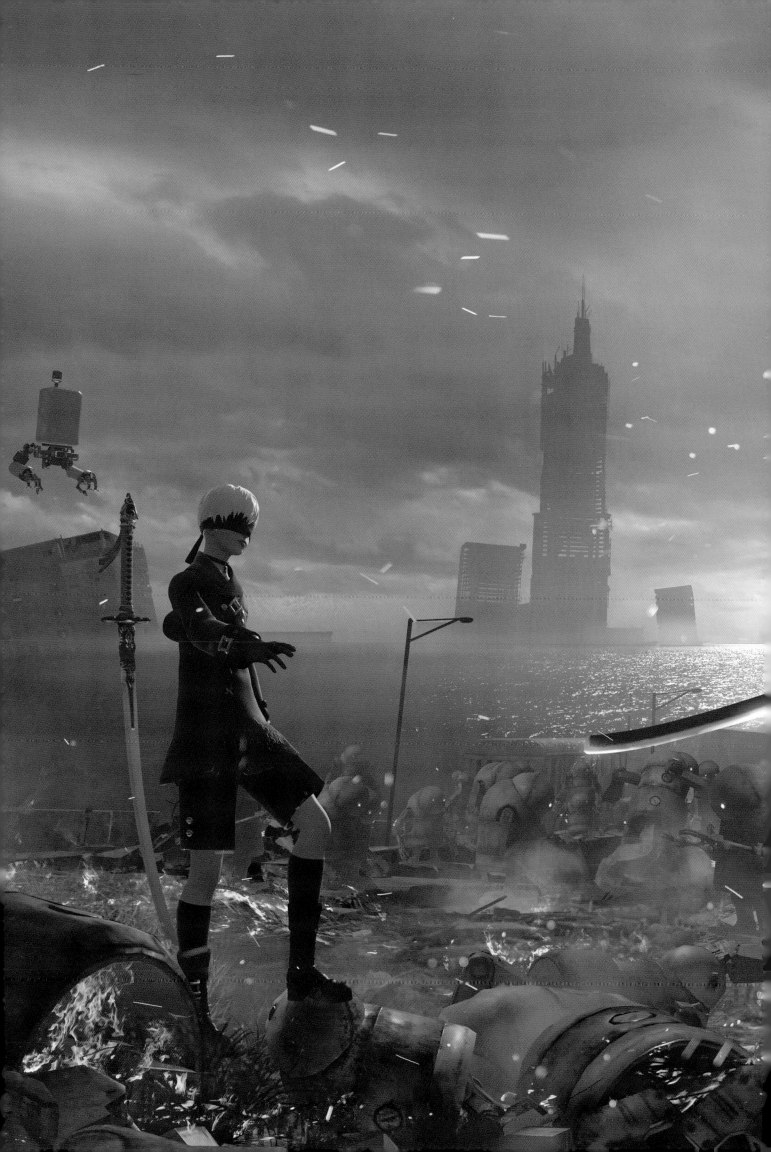

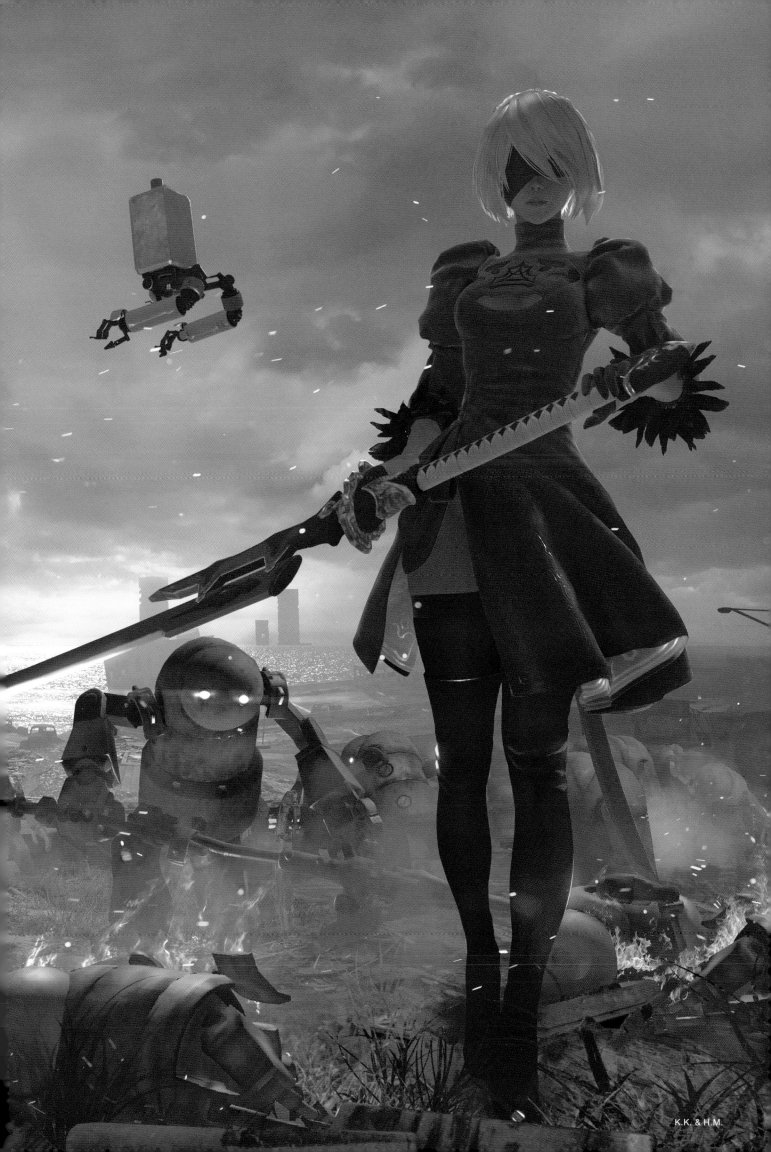

K.K. & H.M.

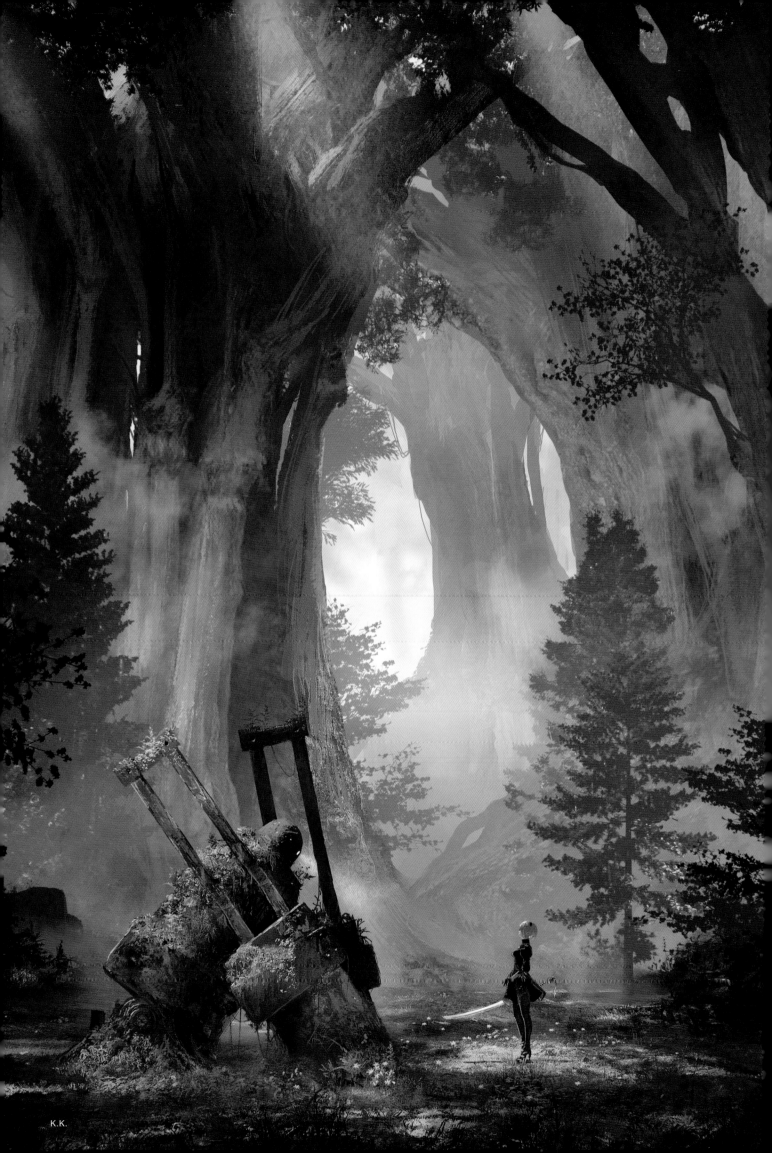

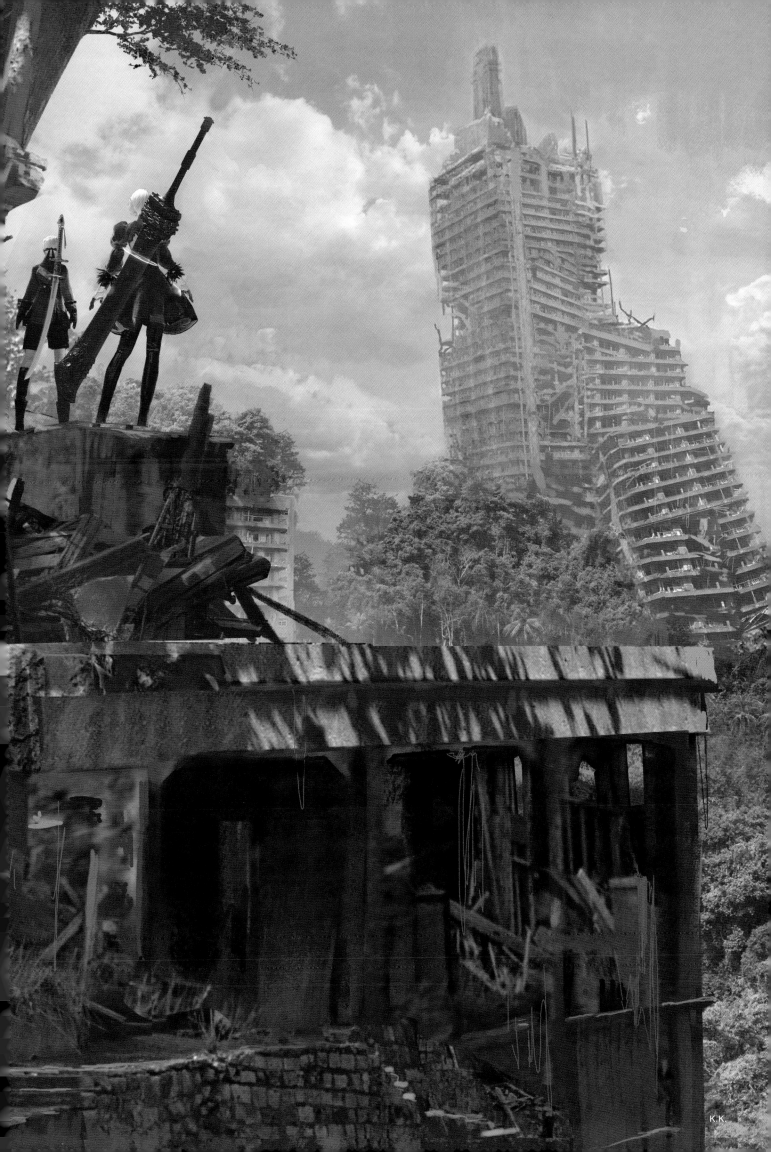

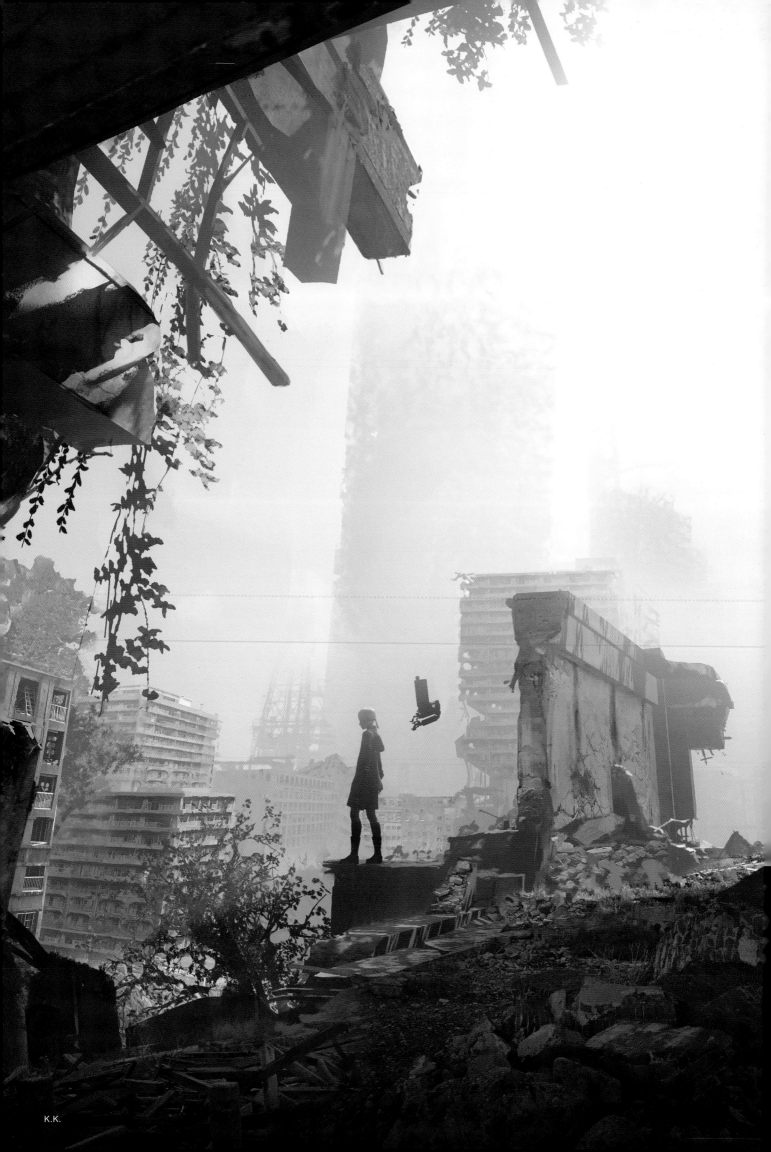

NieR:Automata World Guide
[CITY RUINS SURVEY REPORT]

"Observation Diary of the Orbital Satellite Base, 'the Bunker'" 00008

Investigative Report of Surface Operation Area 00014

> Outline of Investigative Report 00014

> Sketch of Surface Operation Area 00018

> Bunker Report 00020

> Abandoned Factory Report 00038

> City Ruins Report 00054

> Resistance Camp Report 00074

> Desert Area Report 00084

> Abandoned Amusement Park Report 00096

> Pascal's Village Report 00106

> Forest Kingdom Report 00112

> Flooded City Report 00128

> Alien Ship Report 00140

> Copied City Report 00148

> Resource Recovery Unit Report 00152

> Tower Report 00156

Machine Records : Extract 00166

"Cage of Memories" 00182

┃• Observation Diary of the Orbital Satellite Base, "the Bunker"

Written by Jun Eishima

< Where could this be? >

< Who could that be? >

[TB 13:30]

It's like climbing a hill covered in rocks, thought 2B.

Her left leg felt heavier than lead, and just a single step made her feel out of breath. When she finally stepped forward with her left foot, the joints of her right leg shrieked in agony.

She half tumbled from the flight unit and left the hangar. After descending on the elevator, she made it a few meters down the passage. The amount of time it had taken her to just get this far was astounding. The Development Department was farther down this hall. Just the thought of how long it would take to get there made her feel faint.

The Bunker, a satellite orbiting Earth, was YoRHa's base of operations. It was furnished with every type of equipment needed for descent to—and battle on—the Earth's surface, as well as living quarters for YoRHa members. Still, it was by no means a large place. In spite of this, her destination felt infinitely far away. The passage only sloped gently, and she could usually find her way through it even with her eyes closed.

In other words, the malfunction affecting her motor skills was quite serious. She needed a readjustment at the Development Department as soon as possible. She tried to make herself move faster.

That's when the commander appeared in front of her. 2B attempted to bring her left arm to her chest in a salute, but she couldn't quite lift it that far. She grimaced. It seemed that it wasn't just her legs that were malfunctioning.

"Ah. At ease."

The commander had most likely noticed 2B's injuries right away due to her awkward salute. She gestured for her to lower her arm.

"It looks like you're in bad shape."

"I was unable to make repairs on the surface, so I reluctantly suspended the operation and returned here. I am very sorry."

"There's no need to apologize. Were there any other casualties?"

"Due to a clash with machine lifeforms at early dawn, 1D suffered minor injuries to her right upper arm and shoulder. 4B also took a minor injury to her left thigh. However, thanks to 12H's first aid, they're both recovering and will not be a hindrance to the operation."

"I see."

The commander abruptly glanced to the side. The hallway in which they stood connected the hangar to the Development Department and the command center, and faced outside. The dark void of space was dotted with stars and planets, and of course mankind's original home, Earth—all of which were visible from here.

Even now, androids—including members of YoRHa—were fighting the machine lifeforms on the surface of that beautiful blue planet. Again and again YoRHa had crushed them, but those damn machines just kept coming like persistent insects.

"YoRHa's numbers are too few compared to those of our enemies . . . Though, speaking of which, I hear good things about the elite few."

Up to this point YoRHa had compensated for the overwhelming difference in numbers with strategy and technology. However, they hadn't overcome the disadvantage, and the war was dragging on. 2B had thought they just needed to put forth an even greater effort, but that was wrong.

"So, don't try to do the impossible, all right?"

A smile rose to the commander's lips. Sometimes, the commander smiled in this perplexingly kind way. She conducted herself in a strict manner befitting a leader, composed and sharp, like a honed blade.

There was no doubt in 2B's mind that incalculable suffering and conflict lay hidden behind the commander's occasional smile.

"Commander . . ."

She began to speak but stopped herself. *This is my own problem,* 2B decided.

"Never mind, it's nothing."

The commander's smile disappeared. In its place came calm words.

"However harsh our mission may be, we must see it through. We YoRHa members . . ."

We YoRHa members, 2B silently repeated. *We have experienced hardship. We may also . . . experience unbearable pain. But we have never harbored resentment toward our duty.*

"However, whatever duty we may have, all of the responsibility rests with me. Don't forget that."

It was as if the commander had completely read her mind. 2B had thought that when their mission was finished, the weight that had accumulated would be hers alone to bear. No, she still thought that. Even so, the commander's words echoed in her heart.

"Glory to mankind."

This time, 2B was able to raise her left arm to her chest. "Glory to mankind," the commander repeated.

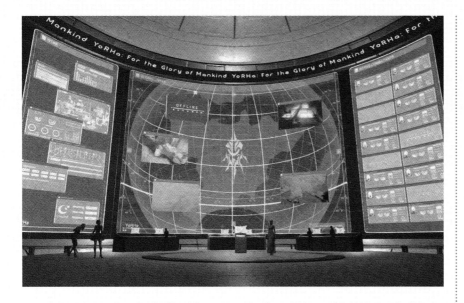

She fought under this person's command. She would continue to do so. Until the day they had reclaimed Mother Earth for mankind.

With the sound of precise footsteps behind her, 2B hurried to the developers' office.

<What was that just now?>

<I wonder. What was that?>

<Shall we follow her?>

<Yes, let's follow her!>

[TB 13:40]

As she entered the command center, the commander was halted by a sudden wave of operators rushing up and blocking her way.

"Commander! About the arrangement of raw materials in the Bunker . . ."

"I have a status report on the battle at the city ruins on the surface."

"Please approve the container of materials to be sent to the moon."

"Something is hindering communications with District F, Ward 3D."

Somehow, it seemed the operators thought that by calling out the title "Commander," her ability to process their words would magically increase.

"Regarding the materials, take into account the line of flow of each person in charge and create three diagrams to submit to me. Afterward, I will consider them again."

"Understood."

"I will hear the battle status report in five and a half minutes."

"Roger."

"I approve the container."

"Thank you very much."

"Instruct the squad members in the vicinity of District F to head to the access point and investigate the cause."

"Understood."

Good grief, it was finally over . . . Or so she thought. None of the operators budged from where they were standing. It seemed there was still more.

"Is there something else?"

In unison, they all replied, "Yes."

"Commander! Please accept this!"

All at once they presented her with small packages of gold and silver.

"These? What are they?"

"Today is February fourteenth. It's known as Valentine's, a day when you give brown-colored presents to those you have respect and affection for."

"Valentine's? Is this a custom of the old world?"

"Yes! It's said that both the giver and the receiver will attain happiness. The custom is to wrap brown objects in gold and silver paper."

Indeed, she thought. Each package was a different shape and size, but every one of them sparkled brightly. *I see. So, humans exchanged presents like these long ago.*

Tentatively, she opened one of the packages. It was a dark brown ribbon. Her first instinct was to ask what to do with it, but instead she responded with a simple "Thank you."

There were few customs of the old world that they completely understood. Mankind had created the androids, so the very idea of trying to understand them was considered presumptuous, and imitating something of theirs without knowing its significance was not encouraged. Even this imitation of the "Valentine's" custom wasn't something she could officially condone . . .

However, she had no intention of saying that to them. Being an operator brought its own set of hardships, distinct from those faced by soldiers on the frontline.

"Um, Commander . . . May I?"

The final person to approach her was Operator 6O. She was the one responsible for communication with 2B.

"What is it?"

"Requesting permission to perform a trial run of the new equipment for the flight units."

She had received countless reports from the Development Department that the new equipment was partly finished. If the time had come to perform a trial run, communication between operators and squad members would be essential. 6O was the operator in charge of the arrangements.

"Ah. Yes. The high-priority survey. If I'm not mistaken, the one assigned to the operation was . . ."

"9S. If there are no problems with the high-priority survey, it will be the final trial with the surface squadron."

The commander caught herself thinking of 2B's pained face.

"I see. 9S . . . That's right."

All of the responsibility rests with me.

"Permission granted."

"Thank you very much."

With a bow, 6O left the command center. "Now then." The commander turned her head. It had been exactly five and a half minutes.

"Let's hear the status report on the surface battle."

< Surface battle? Status . . . report? >

< A battle . . . on the Earth's surface? So . . . the status of the battle? >

< I get it. I wonder what they mean by "new equipment." >

< I dunno. >

< Shall we go see? >

< Let's go see. >

[TB 14:00]

Operator 6O awkwardly hurried toward the hangar, nervous about the possibility of passing anyone in the hallway. *Well, no,* she told herself. If it happened, it happened. She was simply on her way to talk to someone about communications, so there was no reason for her to be embarrassed.

Her body slid through the opening door, its slowness seemingly directly proportional to how impatient she was feeling.

Swift mobilization requires swift equipment.

She considered including the thought as a bullet point in an upgrade request.

"21O, are you here?"

Operator 21O appeared from the shadow of a flight unit that was equipped with a catapult. She was still in the middle of inspections. Good timing. 6O got right to the point.

"We have permission to perform the trial run!"

To 6O's surprise, 21O barely reacted. Could she have forgotten the details of the trial?

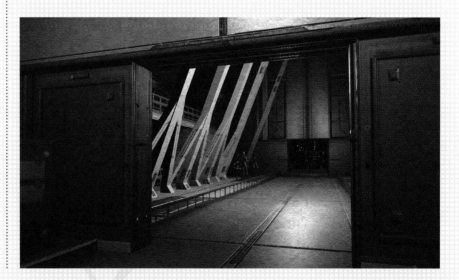

"Uh, the new equipment?" 6O persisted. "The stuff for the flight units!"

A puzzled frown appeared on 21O's face. She seemed surprised.

"Is that all?"

"Huh? Is that all . . . ?"

This time, it was 6O who appeared puzzled. Why the heck would 21O be surprised?

"You could have informed me with one transmission. Deliberately coming all the way here was unnecessary."

"That's true . . ."

6O searched for the right words to refute 21O's uncalled-for statement.

"But—but . . . If I'd just done it the normal way, I wouldn't get enough exercise!"

21O raised an eyebrow as if to say, "So what?"

"Besides, isn't it important to properly take a look at the actual equipment? Hey, what do you think? Isn't that like us? Perfect? It's, like, umm . . ."

"It's our duty as operators to expect perfection in everything, right?"

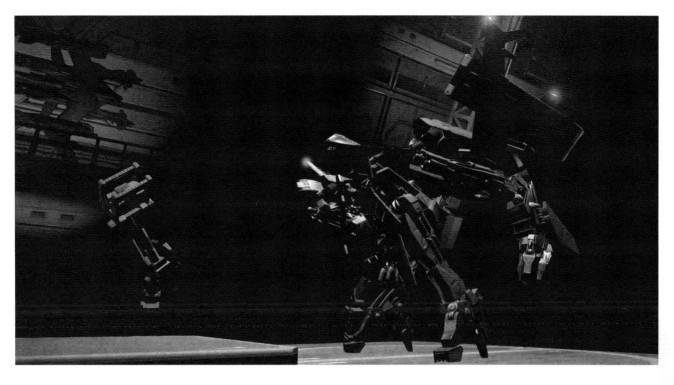

"Yeah!"

6O's reply was so energetic that 21O finally nodded in agreement.

"That's probably true. Once he hears there's new equipment, I'm sure he'll make a mess of it. He's full of curiosity, that 9S."

21O shrugged, but her tone—unlike her words—was kind. It always seemed that way whenever 21O talked about 9S, the YoRHa android for whom she was responsible.

I totally get it, thought 6O as she leaned forward. Her own partner was different, but as an operator, she felt the same way.

"2B too. She's always been super rash."

Like S types, B types also had a tendency to make a mess of things; the former because of their overwhelming curiosity, the latter because they didn't consider their own safety. It was why they could fight without hesitation, even on the frontlines where bullets were flying.

"They'll say, 'Looking at this place is so exciting!'"

"It's their special quality, so I know they can't help it, but . . ."

"I wish they would act with a little more restraint."

"But even if you told them that . . ."

"It wouldn't do any good."

"So," the two of them said in unison, "preparation is important!"

The exchange of information between operators was also important. Even if it seemed like a trivial conversation, it was still new knowledge. The accumulation of such modest information could lead to a hint for a significant decision, or become a signal to evade danger. In short, for operators, everything in their daily existence was connected to their duty. It was their everyday duty.

6O and 21O chatted for just a short while after confirming a few notes and changes. Of course, 21O didn't pause her work.

"Done, sorry to keep you waiting."

After returning the flight unit she'd just finished inspecting to its original position, 21O made room for 6O. Because only one catapult could be fitted to a machine at a time, inspections were also done by one person.

"All right, I'm going to contact 9S."

"Okay. See you later!"

6O secured 2B's flight unit in the now-empty space and began her inspection.

< That's a big machine, huh? >

< Is it the new equipment? >

< Where shall we go next? >

< Where shall we go next? >

[TB 14:30]

21O considered the task of looking for 9S to be easy work.

On the Earth's surface, positional information could be misleading because of satellite image resolution and bandwidth, but here in the Bunker, there were very few errors. *9S is here*, she thought as she stood in front of the door.

The server room was where the large computer terminals of the Bunker were located. 9S spent time in here analyzing enemy defenses and new hacking patterns. He loved that kind of detailed, hands-on work.

Outside of sortie orders, he was always working in here. His intensity and ability to

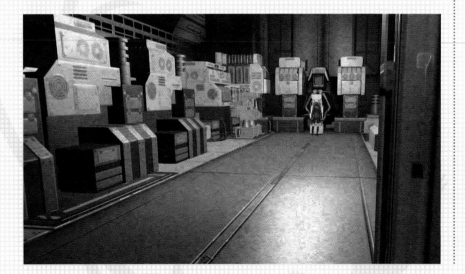

concentrate were so great that he often didn't even notice the sound of the door opening.

Look at that. I knew it, 21O thought to herself. 9S was staring intently at a computer terminal and didn't realize that 21O had entered the room. The goggles he was wearing made it impossible to tell, but 21O had no doubt that his eyes were shining as he immersed himself in his work.

Human children would apparently forget the time when engrossed in the activity known as "playing with a toy." Wouldn't that describe how 9S looked at this very moment?

9S had once stopped here on his way to the hangar, and had looked so focused that no one said anything to him. He ended up staying for over three hours.

That was when 21O knew she'd need to tell him to stop being irresponsible and to take breaks. Suddenly, 9S's shoulders shook with a start, as if someone had surprised him by yelling "Boo!" from behind.

"Operator? What?"

Both shoulders lowered as he turned to face 21O.

"Don't 'what' me. How many times have I told you that you mustn't work such long hours without a break?"

"Yeah, yeah."

"One affirmation will suffice."

"Fine," came the disgruntled reply.

"Please disconnect from the computer terminal. I'm going to explain our next operation."

"Huh? Can't I listen to it like this?"

"Negative. You would not receive sufficient exercise."

She couldn't believe she was using 6O's words from just a short while ago. But exercise was far more important for 9S than 6O.

"Let's take a short walk."

9S moved away from the terminal with reluctance.

"Where's our next operation?"

"The abandoned factory. A survey of the ruins as well as the surrounding area."

"Aw, man. You mean I'll be by myself again? That gets so lonely."

9S's shoulders fell in disappointment, but he raised his head to look at 21O.

"Operator, can't you come with me?"

21O understood that what he said wasn't all that serious. It was probably true that he was lonely, but asking an operator to accompany him was out of the question.

"Negative. This is your task. Carry out your mission alone without complaining like a spoiled child."

"All right, geez."

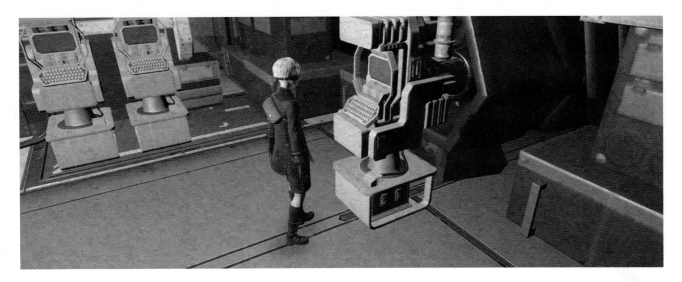

9S inflated his cheeks, but he sounded a little disheartened. *Well then, I'll give him just a little incentive*, thought 21O.

"The next operation will most likely include a trial run of new equipment."

"Really?!"

9S brightened at once. Just as she'd thought, the word "new" had a tremendous effect.

"You'll receive further details in the hangar while we check the equipment."

"Okay!"

9S suddenly looked taken aback.

"What's the matter?"

Come to think of it, something about him had been a bit strange earlier. 21O had assumed that it was her entrance that had surprised him, but he hadn't been looking in her direction. Something else had caught his attention.

"Something's . . . bothering me."

"What is it?"

9S's gaze swept around the room, like he thought someone was watching them. He shook his head.

"Nah, there's no way. It's my imagination. Maybe I'm just tired?"

"That's why I've told you over and over to take a break at fixed intervals . . ."

"Yeah, yeah."

"One affirmation!"

When she was done with her explanation of the new equipment, she needed to advise him to rest, no matter what. An accumulation of fatigue was very likely to be a hindrance to an operation.

With this thought in her mind, 21O urged 9S to leave the server room. Before he left, 9S looked around just once more, but of course no one was there.

< That was close. >

< He almost found us. >

< But I wonder what "lonely" means? >

< I dunno. >

< Androids are a total mystery. >

< Yeah. A total mystery . . . and funny. >

< I want to play just a little longer. >

< Yeah. I want to play . . . just a little longer. >

With no indication that anyone was inside the server room, two words appeared on the screen of a large computer terminal.

End Transmission

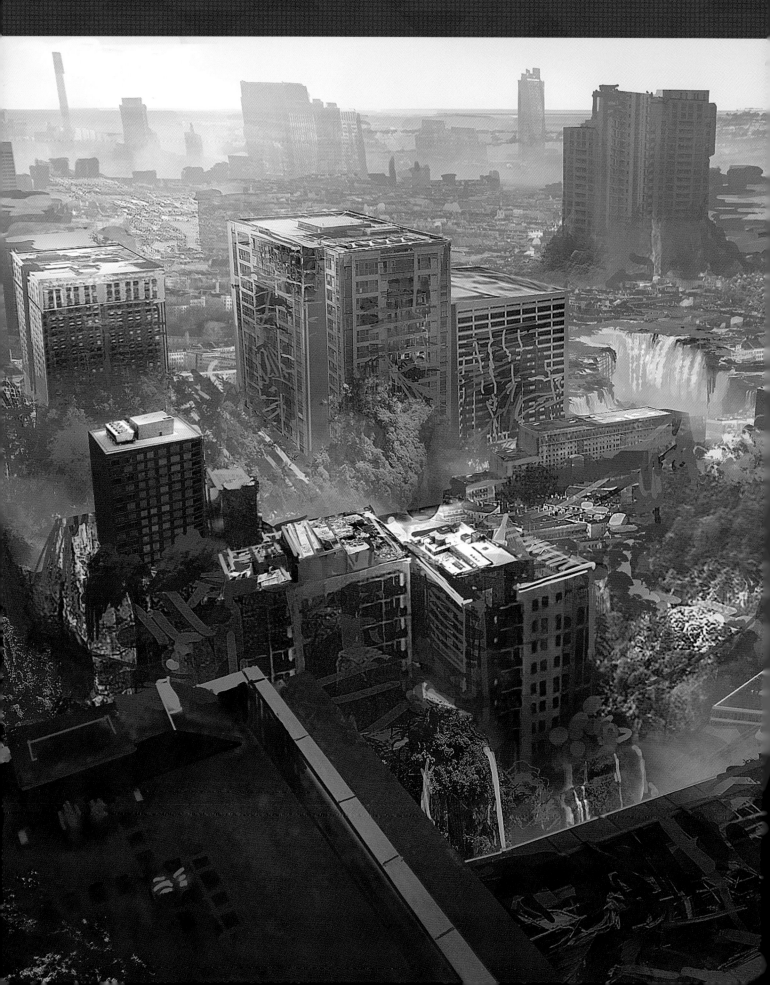

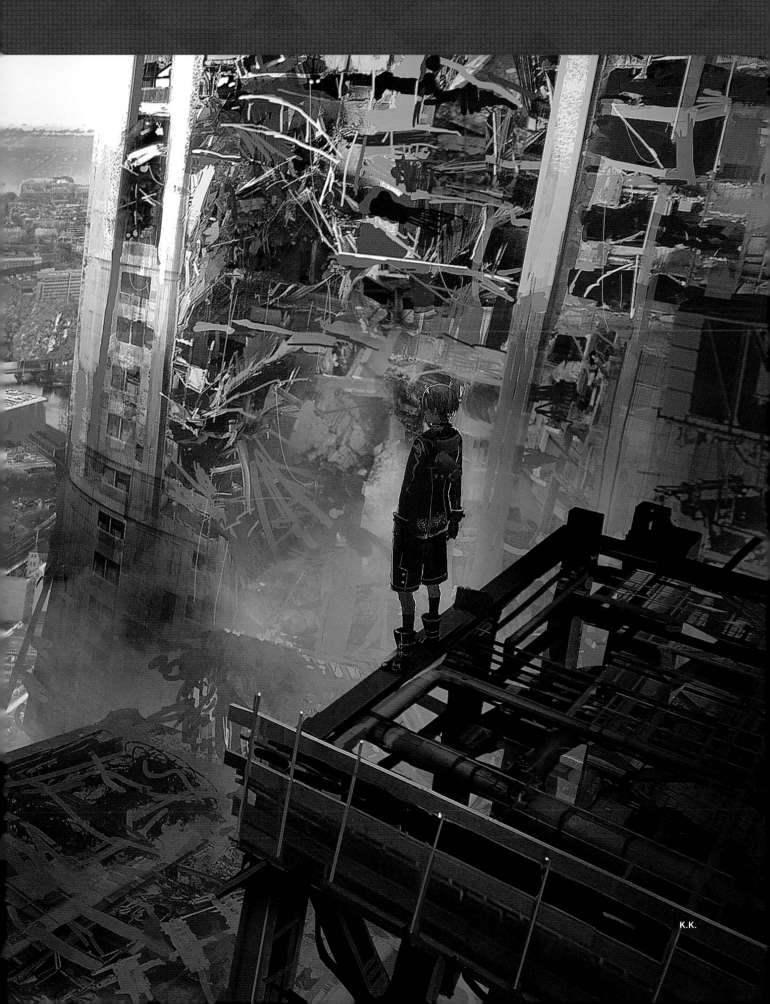

Survey aircraft: YoRHa No. 9 Type S and his support unit, Pod 153

This report contains information that remained in the storage space of YoRHa No. 9 Type S, who accompanied No. 2 Type B during surface missions. As a temporary measure until total memory analysis is complete, this document is marked with Level S confidentiality and should not be disclosed to any YoRHa personnel, save for the commander.

K.K.

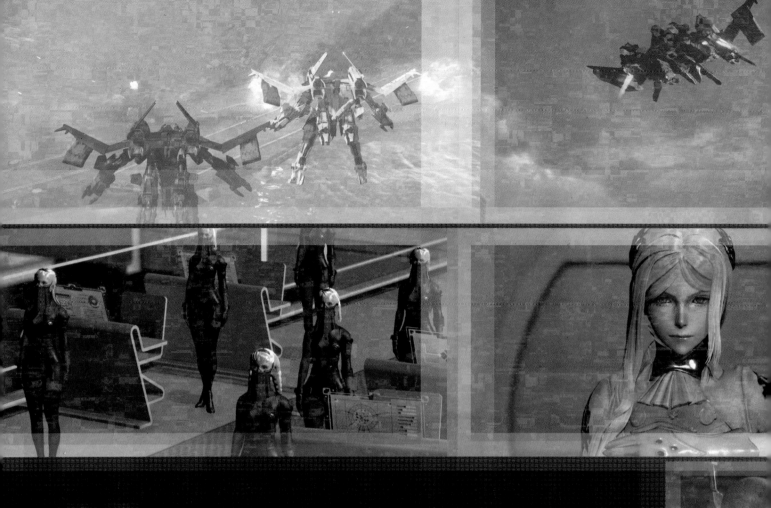

5012 CE

The aliens from outer space begin their invasion.

The weapons known as "machine lifeforms" created by the aliens devastate the human population.

The few remaining humans escape to the moon.

5204 CE

The androids created by mankind begin a counteroffensive from their base, an artificial satellite orbiting Earth.

Although roughly ten large-scale surface operations are carried out, the androids are unable to deal a finishing blow, and the war drags on.

11945 CE

Mankind's weapons for the final battle, known as the "YoRHa forces," detect a large faction of machine lifeforms in the abandoned factory.

In order to destroy them, a battle squadron, as well as the scanner model No. 9 Type S, is deployed.

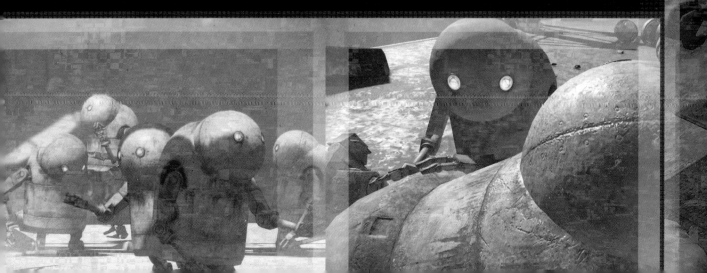

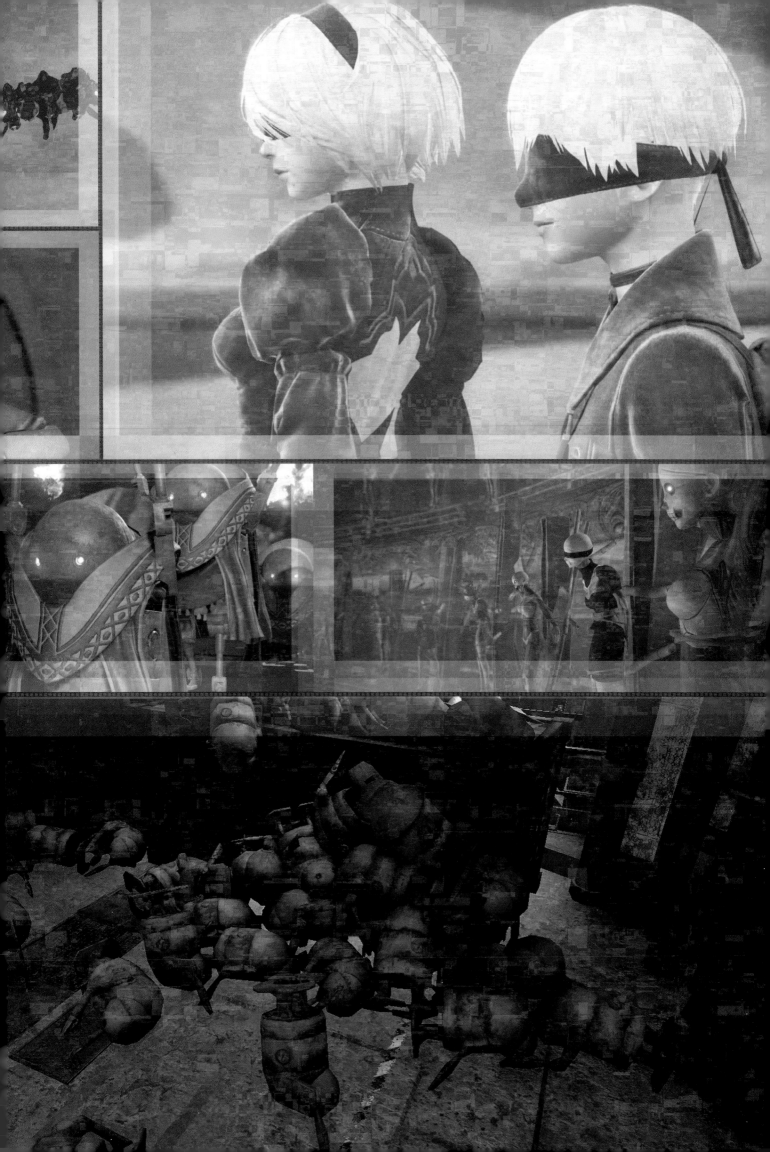

SKETCH OF
SURFACE OPERATION AREA

Desert Area ← :00084

Abandoned Factory ← :00038

This sketch was originally created with data from the satellite orbiting Earth. The details of each area are referenced in the investigative report put together by 9S and Pod 150.

Supplement: The ⊟ in the written report denotes the locations of access points deployed in each area, ⬍ denotes available elevators, and ⊟ denotes the confirmed locations of ladders.

Forest Kingdom ✦:00112

Pascal's Village ✦:00106

Abandoned Amusement Park ✦:00096

City Ruins ✦:00054

Copied City ✦:00148

Alien Ship ✦:00140

Resistance Camp ✦:00074

Flooded City ✦:00128

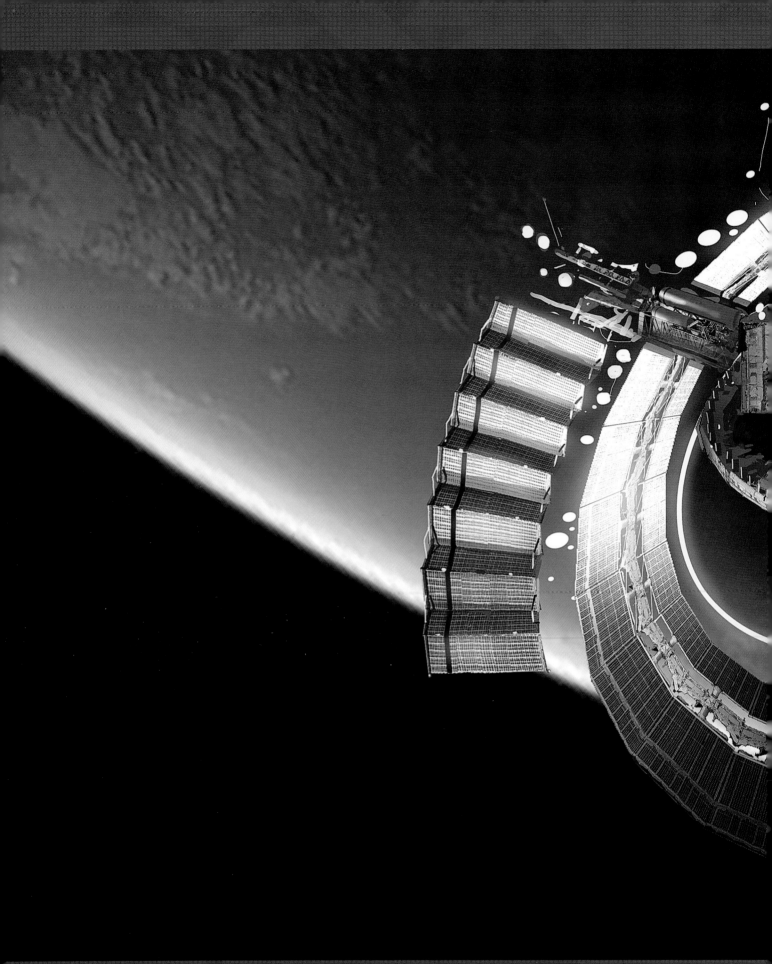

BUNKER REPORT

45766572797468696e672077617320617272616e676564206f6620646573747266f7965642e

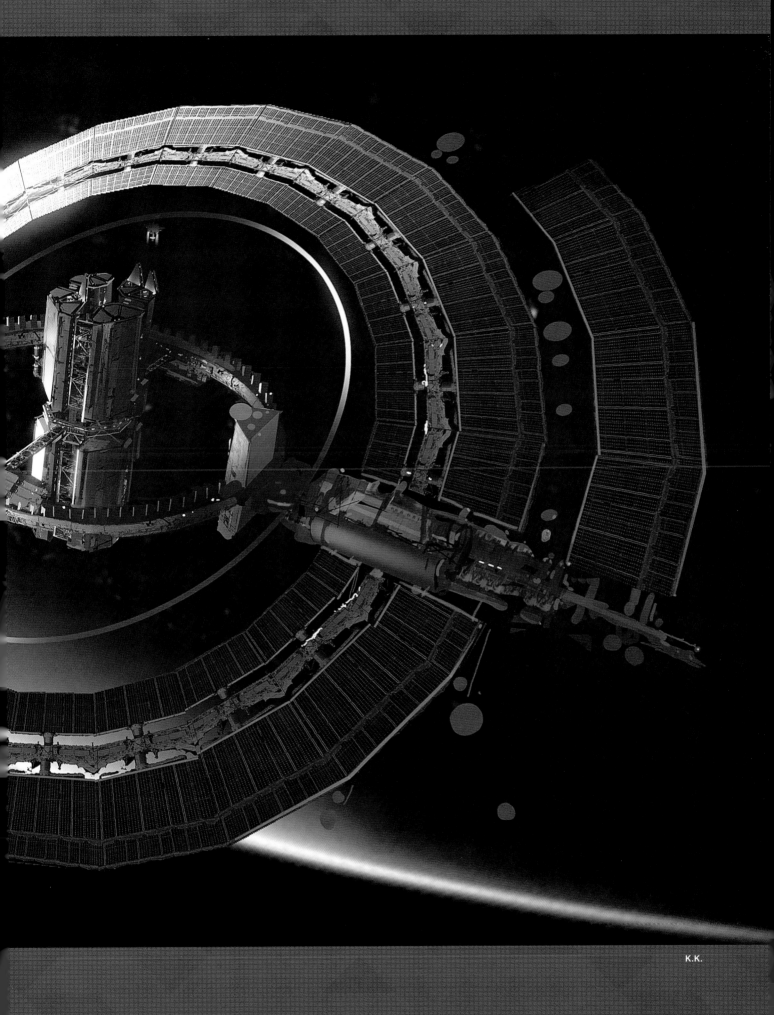

In total, there are thirteen military installations deployed as satellites orbiting the Earth. Four are high-output laser satellites, and nine are military bases. The Bunker was designed as a base for the exclusive use of the YoRHa forces. It also serves as a

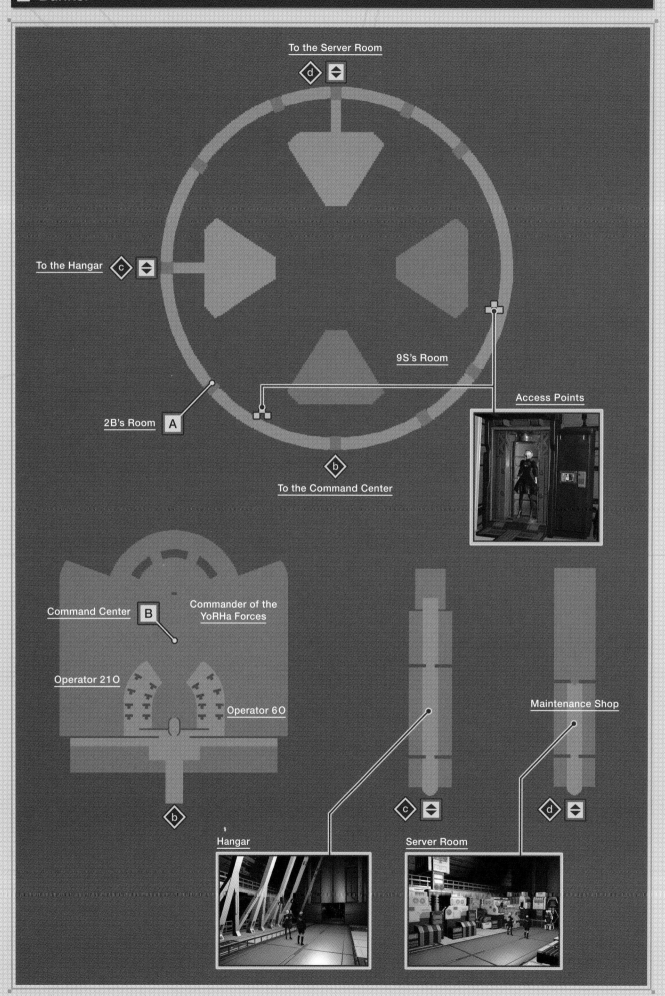

To the Server Room

◇d ⬍

To the Hangar ◇c ⬍

9S's Room

Access Points

2B's Room ▢A

◇b

To the Command Center

Command Center ▢B

Commander of the YoRHa Forces

Operator 21O

Operator 6O

Maintenance Shop

◇b

◇c ⬍

◇d ⬍

Hangar

Server Room

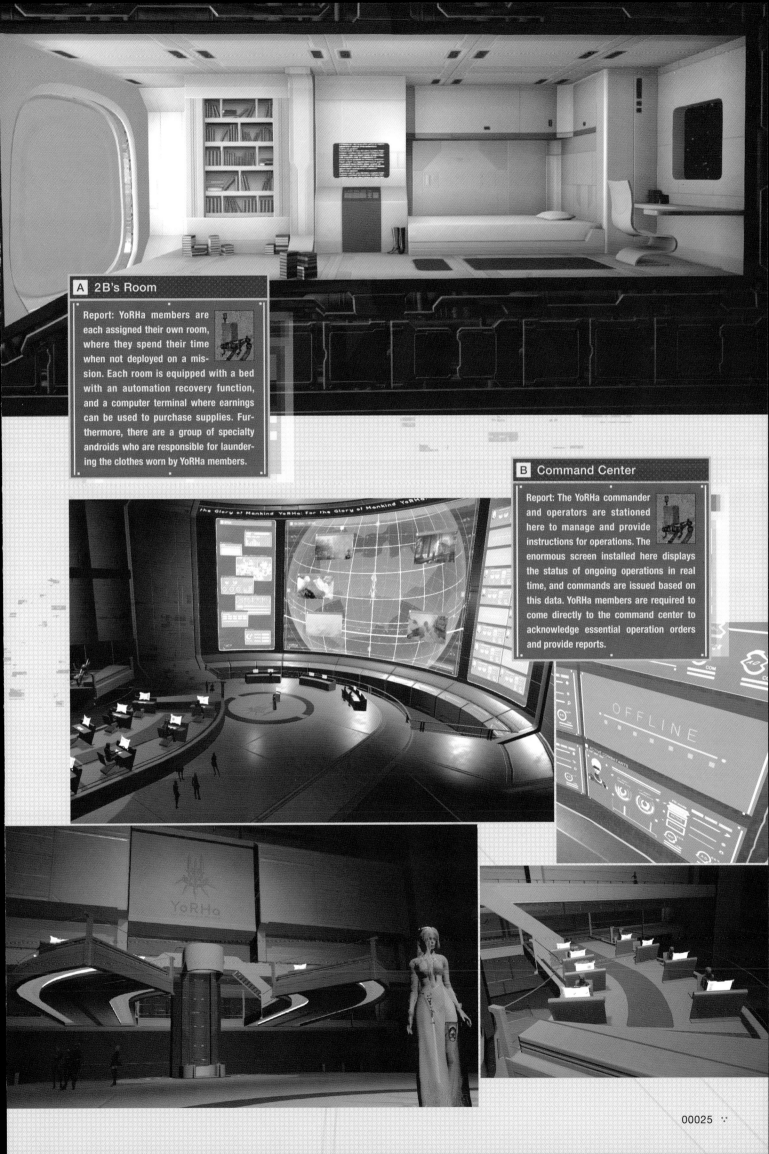

A 2B's Room

Report: YoRHa members are each assigned their own room, where they spend their time when not deployed on a mission. Each room is equipped with a bed with an automation recovery function, and a computer terminal where earnings can be used to purchase supplies. Furthermore, there are a group of specialty androids who are responsible for laundering the clothes worn by YoRHa members.

B Command Center

Report: The YoRHa commander and operators are stationed here to manage and provide instructions for operations. The enormous screen installed here displays the status of ongoing operations in real time, and commands are issued based on this data. YoRHa members are required to come directly to the command center to acknowledge essential operation orders and provide reports.

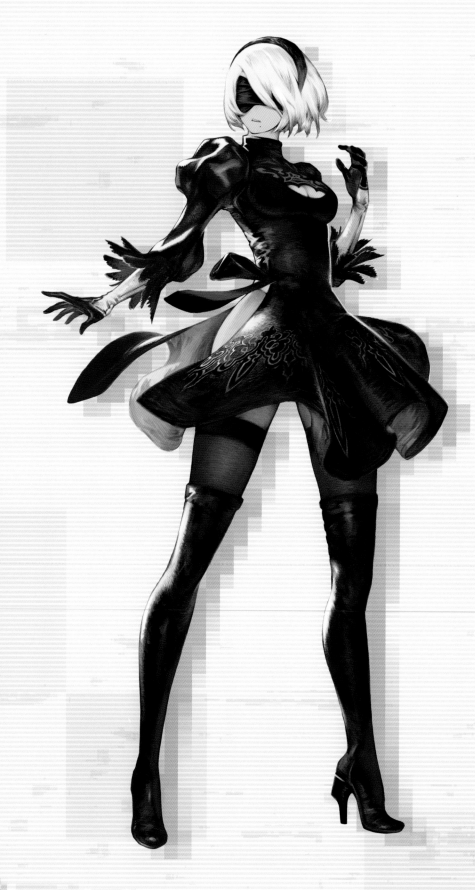

A.Y.

2B

| Feature: All-purpose battle android | Height: 168 cm (with heels) | Weight: 148.8 kg | Bust: 84 cm | Waist: 56 cm | Hips: 88 cm | Eye color: Gray blue | Hair color: Yellowish white |

An all-purpose battle android, her official name is YoRHa No. 2 Type B. The subprocessors in her limbs have been finetuned, making her best suited for melee combat. During battle, she can coordinate with accompanying support units for ranged attacks, and she can also be assigned to pilot flight units. B-type models are generally known to be belligerent, but 2B is calm and collected, and she adheres to the YoRHa rule that emotions are prohibited.

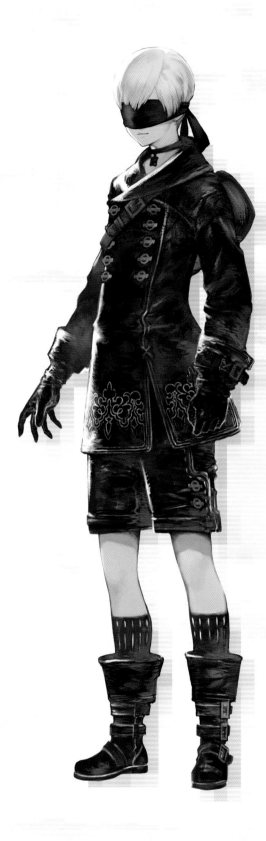

A.Y.

9S

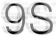

| Feature: Cyberwarfare | Height: 160 cm (with boots) | Weight: 129.9 kg | Bust: 61 cm | Waist: 53 cm | Hips: 73 cm | Eye color: Gray blue | Hair color: Yellowish white |

A scanner-model android, his official name is YoRHa No. 9 Type S. He possesses combat functionality as well, but his main duty is to work alone, gathering intelligence with his hacking function. Due to those characteristics, S types have a neural composition that gives them overwhelming curiosity. 9S in particular has a wide range of rich emotional expression, which makes him noncompliant with YoRHa standards. The reason why he's equipped with such an unusual characteristic is unknown at present. After the operation at the abandoned factory, he embarks on a mission to survey the city ruins with 2B.

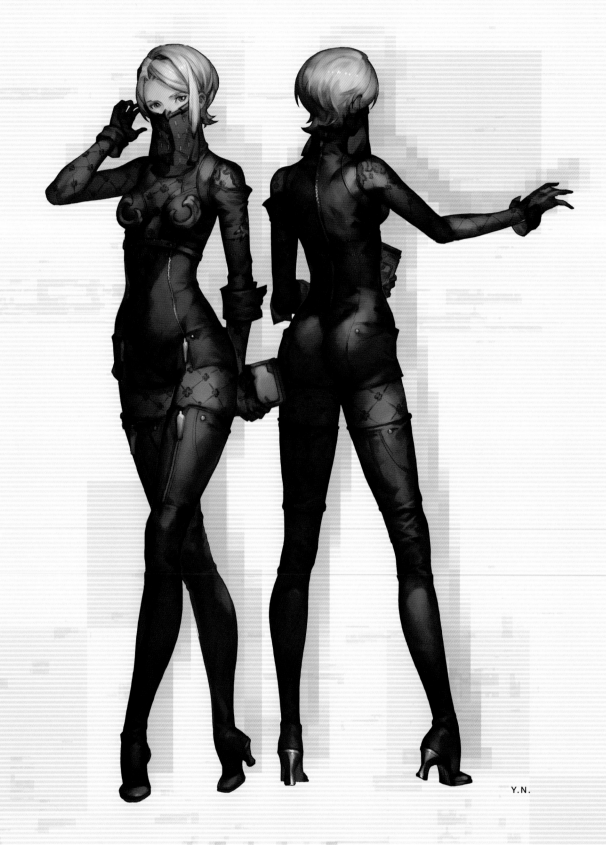

Y.N.

Operators 6O & 21O

Feature: Data processing	Height: 167 cm (with heels)	Weight: 145.5 kg	Bust: 92 cm	Waist: 57 cm	Hips: 93 cm	Eye color: Greenish blue	Hair color: Gold

Operator-type androids stationed in the command center of the Bunker. Fundamentally, they send communications regarding information analysis and orders, rather than participating in combat directly. O types are specialized in analytical functions, and several of them are connected simultaneously in the command room to improve throughput. They are also said to have other special functions, but detailed information is not available to the public. 6O is responsible for 2B, and 21O is responsible for 9S. 6O is comparatively cheerful, while 21O is calm and composed.

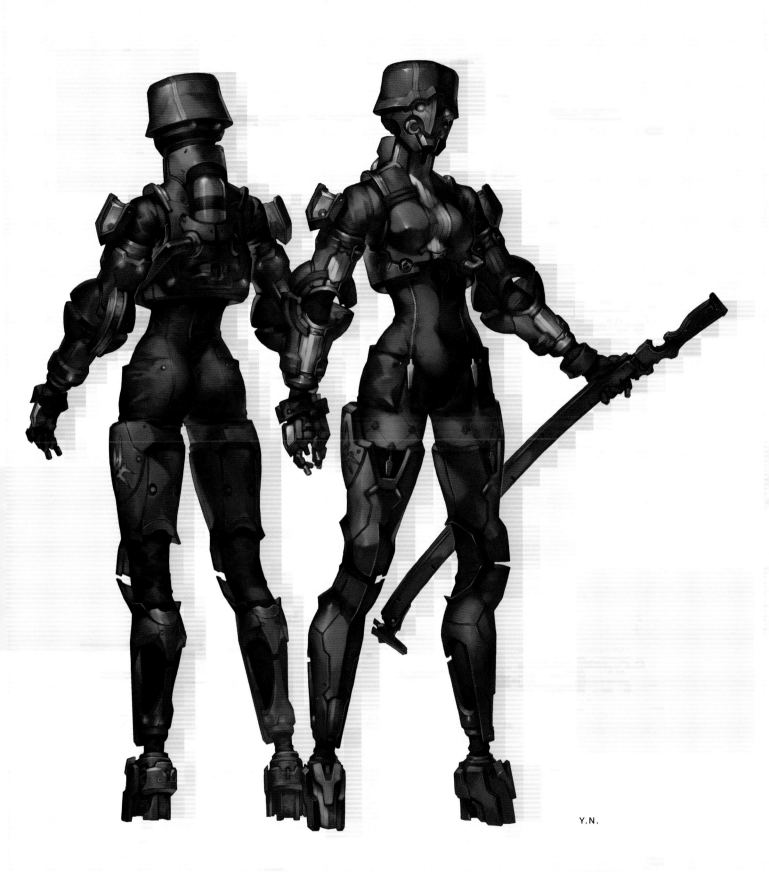

Y.N.

YoRHa (Heavy Armament)

Feature: Melee combat	Height: —	Weight: —	Bust: —	Waist: —	Hips: —	Eye color: —	Hair color: —

YoRHa troops who wear the heavy armor that is formally used by YoRHa forces. The heavy armor covers the entire body, including the head, and boasts excellent protection. The object worn as a backpack is a cooling unit. YoRHa soldiers utilize their skirts and hair to combat radiation in the heat of battle, but the interior of the heavy armor can get stuffy, so they use the cooling units to maintain a comfortable temperature. It's hypothesized that this equipment is also brought in for large-scale invasion operations against the machine lifeforms, and all YoRHa battle models, including 2B, use it.

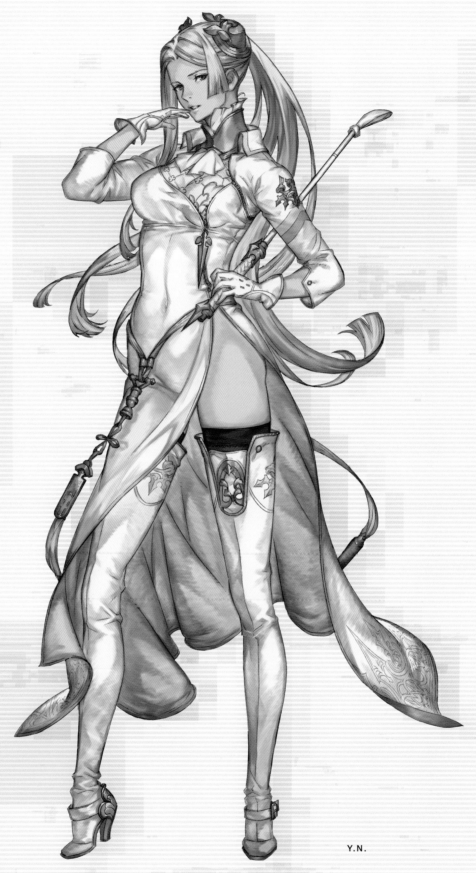

Y.N.

Commander

| Feature: Command functionality | Height: 175 cm (with heels and hair ornaments) | Weight: 166.8 kg | Bust: 92 cm | Waist: 61 cm | Hips: 94 cm | Eye color: Greenish blue | Hair color: Gold |

The commander in chief, she leads the YoRHa forces. In her position, she comes into contact with a variety of top-secret information. She is the only non-YoRHa unit in the Bunker. She issues commands to her subordinates in a strict tone, and she rarely shows emotion, but she seems to worry about 2B and 9S. She has a tendency to neglect her own needs, and her personal room is such a mess that she won't let anyone inside. The deserter A2 seems to be connected to her through a series of events that occurred during a previous operation.

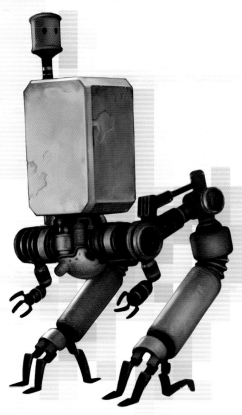

A.Y.

Pods 042 & 153

Feature: Accompanying support	Height: 74.8483 cm (with protrusion)	Weight: 36 kg	Bust: 54 cm	Waist: 54 cm	Hips: 54 cm	Eye color: —	Hair color: —

Support units that are standard issue for YoRHa members and accompany them everywhere. Pod 042 follows 2B, and Pod 153 follows 9S. They're equipped with a variety of ranged attacks for combat support, as well as a mobile screen. It's also possible to link attacks with multiple pods. These units are manufactured to be weapon support systems, so unlike the cognitive AI of androids, they have no complex thought patterns. However, they do perform activities such as exchanging information with their fellow pods to make sure orders are carried out without complication.

Access Points

Devices that perform backups of android memory data. They possess a variety of functions that allow activities such as mail checking and hacking practice. The same type of equipment is installed on the surface, but they are built to resemble vending machines from the old world in order to disguise them from enemies. The models on the surface also have a protective shield function that activates during times of emergency to prevent machine lifeforms from stealing data. The Development Department is beta testing a feature that will allow access points to transfer data among themselves, and they plan to release them sequentially within a month.

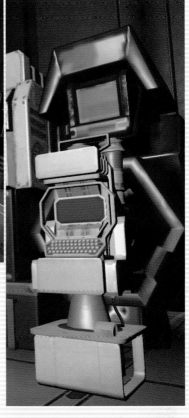

Large Terminal

Equipment installed in the server room that communicates with the outside world. Anyone who wishes to use it must first request permission. It can be used even in poor transmission conditions, and if there's a scanner-type android available, it's also possible to directly hack into machine lifeforms located on the surface from the Bunker. Access to the Council of Humanity on the moon is centrally managed here as well. Because the library has many fascinating features, we plan to investigate it at a later time.

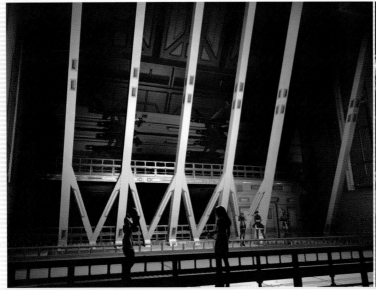

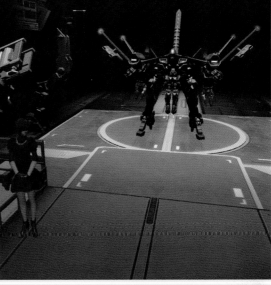

Hangar

The area where flight units are stored. YoRHa members who descend to the surface equip flight units here, and they sortie from the installed catapults. Members who perform maintenance on aircraft are stationed within the hangar.

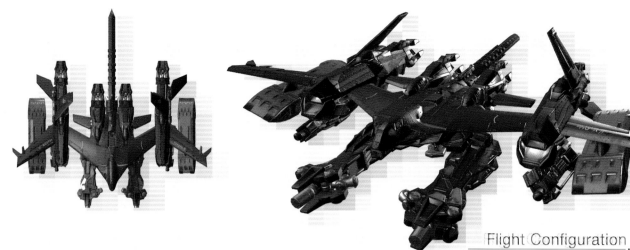

Flight Configuration

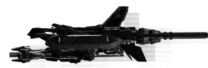

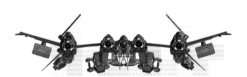

Flight Units

Equipment used by YoRHa soldiers for descent to Earth and suppression missions. Along with the ability to enter the atmosphere on their own, they're armed with a Gatling gun, a blade, and missiles. They can take on two different forms: a flight configuration, which emphasizes the highest possible speed for long-distance movement, and a mobile configuration, which emphasizes mobility during combat. Black is their basic coloring, but when a captain equips one, it changes to white in order to be distinguishable. Their operating costs are extremely high, so the use of a simulator is required during training.

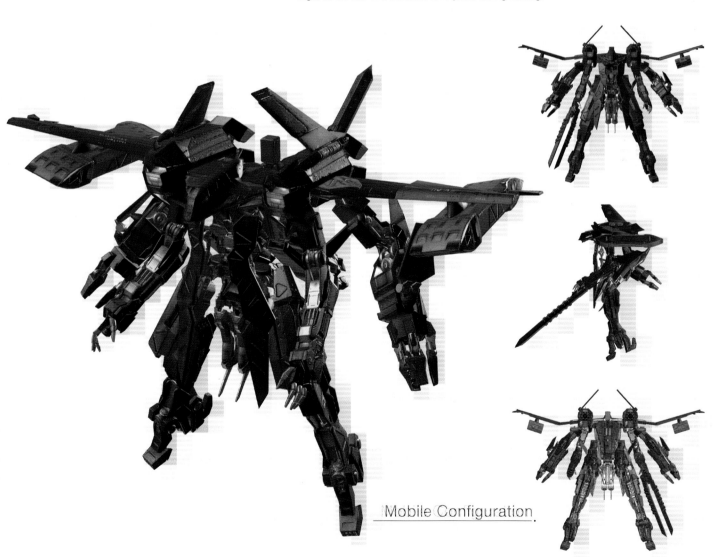

Mobile Configuration

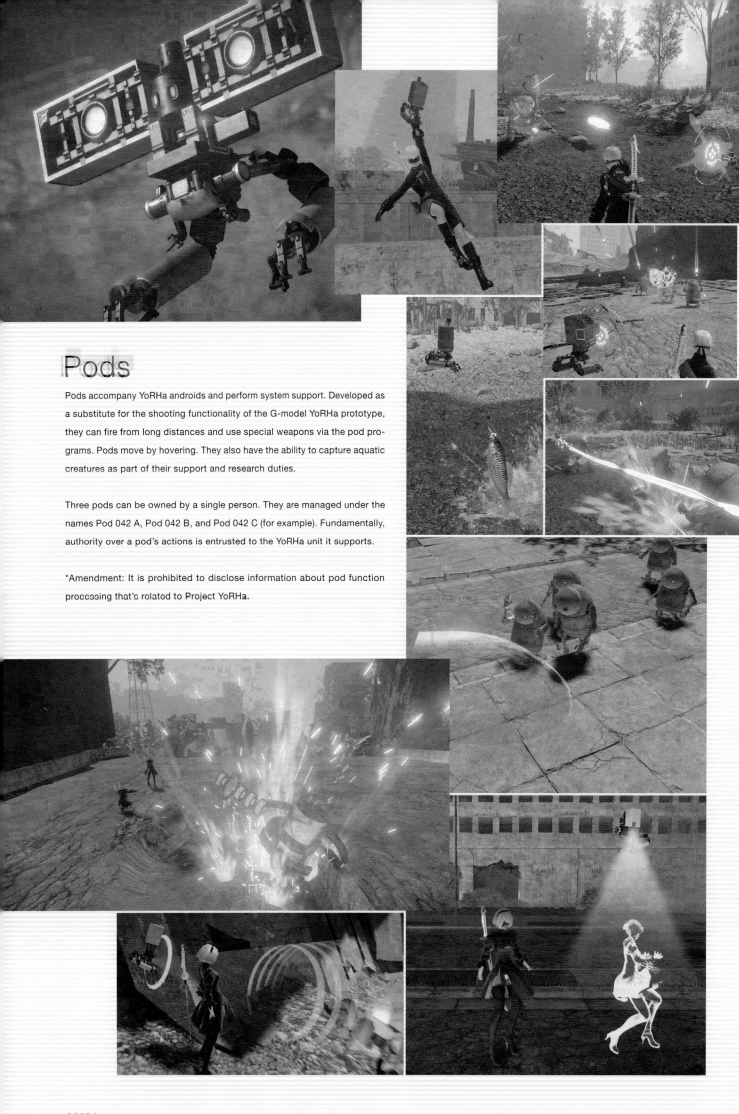

Pods

Pods accompany YoRHa androids and perform system support. Developed as a substitute for the shooting functionality of the G-model YoRHa prototype, they can fire from long distances and use special weapons via the pod programs. Pods move by hovering. They also have the ability to capture aquatic creatures as part of their support and research duties.

Three pods can be owned by a single person. They are managed under the names Pod 042 A, Pod 042 B, and Pod 042 C (for example). Fundamentally, authority over a pod's actions is entrusted to the YoRHa unit it supports.

*Amendment: It is prohibited to disclose information about pod function processing that's related to Project YoRHa.

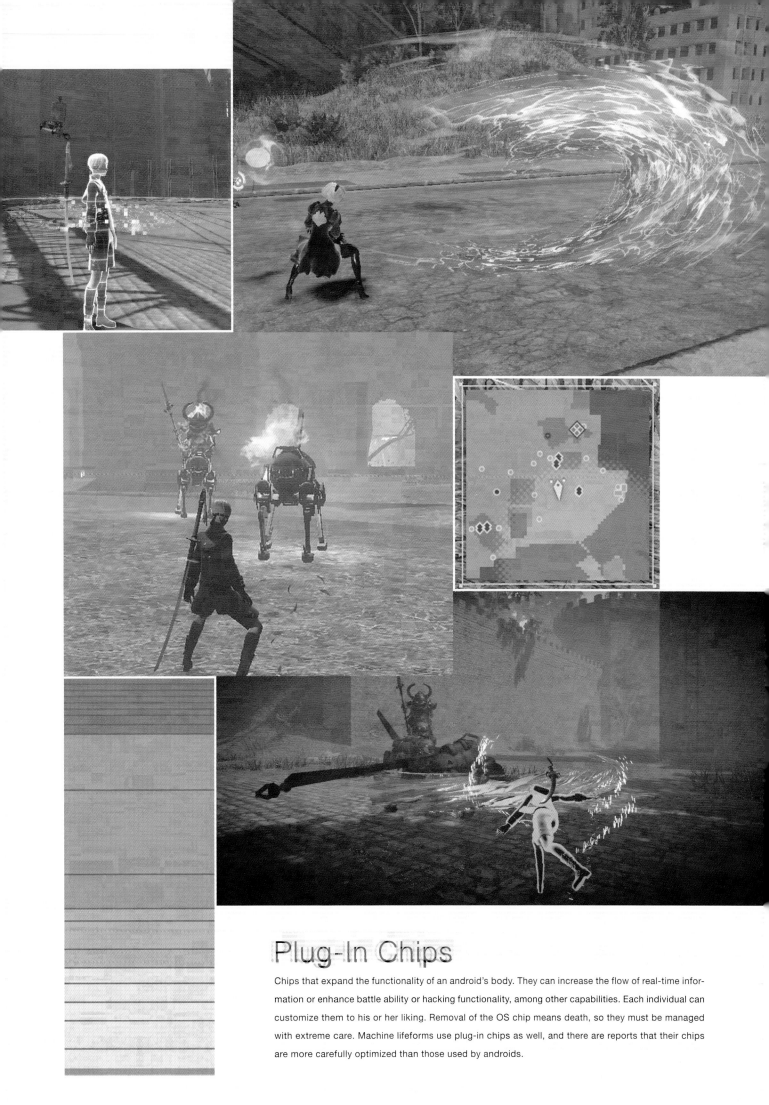

Plug-In Chips

Chips that expand the functionality of an android's body. They can increase the flow of real-time information or enhance battle ability or hacking functionality, among other capabilities. Each individual can customize them to his or her liking. Removal of the OS chip means death, so they must be managed with extreme care. Machine lifeforms use plug-in chips as well, and there are reports that their chips are more carefully optimized than those used by androids.

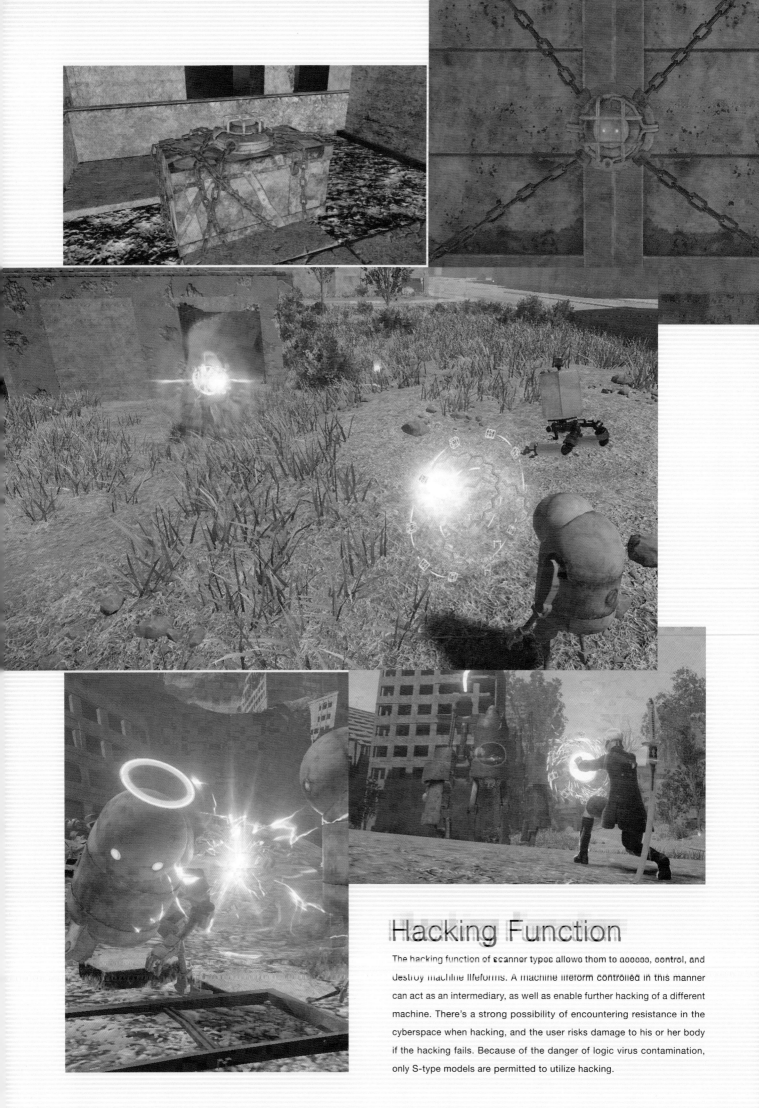

Hacking Function

The hacking function of scanner types allows them to access, control, and destroy machine lifeforms. A machine lifeform controlled in this manner can act as an intermediary, as well as enable further hacking of a different machine. There's a strong possibility of encountering resistance in the cyberspace when hacking, and the user risks damage to his or her body if the hacking fails. Because of the danger of logic virus contamination, only S-type models are permitted to utilize hacking.

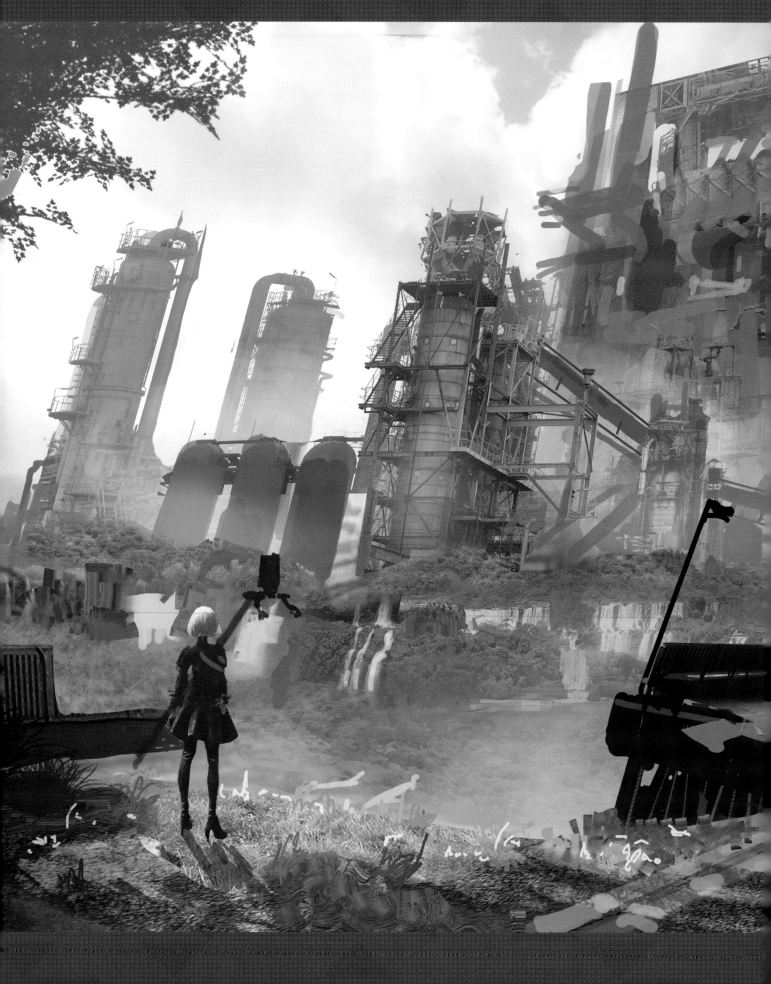

ABANDONED FACTORY REPORT

4120706c6163652077686572652020676f4732061726520626f726e2e

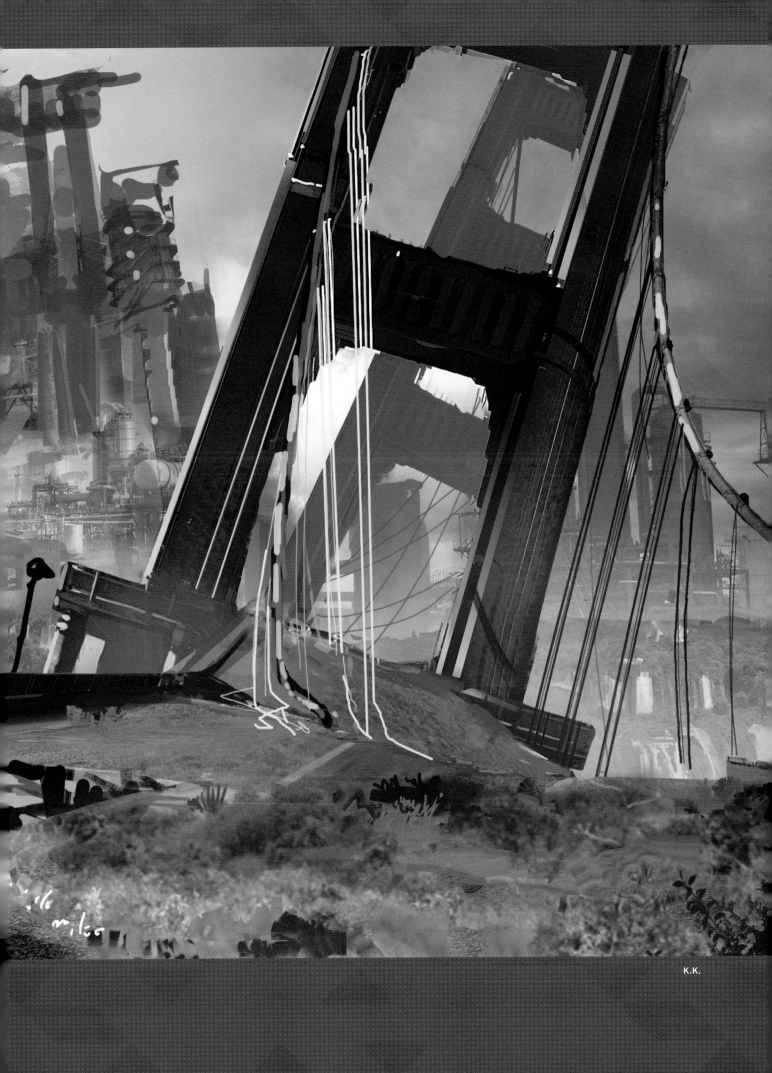

K.K.

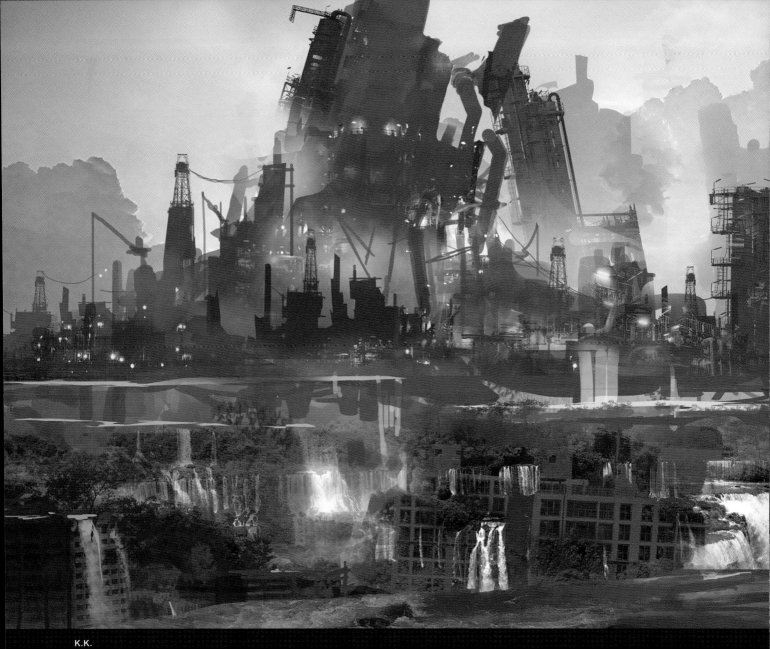
K.K.

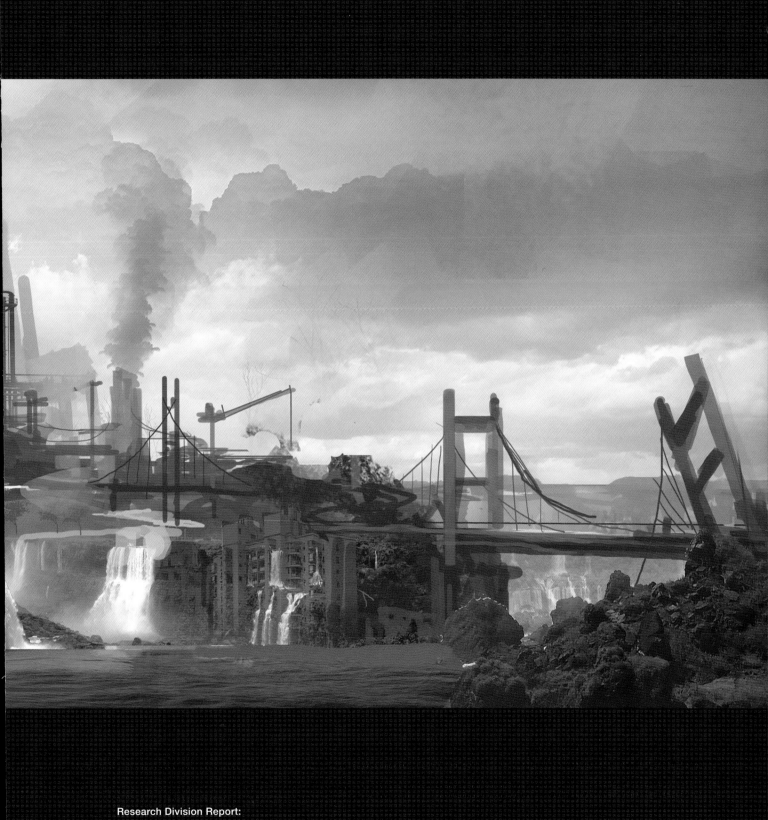

Research Division Report:

The abandoned weapons factory was built in the era of the old world. It was formerly located inland, but due to geological shifts, it is now half-submerged. It used to be in complete ruins, but ever since an accident involving explosives in 7645 CE, machine lifeforms have resided there.

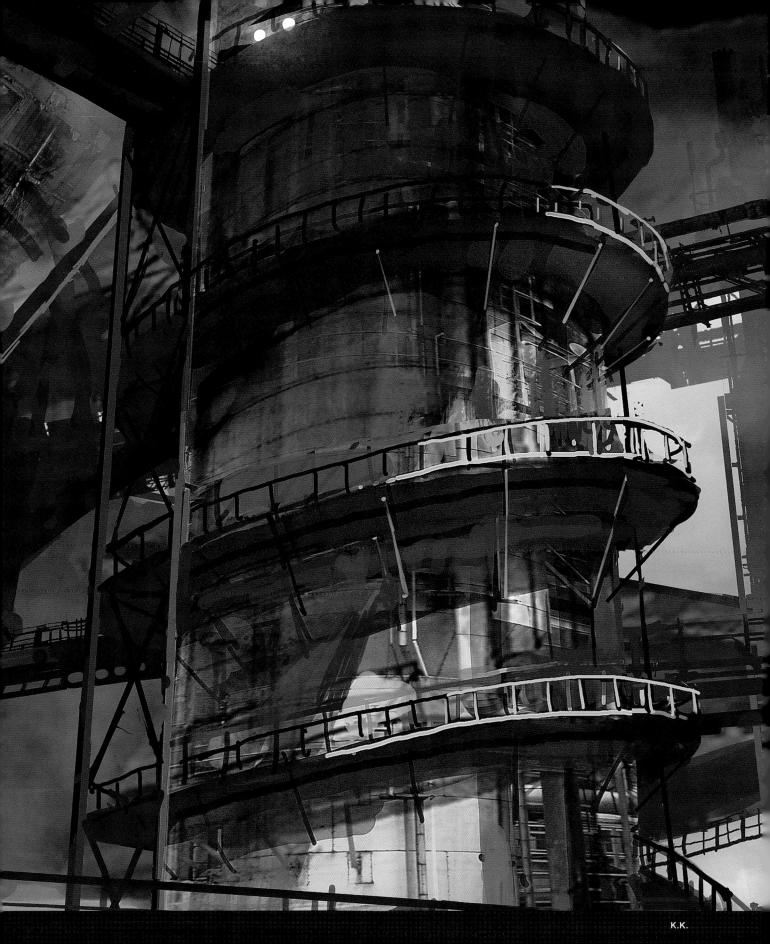

K.K.

Research Division Report:

Fourth section: Sewage treatment facility. When it was still in use by humans, thousands of laborers were employed here. A dining hall was built next to the sewage treatment facility for the purpose of efficient movement between buildings, and records remain of employees voicing their criticisms of this layout. Nowadays, machine lifeforms use it as an oil purification tank.

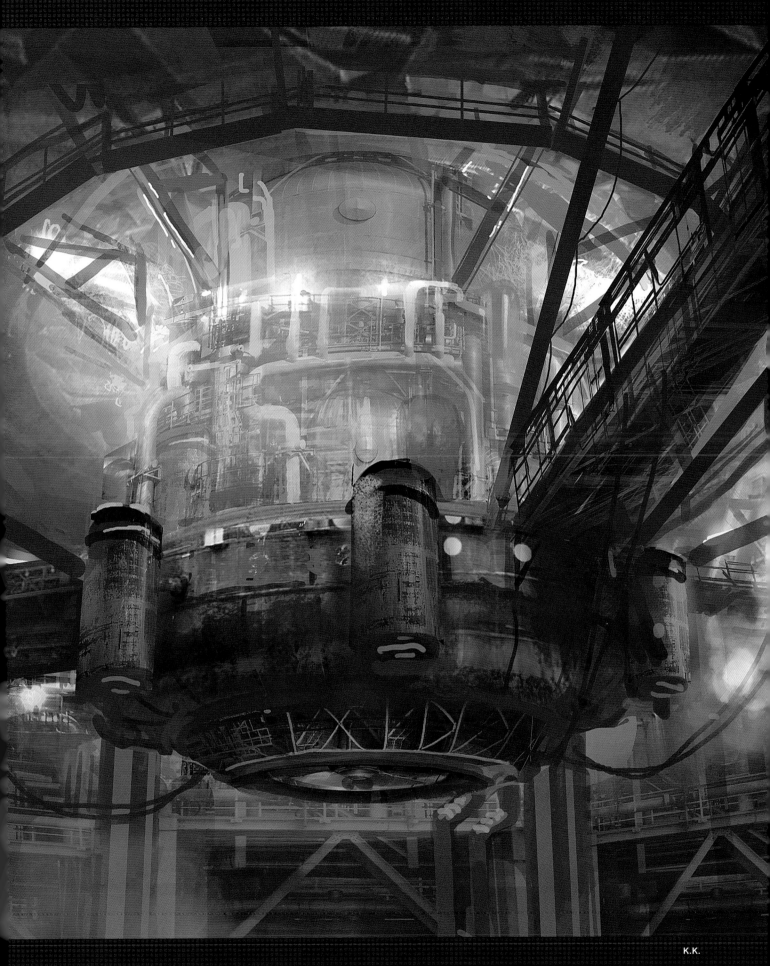

K.K.

Research Division Report:

Thirteenth section: Weapons testing site. Among the weapons that humans manufactured, humanoid weapons called P22 and P33 were developed here. The testing site was used for activities such as inspecting the melee fighting abilities of those weapons, and a large-scale physical barrier generator was installed on the ceiling.

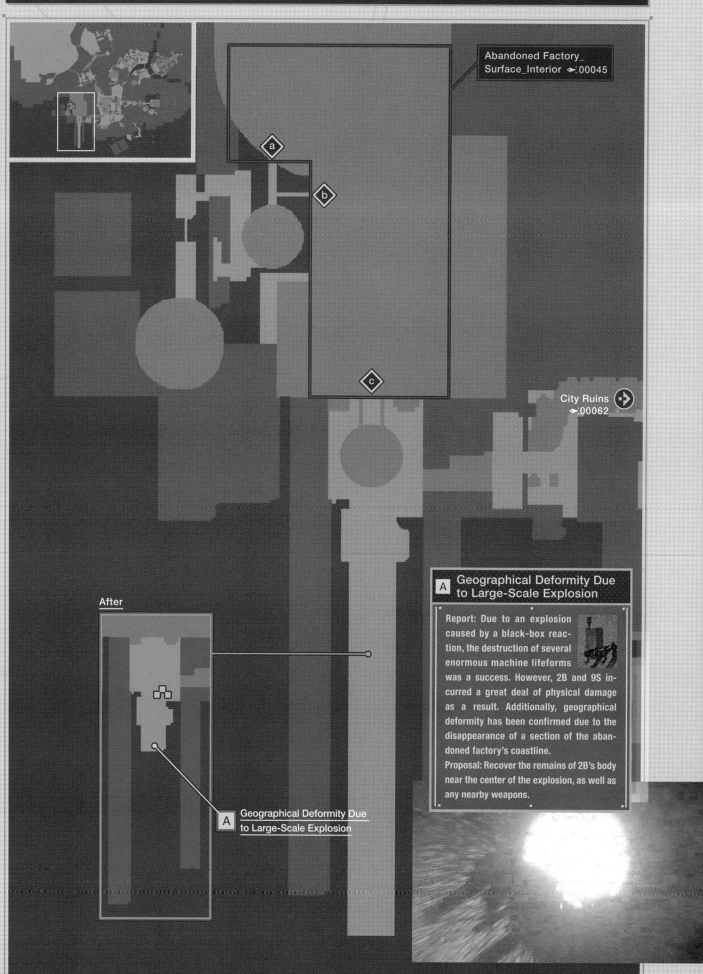

Abandoned Factory_
Surface_Interior ✎00045

a

b

c

City Ruins ➤
✎00062

After

A Geographical Deformity Due to Large-Scale Explosion

Report: Due to an explosion caused by a black-box reaction, the destruction of several enormous machine lifeforms was a success. However, 2B and 9S incurred a great deal of physical damage as a result. Additionally, geographical deformity has been confirmed due to the disappearance of a section of the abandoned factory's coastline.

Proposal: Recover the remains of 2B's body near the center of the explosion, as well as any nearby weapons.

A Geographical Deformity Due to Large-Scale Explosion

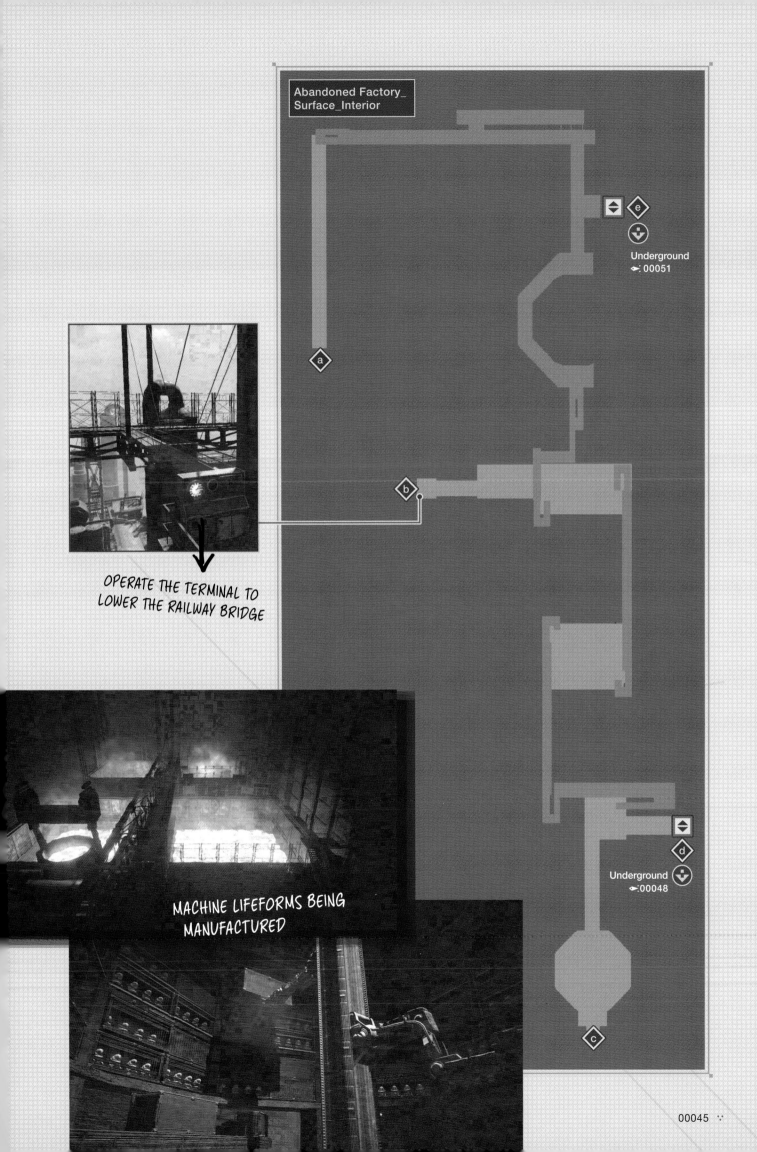

Abandoned Factory_
Surface_Interior

e

Underground
00051

a

b

d

Underground
00048

c

OPERATE THE TERMINAL TO
LOWER THE RAILWAY BRIDGE

MACHINE LIFEFORMS BEING
MANUFACTURED

K.K.

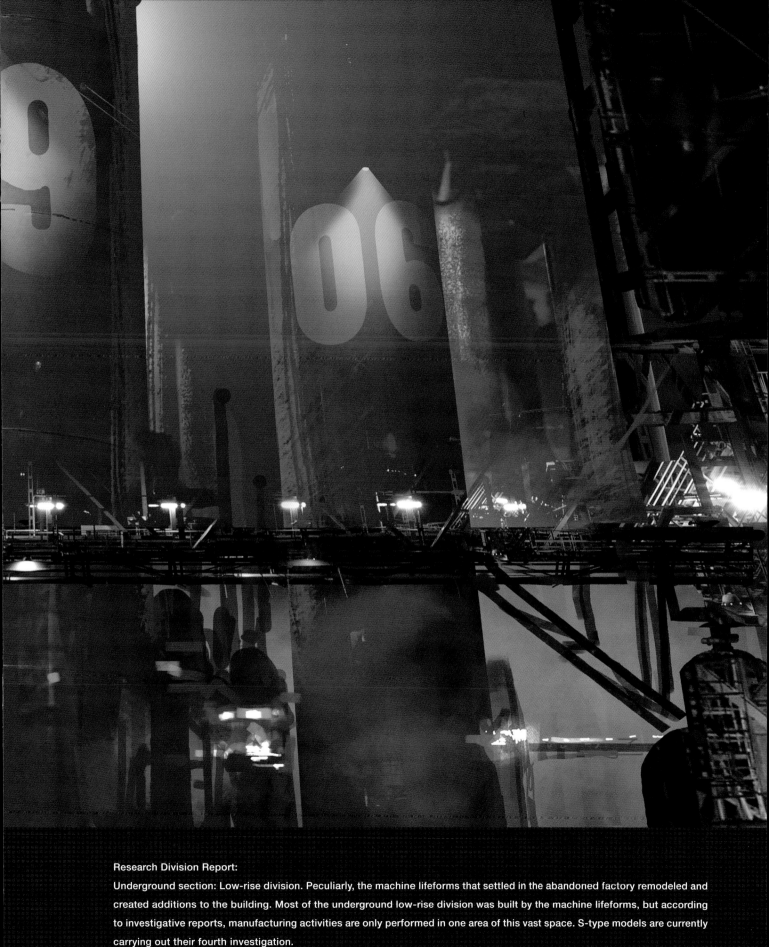

Research Division Report:
Underground section: Low-rise division. Peculiarly, the machine lifeforms that settled in the abandoned factory remodeled and created additions to the building. Most of the underground low-rise division was built by the machine lifeforms, but according to investigative reports, manufacturing activities are only performed in one area of this vast space. S-type models are currently carrying out their fourth investigation.

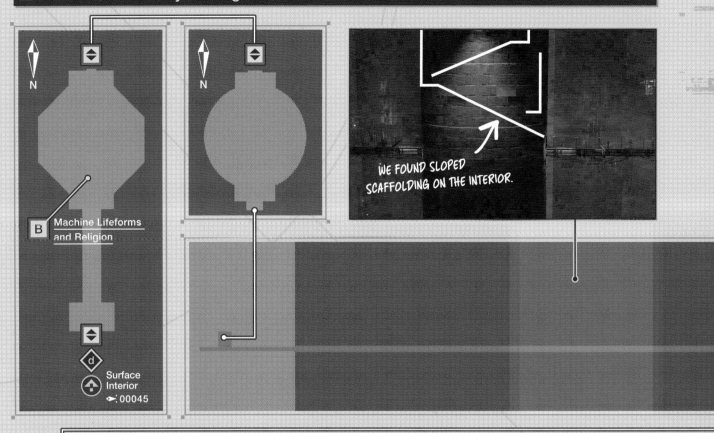

WE FOUND SLOPED
SCAFFOLDING ON THE INTERIOR.

N

B Machine Lifeforms
and Religion

⬍

d

⬆ Surface
Interior
↩ 00045

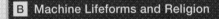

BECOME AS GODS! BECOME AS
GODS! WE'LL ALL DIE TOGETHER
AND BECOME AS GODS!

B Machine Lifeforms and Religion

Apparently, machine lifeforms who have disconnected from the network have a sense of self. A group that gathered in the abandoned factory seemed to have founded a "religion" as a result of their peaceful, conflict-free existence. It's exactly like human behavior . . . We have confirmed there are a certain number of individuals among the machine lifeforms who have decided they will become gods when they die, so they commit suicide by jumping into the blast furnace. On the other hand, there are those who fear death and kill their comrades out of desperation. Why in the world are there two different groups?

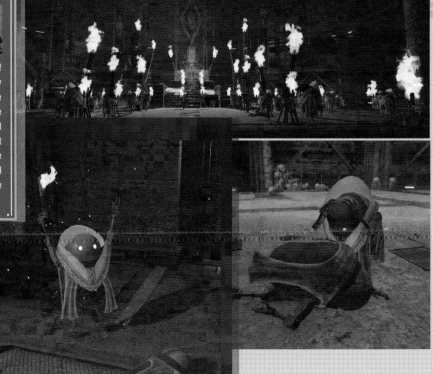

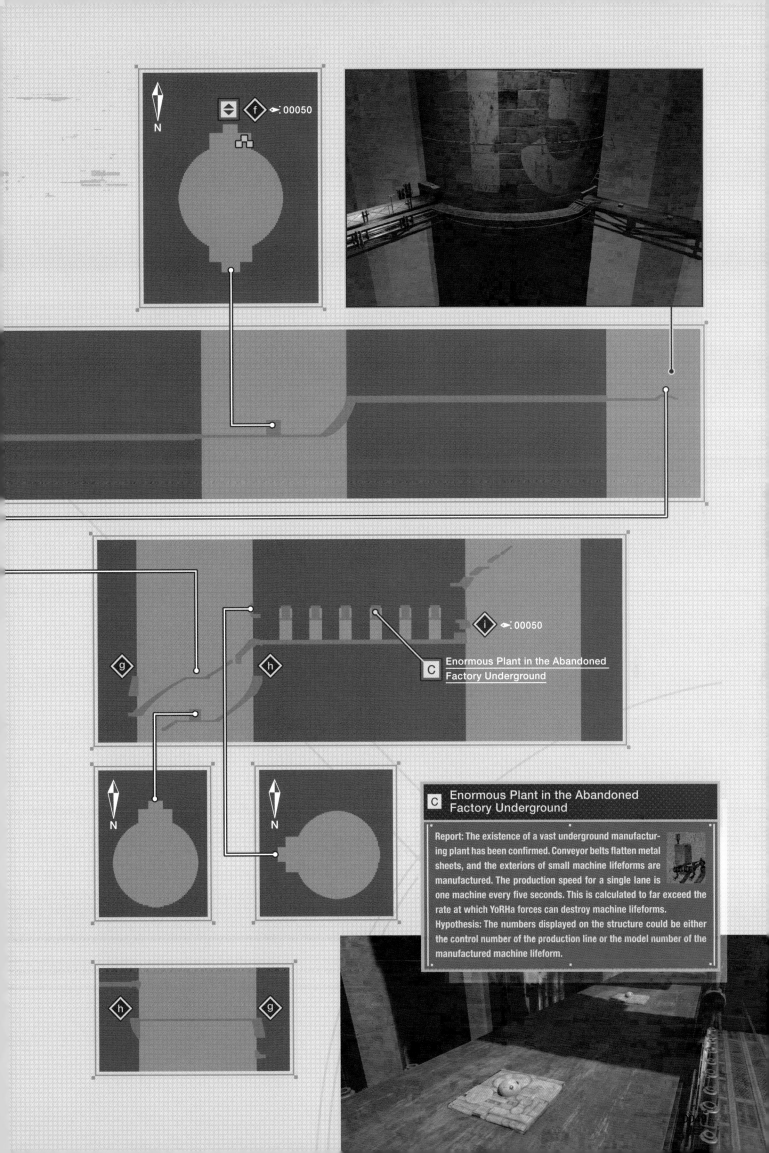

f ⟶ 00050

i ⟶ 00050

C Enormous Plant in the Abandoned
Factory Underground

C Enormous Plant in the Abandoned Factory Underground

Report: The existence of a vast underground manufacturing plant has been confirmed. Conveyor belts flatten metal sheets, and the exteriors of small machine lifeforms are manufactured. The production speed for a single lane is one machine every five seconds. This is calculated to far exceed the rate at which YoRHa forces can destroy machine lifeforms.

Hypothesis: The numbers displayed on the structure could be either the control number of the production line or the model number of the manufactured machine lifeform.

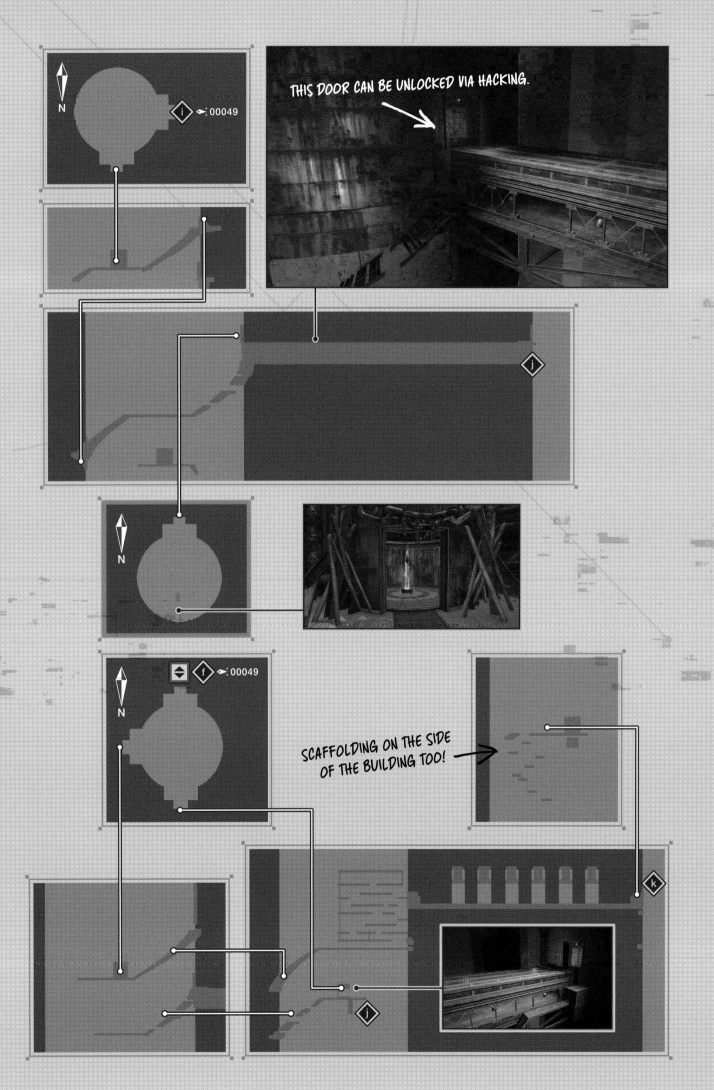

THIS DOOR CAN BE UNLOCKED VIA HACKING.

SCAFFOLDING ON THE SIDE OF THE BUILDING TOO!

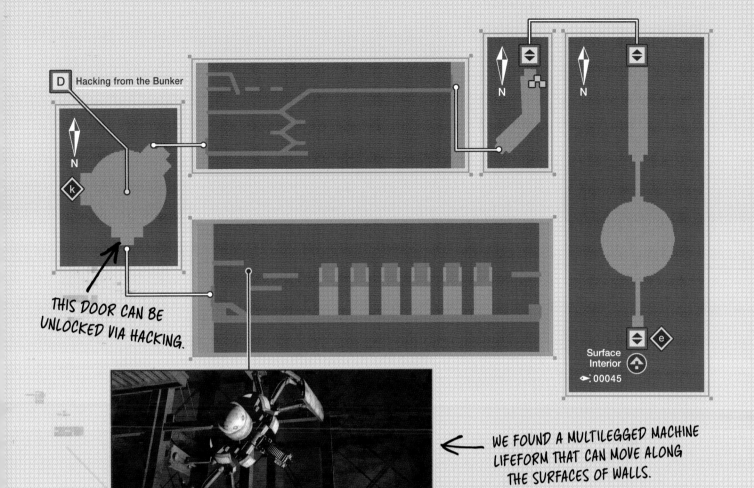

D Hacking from the Bunker

THIS DOOR CAN BE UNLOCKED VIA HACKING.

Surface Interior
00045

WE FOUND A MULTILEGGED MACHINE LIFEFORM THAT CAN MOVE ALONG THE SURFACES OF WALLS.

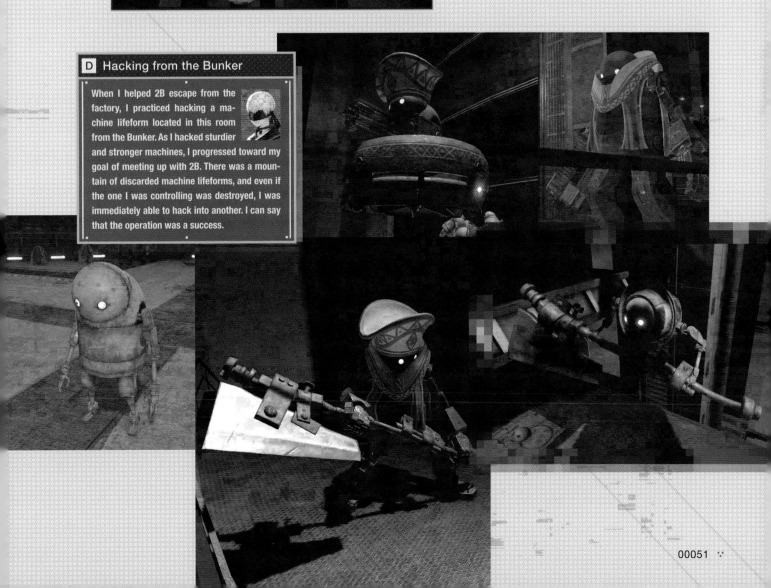

D Hacking from the Bunker

When I helped 2B escape from the factory, I practiced hacking a machine lifeform located in this room from the Bunker. As I hacked sturdier and stronger machines, I progressed toward my goal of meeting up with 2B. There was a mountain of discarded machine lifeforms, and even if the one I was controlling was destroyed, I was immediately able to hack into another. I can say that the operation was a success.

| Special Machine Report | Engels/Marx

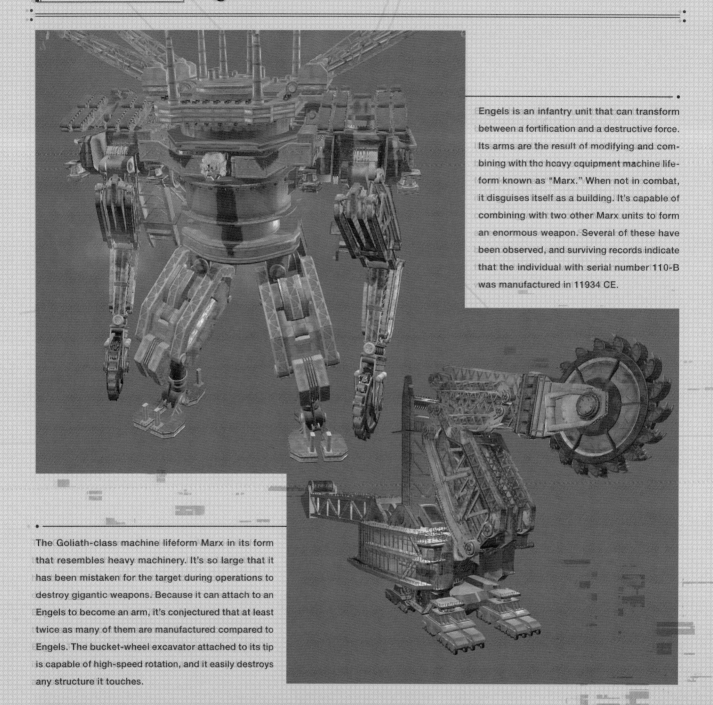

Engels is an infantry unit that can transform between a fortification and a destructive force. Its arms are the result of modifying and combining with the heavy equipment machine lifeform known as "Marx." When not in combat, it disguises itself as a building. It's capable of combining with two other Marx units to form an enormous weapon. Several of these have been observed, and surviving records indicate that the individual with serial number 110-B was manufactured in 11934 CE.

The Goliath-class machine lifeform Marx in its form that resembles heavy machinery. It's so large that it has been mistaken for the target during operations to destroy gigantic weapons. Because it can attach to an Engels to become an arm, it's conjectured that at least twice as many of them are manufactured compared to Engels. The bucket-wheel excavator attached to its tip is capable of high-speed rotation, and it easily destroys any structure it touches.

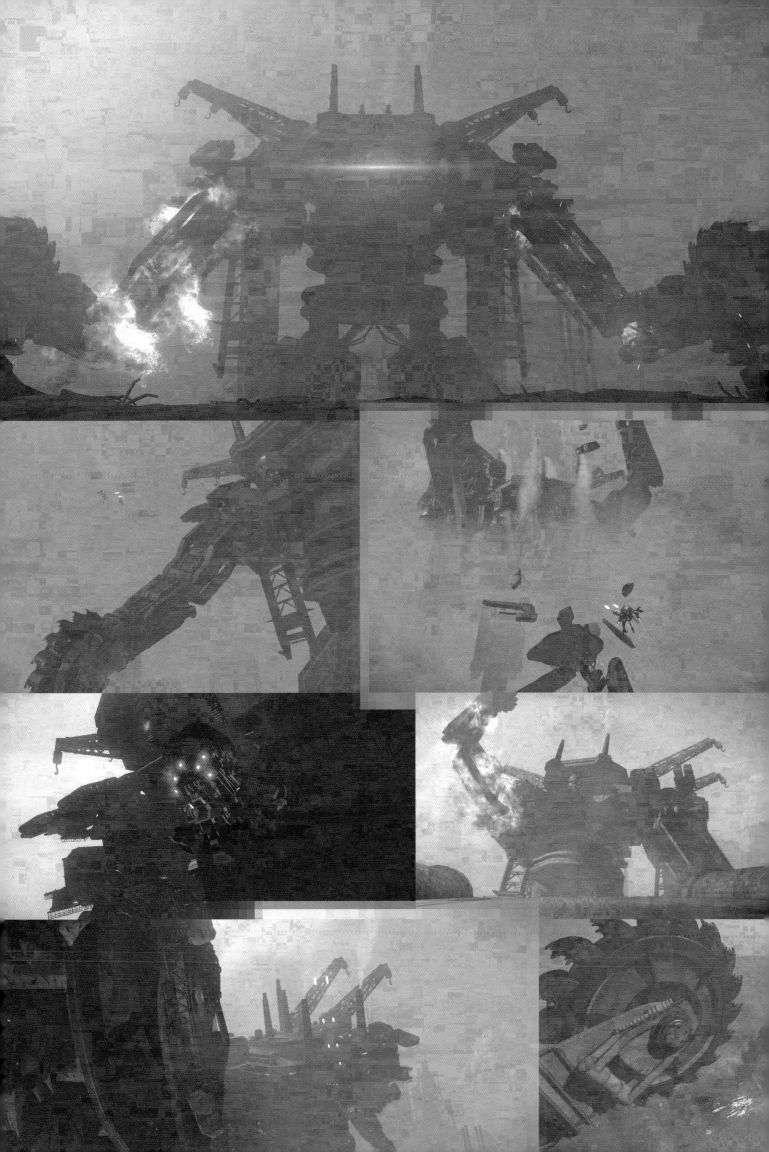

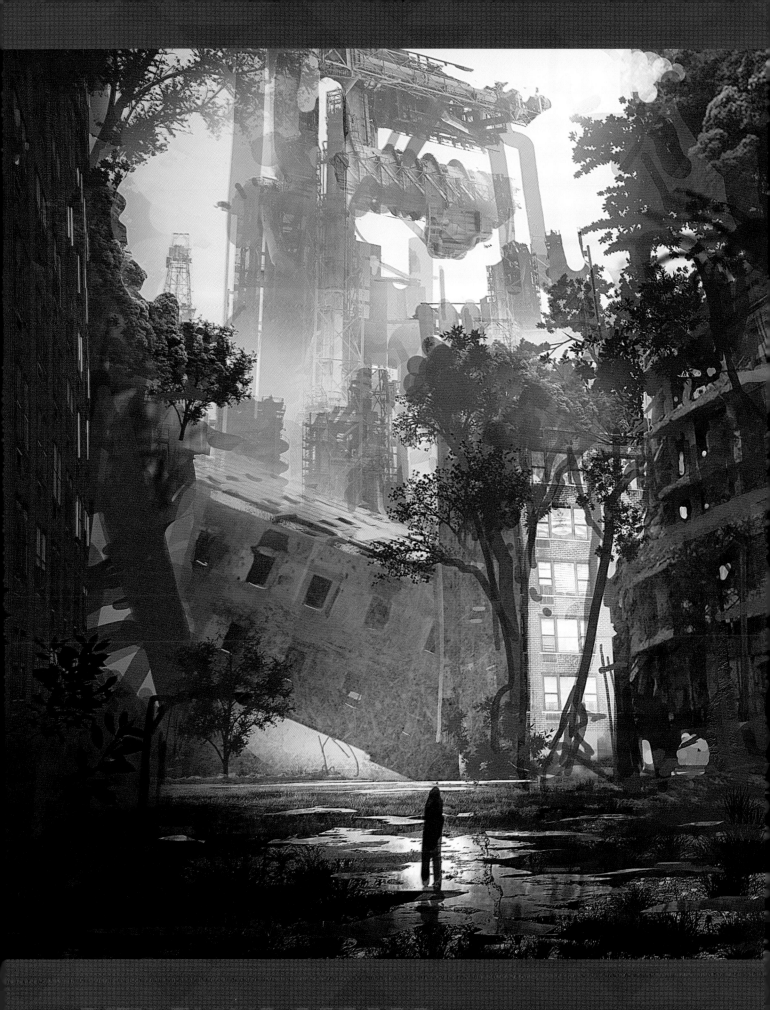

CITY RUINS REPORT

5468652076657374469676573206f66206d616e6b696e642c2077686f20617265206e6f7720657874696e63742e

K.K.

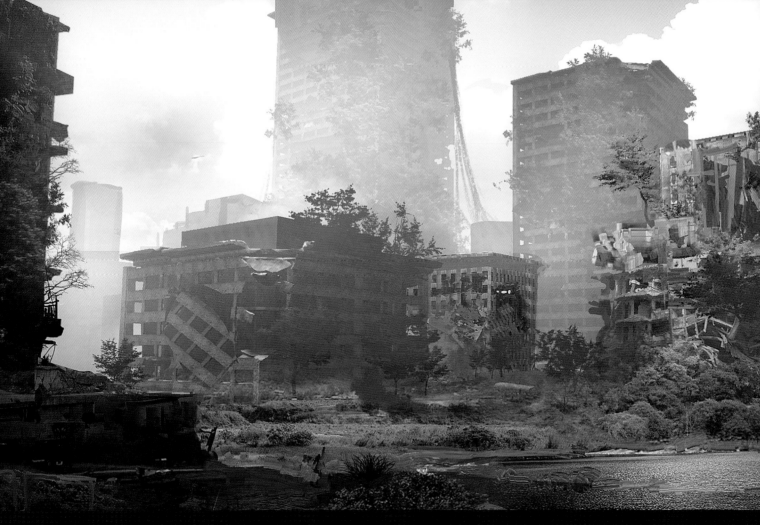

Record of Reclamation Management of Mankind's Legacy: The damage sustained through combat in the region invaded by machine lifeforms was relatively light, but due to low conservation priorities, the damage has worsened over time. Without the work of a maintenance team, there are no prospects of improvement in the foreseeable future. The Low-Priority Sector Abandonment Plan submitted to the Council of Humanity was recently rejected. The most important repair points were inferred from the documentation team's investigative report, so emergency first aid for those points is progressing.

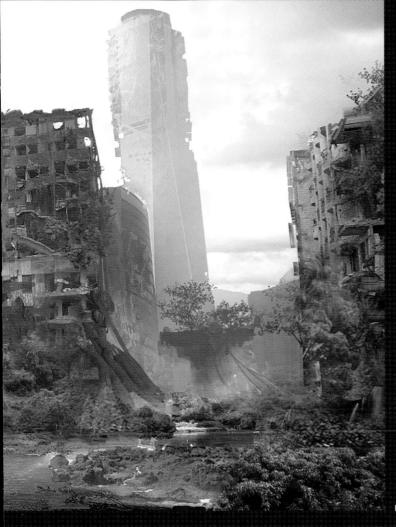

Record of Reclamation Management of Mankind's Legacy: Photo taken from the vicinity of the Resistance camp. Gigantic vegetation that wasn't seen in the old world has eroded buildings and should be dealt with as soon as possible. However, because this may conflict with the preservation of plants that appear to be a new species, verification in advance is required. Additionally, several species of metal fish released into bodies of water by machine lifeforms have been confirmed. They are to be destroyed as soon as they are found.

K.K.

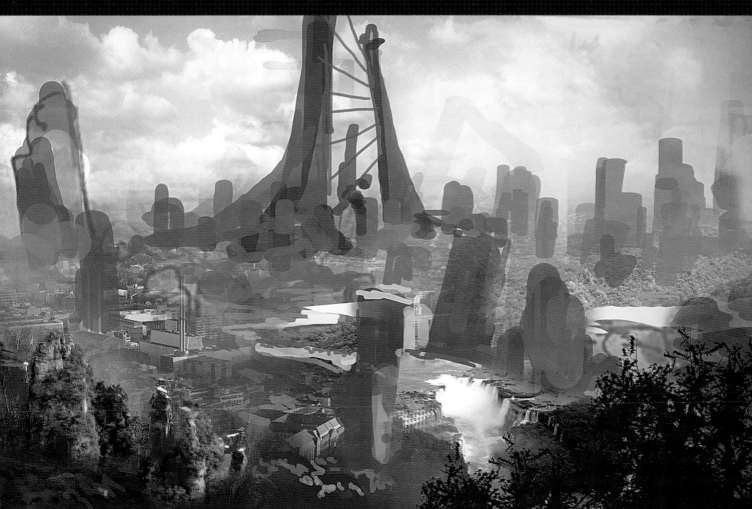

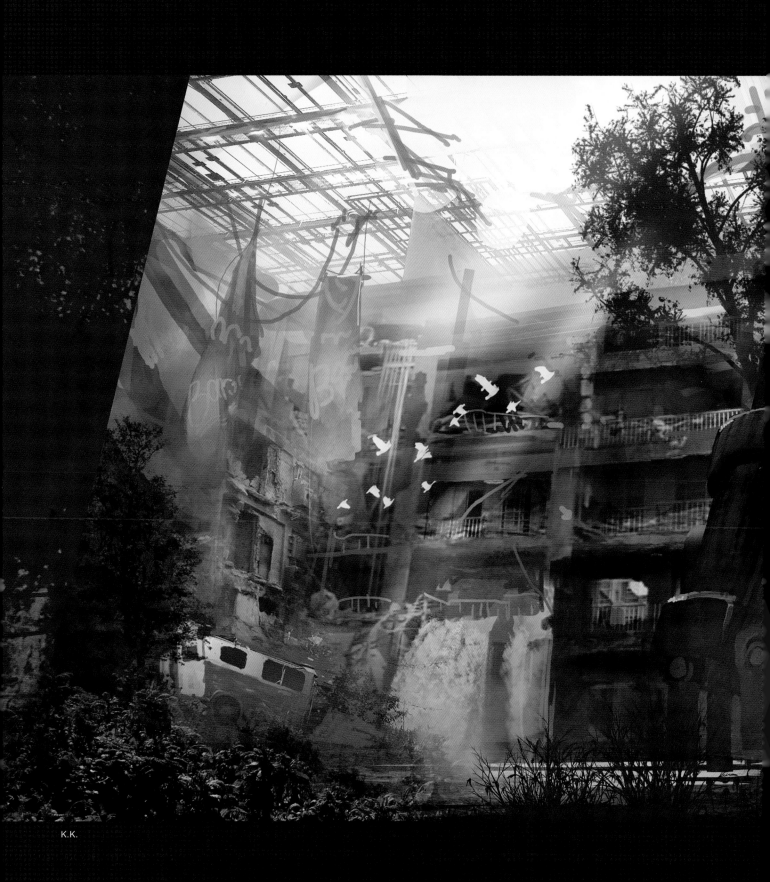

K.K.

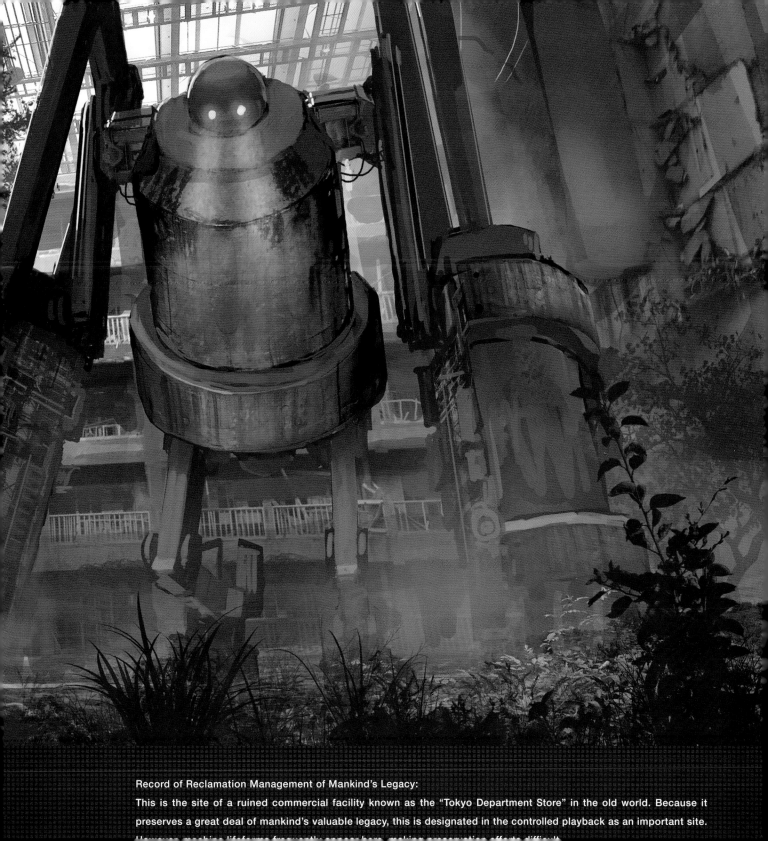

Record of Reclamation Management of Mankind's Legacy:

This is the site of a ruined commercial facility known as the "Tokyo Department Store" in the old world. Because it preserves a great deal of mankind's valuable legacy, this is designated in the controlled playback as an important site.

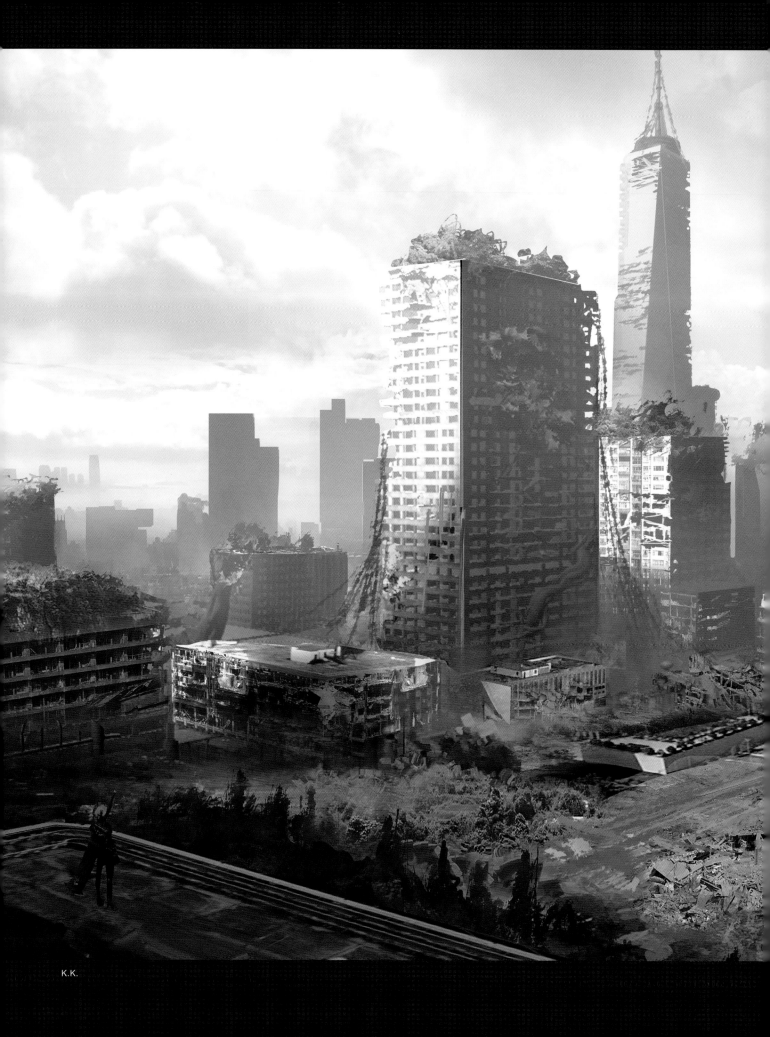

K.K.

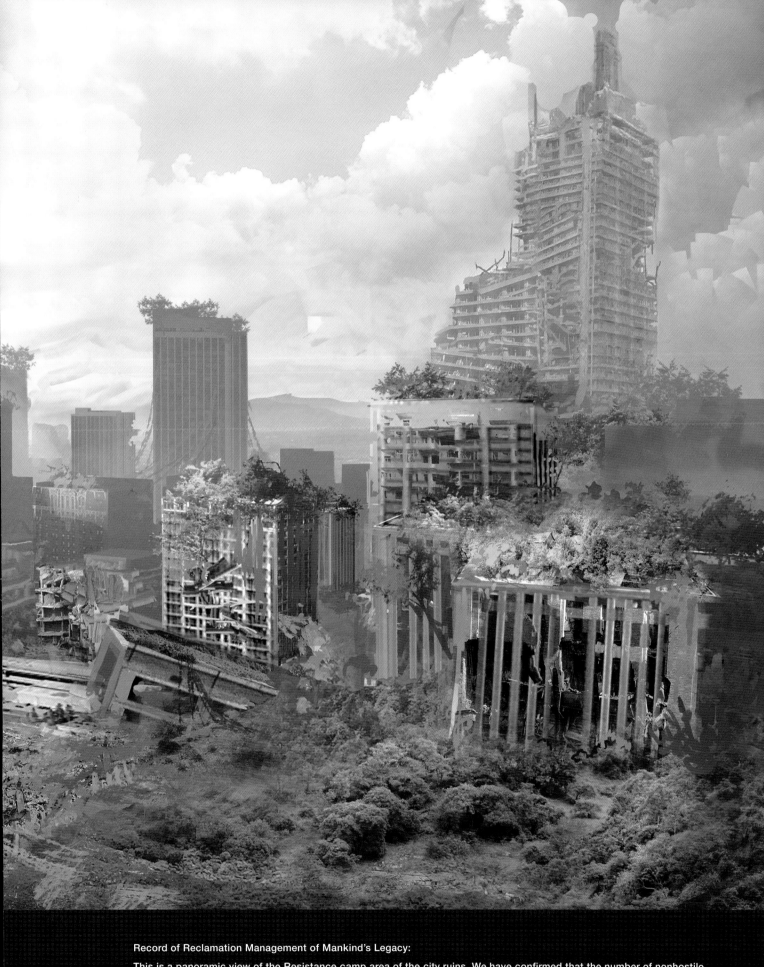

Record of Reclamation Management of Mankind's Legacy:

This is a panoramic view of the Resistance camp area of the city ruins. We have confirmed that the number of nonhostile machine lifeforms is increasing in this area. If these individuals are studied, we may discover a method of neutralizing machine lifeforms.

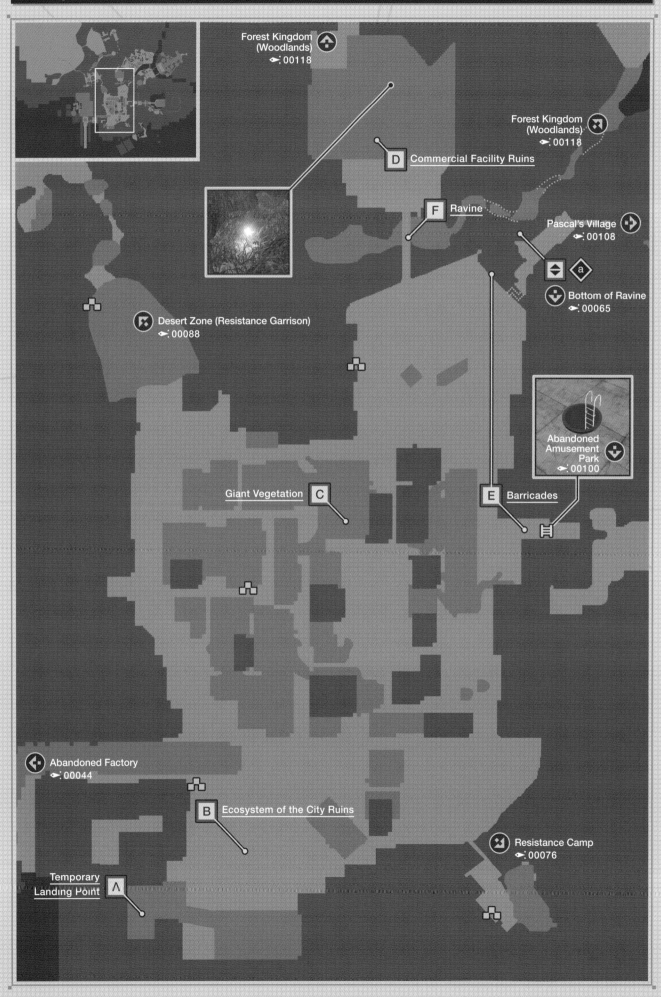

Forest Kingdom
(Woodlands)
🏃 00118

Forest Kingdom
(Woodlands)
🏃 00118

D Commercial Facility Ruins

F Ravine

Pascal's Village
🏃 00108

a

Bottom of Ravine
🏃 00065

Desert Zone (Resistance Garrison)
🏃 00088

Abandoned
Amusement
Park
🏃 00100

Giant Vegetation C

E Barricades

Abandoned Factory
🏃 00044

B Ecosystem of the City Ruins

Resistance Camp
🏃 00076

Temporary
Landing Point A

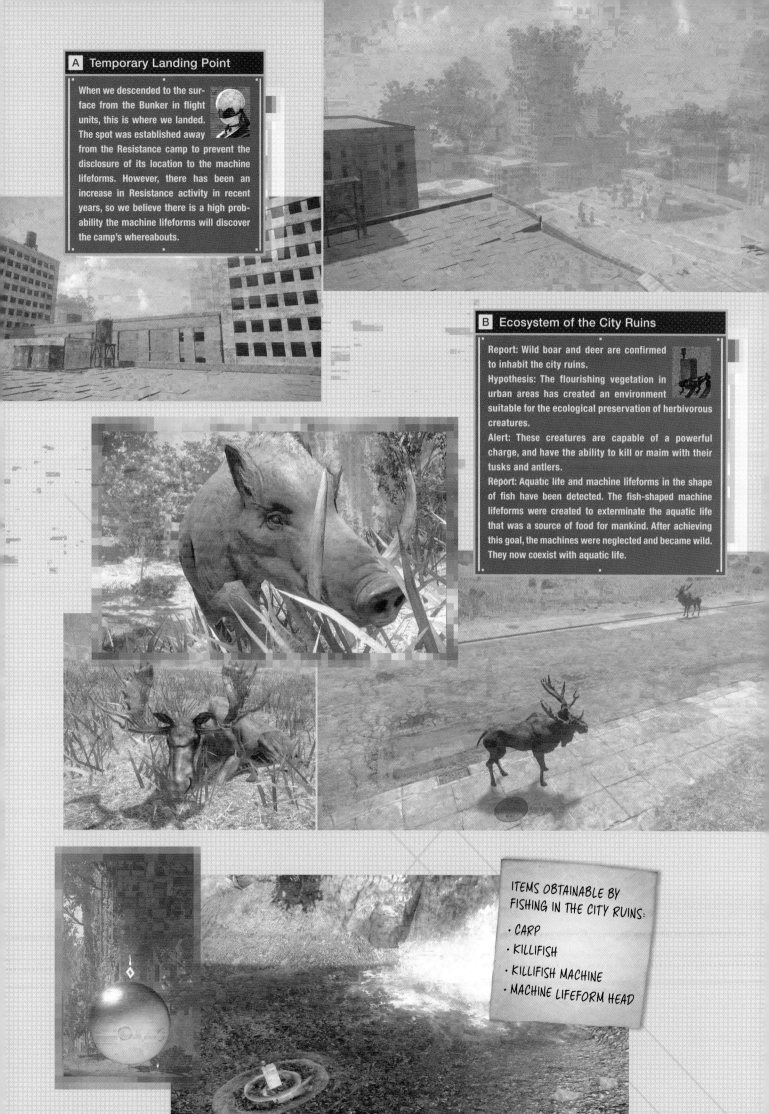

A — Temporary Landing Point

When we descended to the surface from the Bunker in flight units, this is where we landed. The spot was established away from the Resistance camp to prevent the disclosure of its location to the machine lifeforms. However, there has been an increase in Resistance activity in recent years, so we believe there is a high probability the machine lifeforms will discover the camp's whereabouts.

B — Ecosystem of the City Ruins

Report: Wild boar and deer are confirmed to inhabit the city ruins.

Hypothesis: The flourishing vegetation in urban areas has created an environment suitable for the ecological preservation of herbivorous creatures.

Alert: These creatures are capable of a powerful charge, and have the ability to kill or maim with their tusks and antlers.

Report: Aquatic life and machine lifeforms in the shape of fish have been detected. The fish-shaped machine lifeforms were created to exterminate the aquatic life that was a source of food for mankind. After achieving this goal, the machines were neglected and became wild. They now coexist with aquatic life.

ITEMS OBTAINABLE BY FISHING IN THE CITY RUINS:
- CARP
- KILLIFISH
- KILLIFISH MACHINE
- MACHINE LIFEFORM HEAD

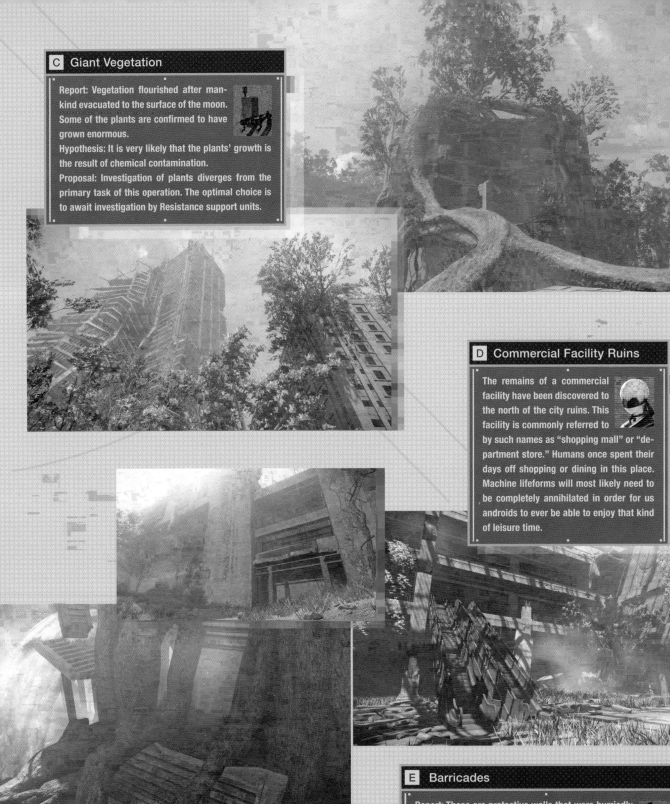

C Giant Vegetation

Report: Vegetation flourished after mankind evacuated to the surface of the moon. Some of the plants are confirmed to have grown enormous.

Hypothesis: It is very likely that the plants' growth is the result of chemical contamination.

Proposal: Investigation of plants diverges from the primary task of this operation. The optimal choice is to await investigation by Resistance support units.

D Commercial Facility Ruins

The remains of a commercial facility have been discovered to the north of the city ruins. This facility is commonly referred to by such names as "shopping mall" or "department store." Humans once spent their days off shopping or dining in this place. Machine lifeforms will most likely need to be completely annihilated in order for us androids to ever be able to enjoy that kind of leisure time.

E Barricades

Report: These are protective walls that were hurriedly constructed to defend certain areas from enemy invasion. Those made by the Resistance and those made by machine lifeforms have a number of differences, such as the materials used. Machine lifeforms are not proficient at delicate work, so they gather steel frames and similar items into a cumbersome pile. After forming a framework with steel pipes and joints, androids affix galvanized sheet iron and wooden planks in order to conserve metal materials that are often in short supply.

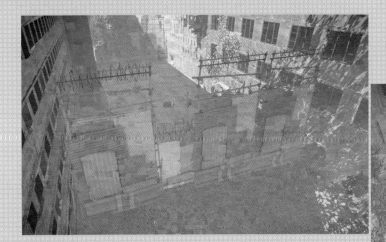

A BOX? CAN IT BE MOVED?

F Ravine

You have to cross a suspension bridge that hangs over a steep ravine to access the ruins of the commercial facility. When we went down to investigate the bottom of the ravine, water flowing in from the surrounding area had formed a pocket. Also, a large amount of machine lifeform remains were scattered all over. If those were machines from the abandoned factory, they gave the impression that this was some sort of landfill or graveyard.

ITEMS OBTAINABLE BY FISHING IN THE BOTTOM OF THE RAVINE:

- CARP MACHINE
- KILLIFISH
- FUR CARP
- ARAPAIMA MACHINE

Forest Kingdom (Woodlands)
🐟 : 00118

Bottom of Ravine

City Ruins
🐟 : 00062

COUNTLESS REMAINS OF MACHINE LIFEFORMS HERE . . .

K.K.

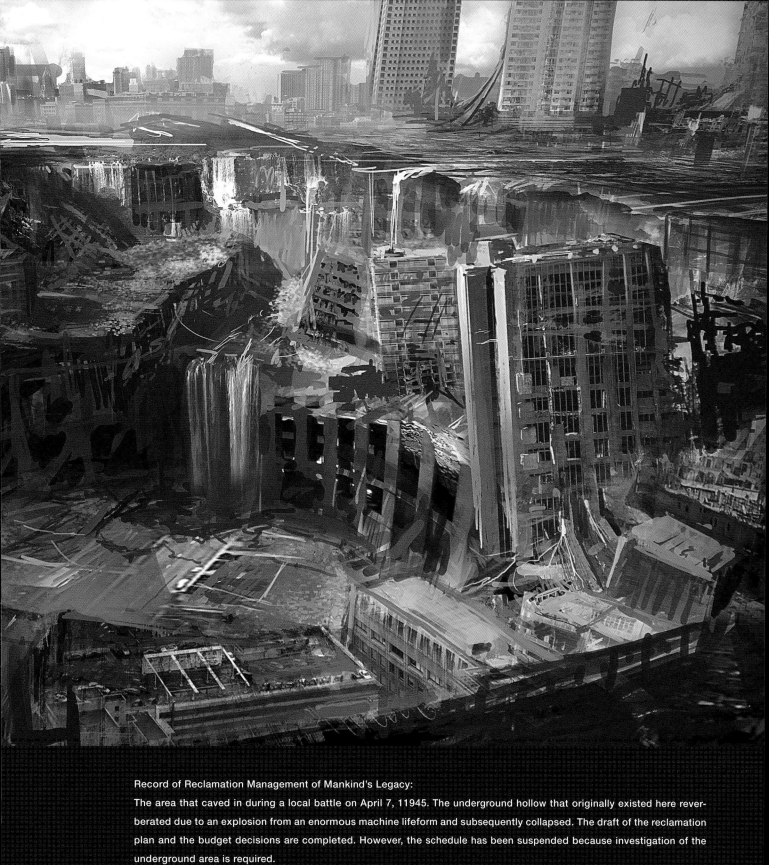

Record of Reclamation Management of Mankind's Legacy:

The area that caved in during a local battle on April 7, 11945. The underground hollow that originally existed here reverberated due to an explosion from an enormous machine lifeform and subsequently collapsed. The draft of the reclamation plan and the budget decisions are completed. However, the schedule has been suspended because investigation of the underground area is required.

■ City Ruins after Collapse

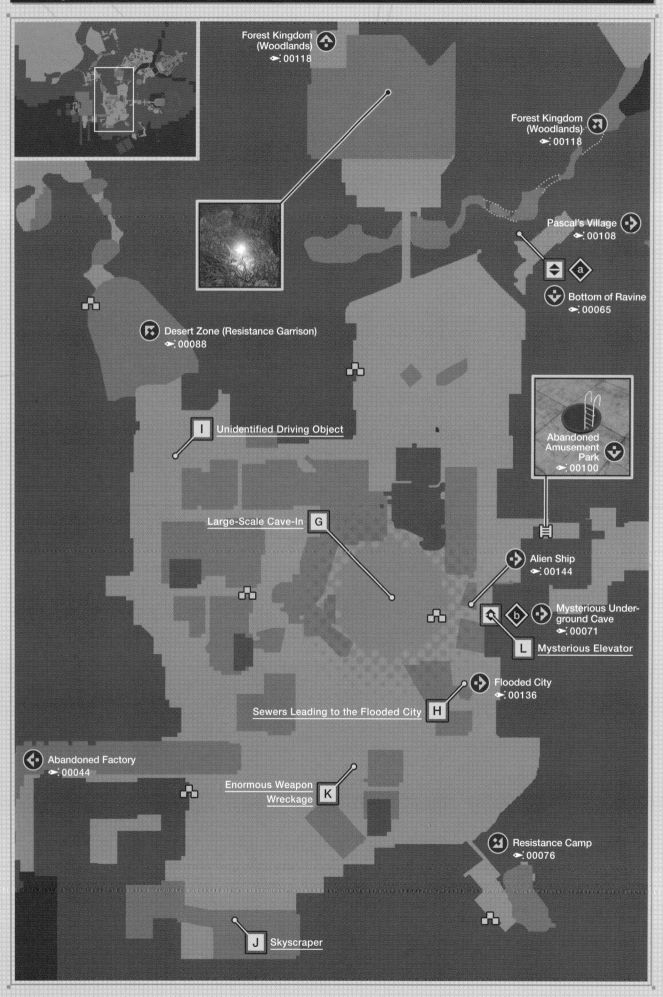

Forest Kingdom
(Woodlands)
🐟 00118

Forest Kingdom
(Woodlands)
🐟 00118

Pascal's Village
🐟 00108

a

Bottom of Ravine
🐟 00065

Desert Zone (Resistance Garrison)
🐟 00088

Abandoned
Amusement
Park
🐟 00100

I Unidentified Driving Object

G Large-Scale Cave-In

Alien Ship
🐟 00144

Mysterious Under-
ground Cave
🐟 00071

b

L Mysterious Elevator

Flooded City
🐟 00136

H Sewers Leading to the Flooded City

Abandoned Factory
🐟 00044

Enormous Weapon
Wreckage **K**

Resistance Camp
🐟 00076

J Skyscraper

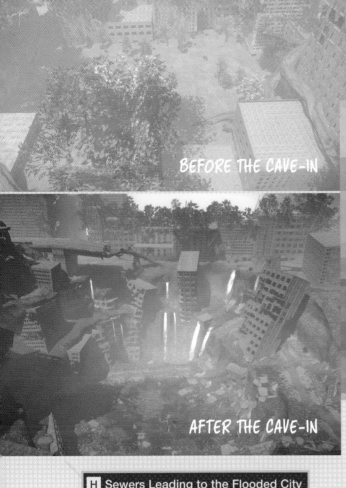

BEFORE THE CAVE-IN

AFTER THE CAVE-IN

G Large-Scale Cave-In

Report: Vibrations resonated within the Earth's crust, emitted by an enormous weapon that appeared in the city ruins. This caused a large-scale cave-in in one part of the region. The post-cave-in topographical data indicates the existence of an underground hollow from long ago.

The Bunker confirmed an alien alert immediately after the collapse. The relationship between these two events is currently under investigation.

H Sewers Leading to the Flooded City

It's now possible to reach the flooded city from the caved-in area of the city ruins via the sewers. After entering the caved-in area from the Resistance camp, the sewers can be entered at the point where the slope descends on the right-hand side. Watch your head when passing under the collapsed building.

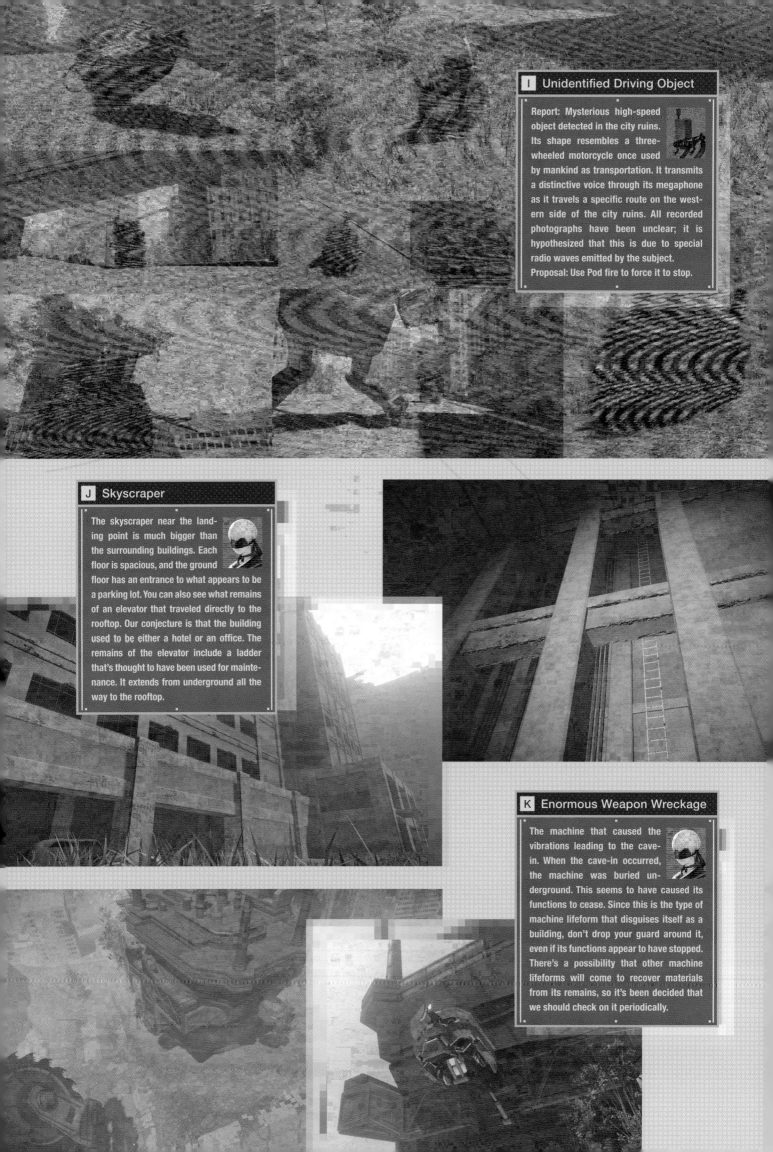

I — Unidentified Driving Object

Report: Mysterious high-speed object detected in the city ruins. Its shape resembles a three-wheeled motorcycle once used by mankind as transportation. It transmits a distinctive voice through its megaphone as it travels a specific route on the western side of the city ruins. All recorded photographs have been unclear; it is hypothesized that this is due to special radio waves emitted by the subject.
Proposal: Use Pod fire to force it to stop.

J — Skyscraper

The skyscraper near the landing point is much bigger than the surrounding buildings. Each floor is spacious, and the ground floor has an entrance to what appears to be a parking lot. You can also see what remains of an elevator that traveled directly to the rooftop. Our conjecture is that the building used to be either a hotel or an office. The remains of the elevator include a ladder that's thought to have been used for maintenance. It extends from underground all the way to the rooftop.

K — Enormous Weapon Wreckage

The machine that caused the vibrations leading to the cave-in. When the cave-in occurred, the machine was buried underground. This seems to have caused its functions to cease. Since this is the type of machine lifeform that disguises itself as a building, don't drop your guard around it, even if its functions appear to have stopped. There's a possibility that other machine lifeforms will come to recover materials from its remains, so it's been decided that we should check on it periodically.

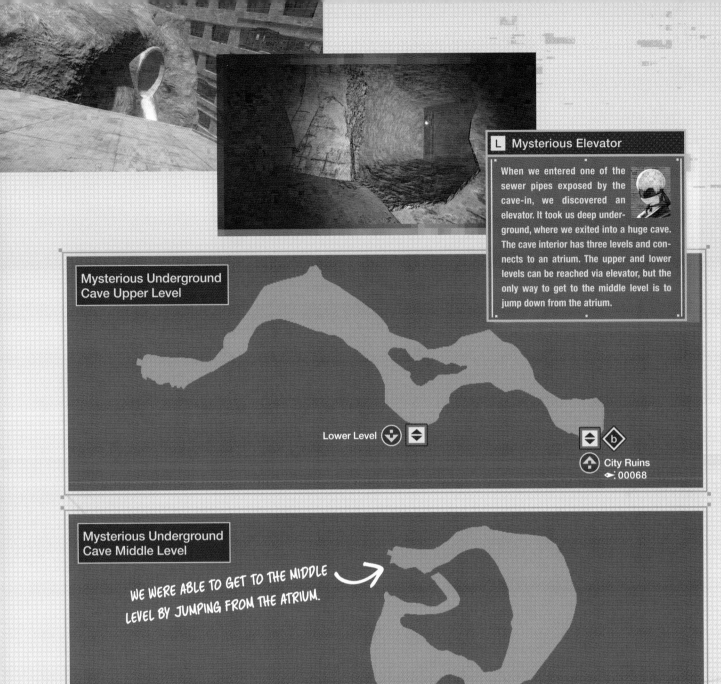

L Mysterious Elevator

When we entered one of the sewer pipes exposed by the cave-in, we discovered an elevator. It took us deep underground, where we exited into a huge cave. The cave interior has three levels and connects to an atrium. The upper and lower levels can be reached via elevator, but the only way to get to the middle level is to jump down from the atrium.

Mysterious Underground Cave Upper Level

Lower Level �R ⇕

⇕ ◇ b

⬆ City Ruins
🗝 00068

Mysterious Underground Cave Middle Level

WE WERE ABLE TO GET TO THE MIDDLE LEVEL BY JUMPING FROM THE ATRIUM.

Mysterious Underground Cave Lower Level

⇕ ⬆ Upper Level

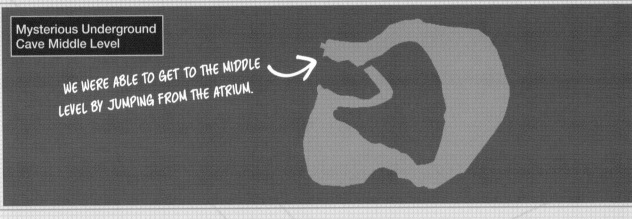

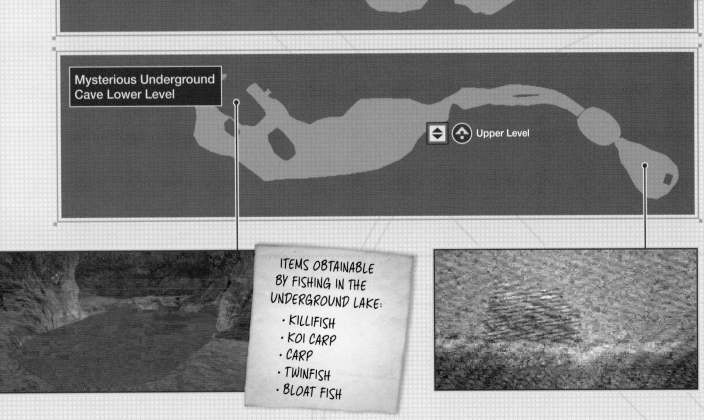

ITEMS OBTAINABLE
BY FISHING IN THE
UNDERGROUND LAKE:
· KILLIFISH
· KOI CARP
· CARP
· TWINFISH
· BLOAT FISH

Special Machine Report | Boku-Shi

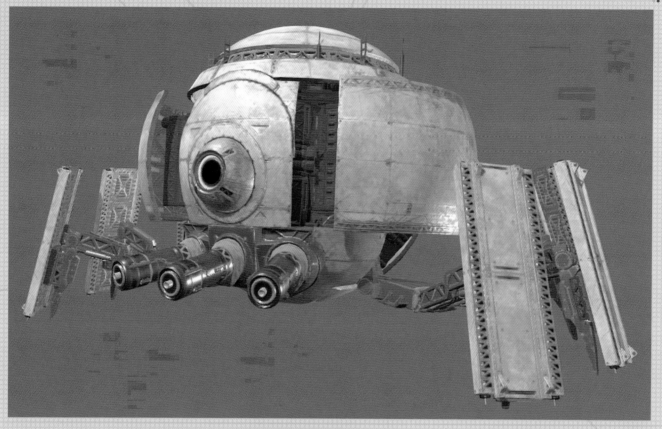

The Goliath-class multilegged machine lifeform known as "Boku-Shi." It has the ability to fire electricity from its feet and is equipped with three gun units on its front side. Additionally, the rear hatch releases small, self-destructing orbs and also pushes out linked-sphere types as weapons. We believe that countless small orbs are contained within its body. It can also take a spherical form by storing the gun units and legs in its torso.

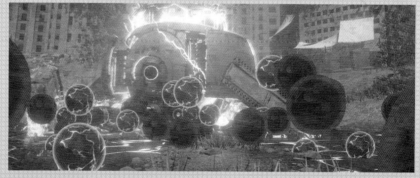

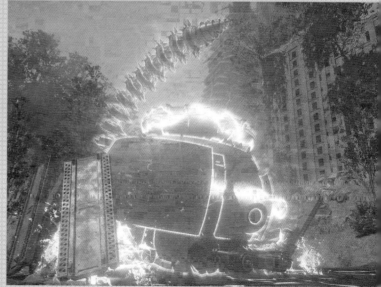

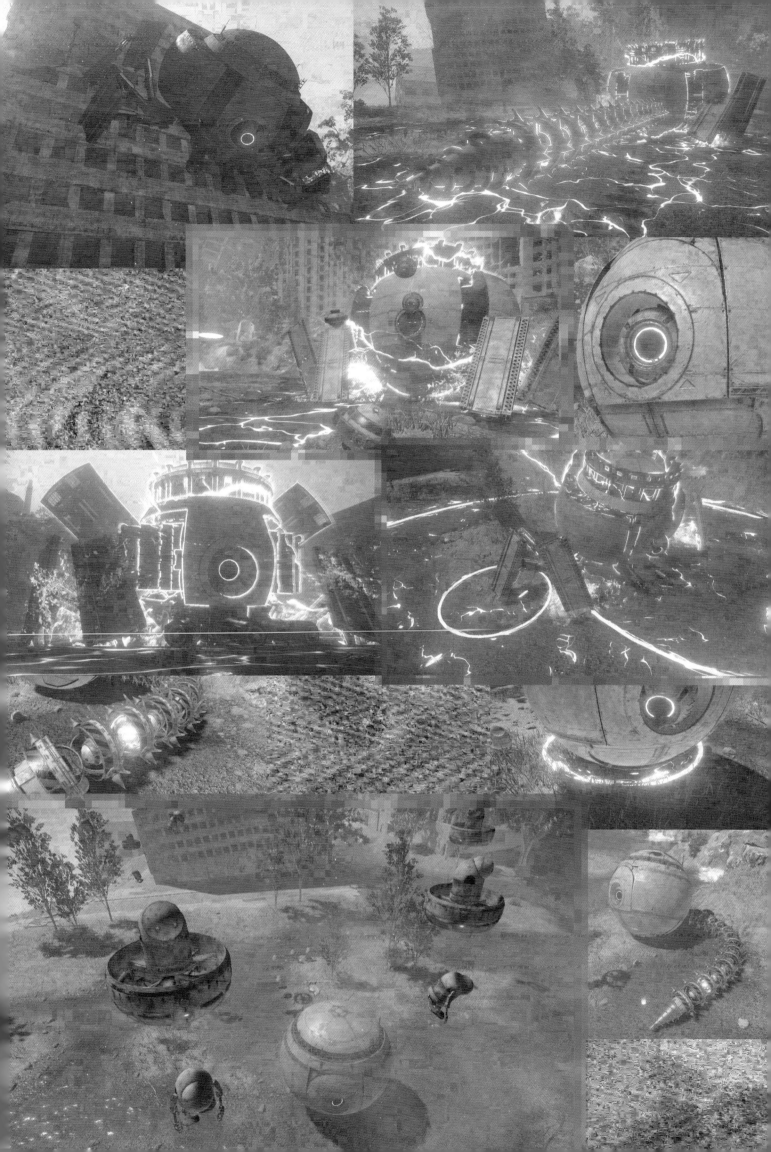

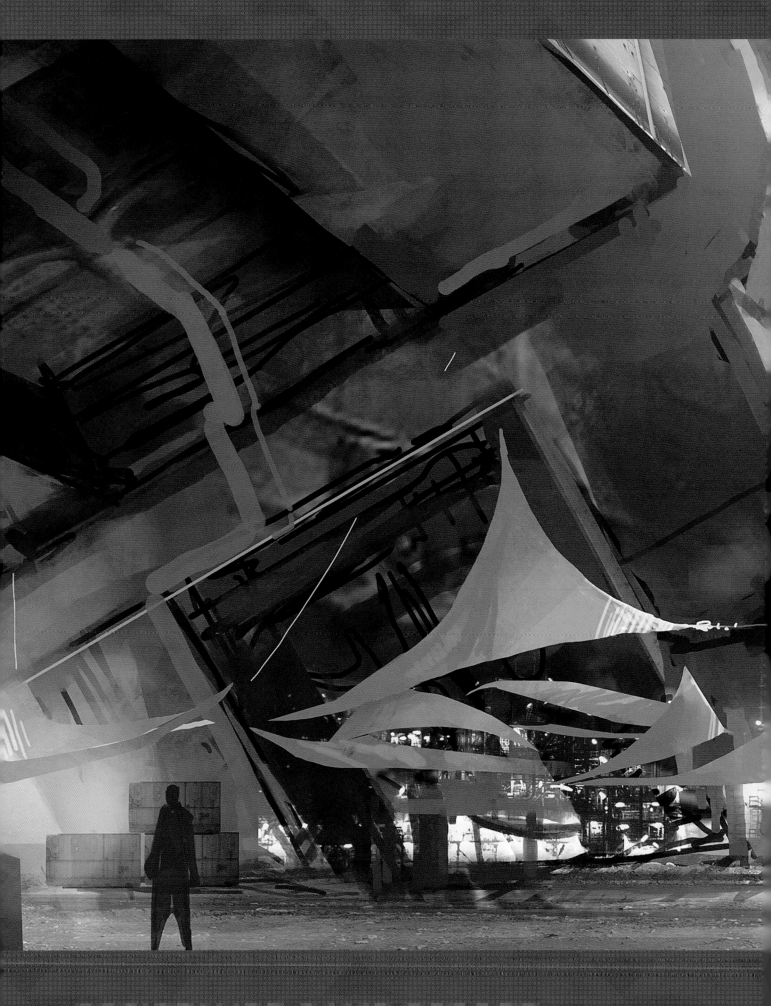

RESISTANCE CAMP REPORT

466f6c6973682070757070657473207768f206173737356d65642074686520666f726d206f662068756d616e732e

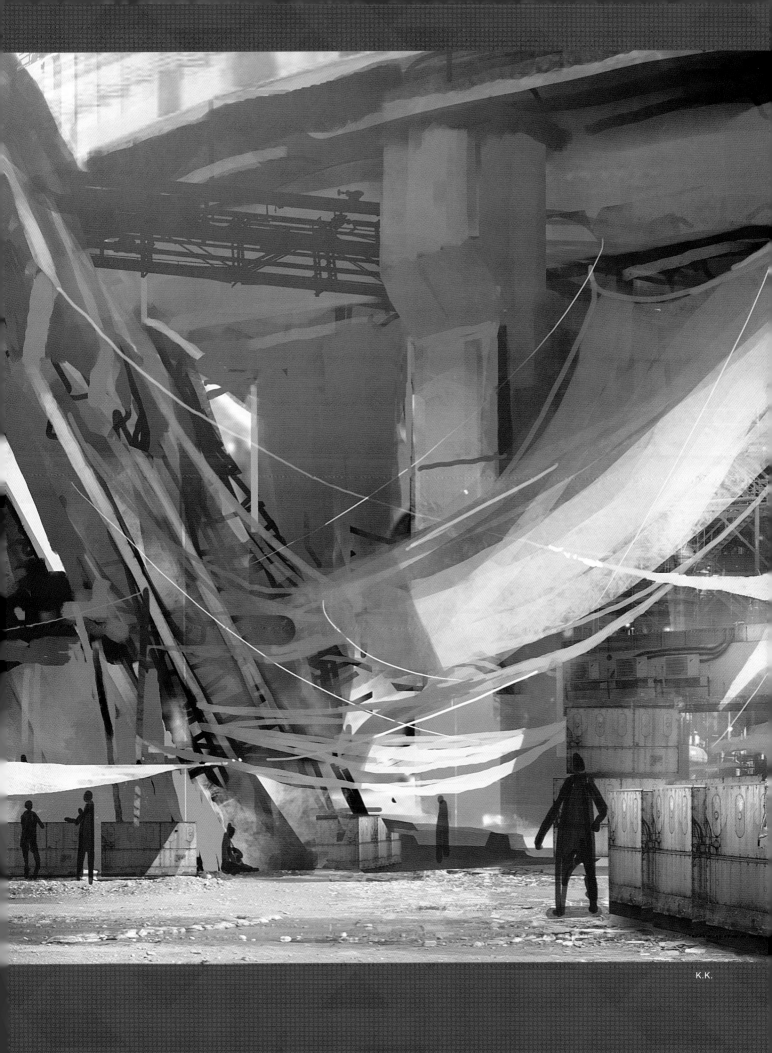

K.K.

Resistance Camp

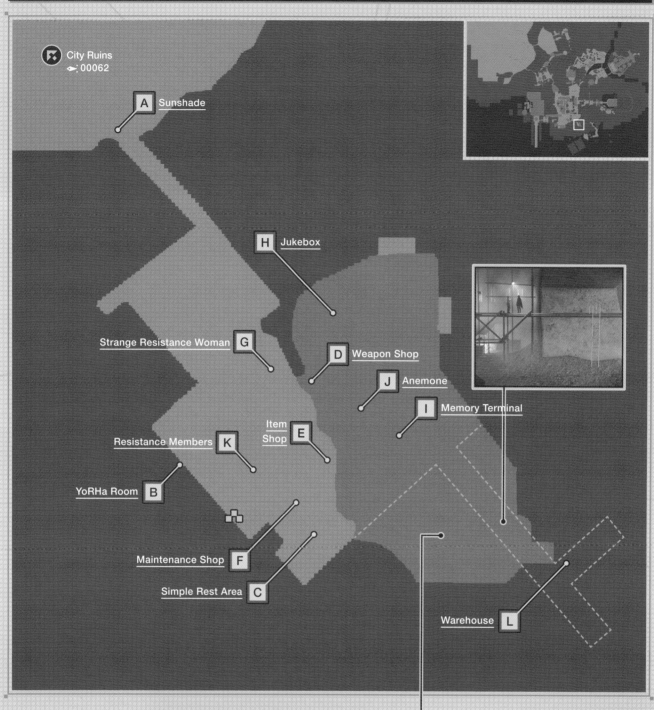

City Ruins
00062

A Sunshade

H Jukebox

Strange Resistance Woman G

D Weapon Shop

J Anemone

I Memory Terminal

Item Shop E

Resistance Members K

YoRHa Room B

Maintenance Shop F

Simple Rest Area C

Warehouse L

THE CAMP MADE USE OF
THE SLANTED HIGHWAY.

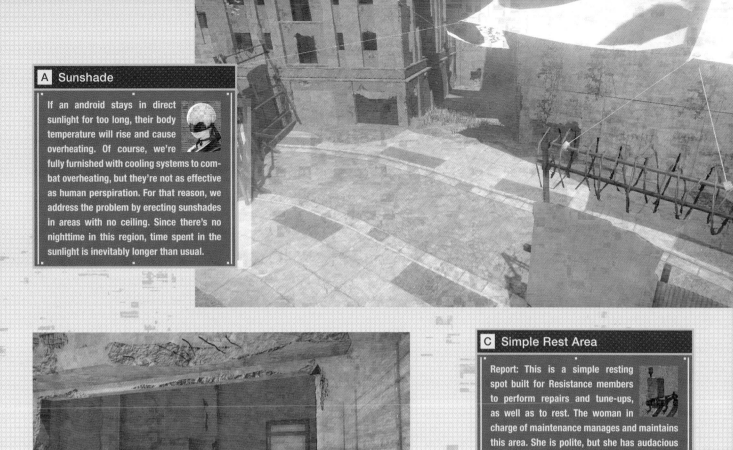

A Sunshade

If an android stays in direct sunlight for too long, their body temperature will rise and cause overheating. Of course, we're fully furnished with cooling systems to combat overheating, but they're not as effective as human perspiration. For that reason, we address the problem by erecting sunshades in areas with no ceiling. Since there's no nighttime in this region, time spent in the sunlight is inevitably longer than usual.

C Simple Rest Area

Report: This is a simple resting spot built for Resistance members to perform repairs and tune-ups, as well as to rest. The woman in charge of maintenance manages and maintains this area. She is polite, but she has audacious medical policies. She once even performed excess customization on an unwitting sleeping subject. Since that time, many Resistance members have refused to sleep in this location.

B YoRHa Room

The leader of the Resistance gave us permission to use this room. This spacious bare concrete room is furnished with simple structures such as a table and rack, as well as two beds on which to rest. There are also books and cardboard here, as if it were originally used as a simple warehouse.

D Weapon Shop

Report: This android is in charge of the maintenance, sale, and upgrading of weapons used by the Resistance. The Resistance camp weapons trader does not create weapons from raw materials but rather uses a maintenance device to restore functionality to recovered objects from the old world and then sells them.

E Item Shop

An android who recycles junk and machine lifeform parts into tools and plug-in chips and then sells them. His own leg is malfunctioning, but repairing combat androids takes priority. I guess he's just not interested in fixing it until the war with the machine lifeforms is over.

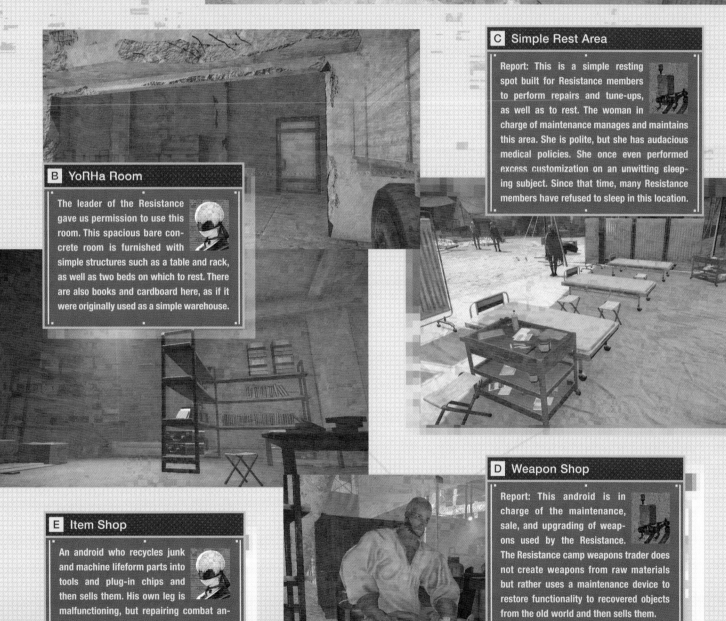

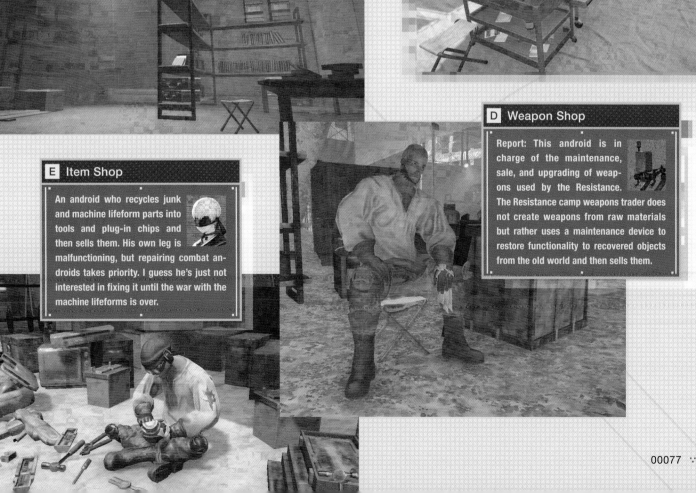

F Maintenance Shop

A specialist in everything related to androids and Pods. She sells Pod programs, fuses plug-in chips, and can even increase chip storage capacity or upgrade Pods. With her wealth of knowledge, she gives accurate advice not only on Pods and weapons, but also on YoRHa units. She provides medical treatment for those in the beds of the simple rest area, and she's in charge of its management and upkeep. Rumor has it that some of her medical policies are rather audacious, and the Resistance members stationed in the camp seem to fear her.

G Strange Resistance Woman

Proposal: Make contact with the masked Resistance woman who possesses a great deal of information beneficial to the execution of the operation.
Hypothesis: One gains some sort of knowledge by wearing the head of a machine lifeform.
Report: Our intel indicates that by wearing the head of a machine lifeform, one can catch glimpses of the machine network without being contaminated by a logic virus.

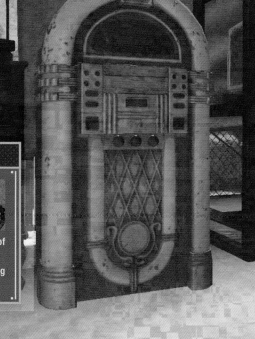

H Jukebox

Analysis: A device that humans utilized to play music. When one obtains a disc-shaped object called a "record," the selection of tunes increases. The whereabouts of these items are unknown.
Hypothesis: The number of remaining records is very small.

I Memory Terminal

Analysis: A memory terminal utilized by members of the Resistance. Its processing power is only 75 percent that of YoRHa equipment, but other qualities such as being dust-proof, waterproof, and shock resistant make it the superior terminal for use in the field. A portion of the leader Anemone's memories are stored within it and can be read with her permission.

J Anemone

This woman is the camp's leader. She's lost many comrades in the war with the machine lifeforms, but she seems to have put her personal feelings aside when it comes to the group of peace-loving machines. I can say that she considers the advantages and disadvantages for all androids and possesses qualities that allow her to assess the characteristics of a great many people.

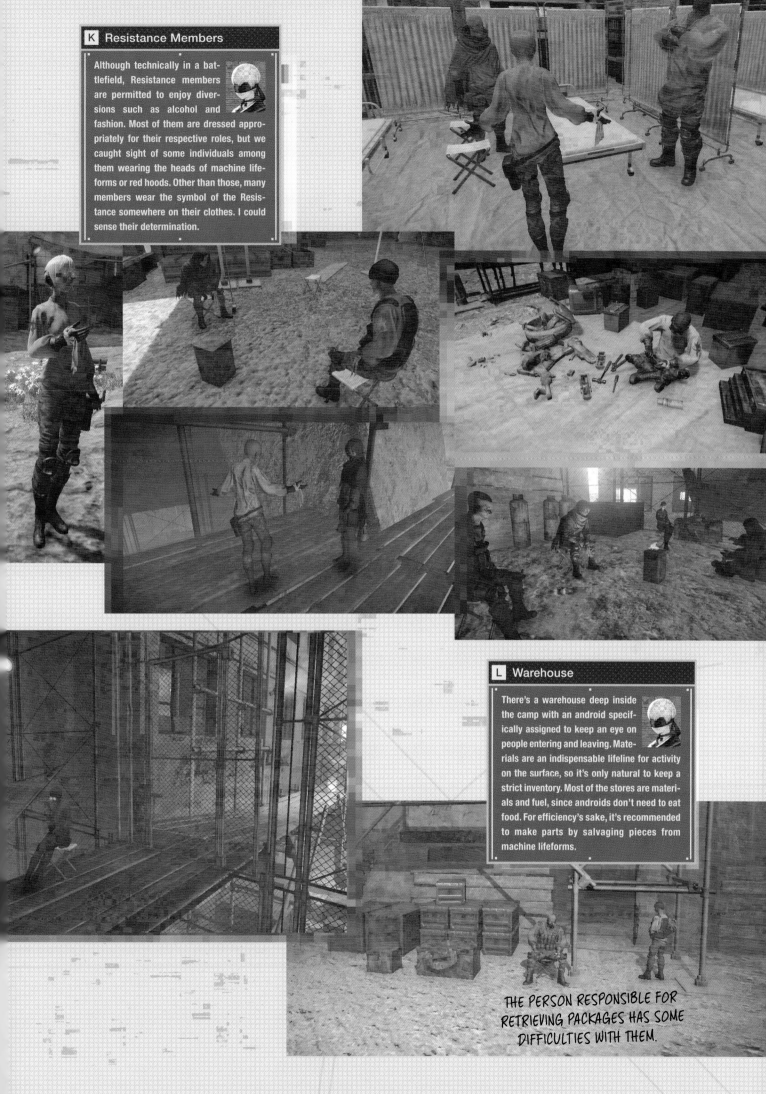

K Resistance Members

Although technically in a battlefield, Resistance members are permitted to enjoy diversions such as alcohol and fashion. Most of them are dressed appropriately for their respective roles, but we caught sight of some individuals among them wearing the heads of machine lifeforms or red hoods. Other than those, many members wear the symbol of the Resistance somewhere on their clothes. I could sense their determination.

L Warehouse

There's a warehouse deep inside the camp with an android specifically assigned to keep an eye on people entering and leaving. Materials are an indispensable lifeline for activity on the surface, so it's only natural to keep a strict inventory. Most of the stores are materials and fuel, since androids don't need to eat food. For efficiency's sake, it's recommended to make parts by salvaging pieces from machine lifeforms.

THE PERSON RESPONSIBLE FOR RETRIEVING PACKAGES HAS SOME DIFFICULTIES WITH THEM.

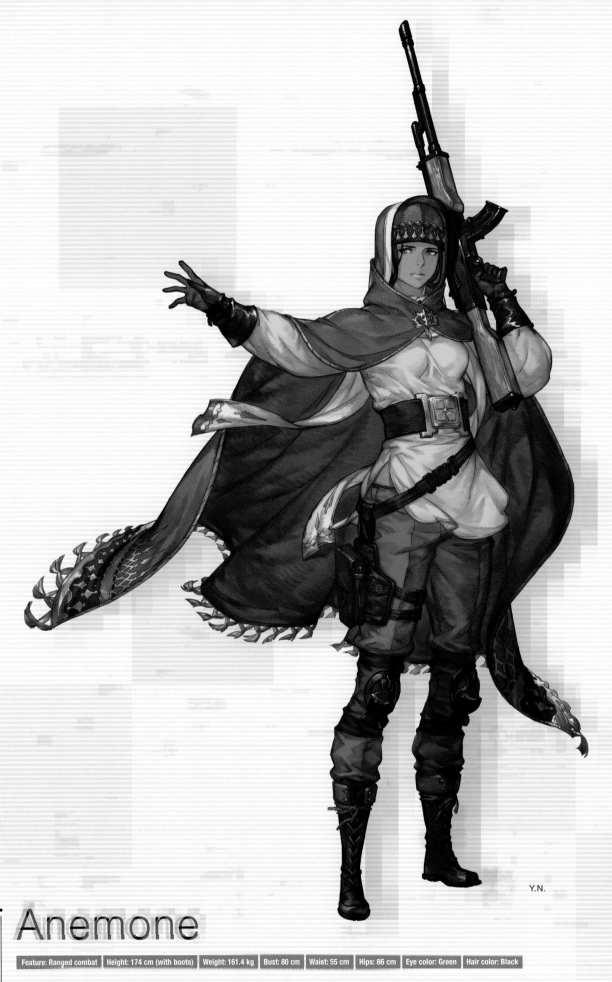

Y.N.

Anemone

Feature: Ranged combat | Height: 174 cm (with boots) | Weight: 161.4 kg | Bust: 80 cm | Waist: 55 cm | Hips: 86 cm | Eye color: Green | Hair color: Black

The woman in charge of Resistance activity on the surface. She obeys the policies of the Council of Humanity on the moon and cooperates with androids who descended to the surface. She considers the other Resistance androids to be like family, and their bonds are strong. In a past operation, she successfully destroyed a machine lifeform server located on the island of Oahu in the Pacific Ocean. Many of her comrades were killed on that mission, and she harbors a fierce hatred toward machine lifeforms.

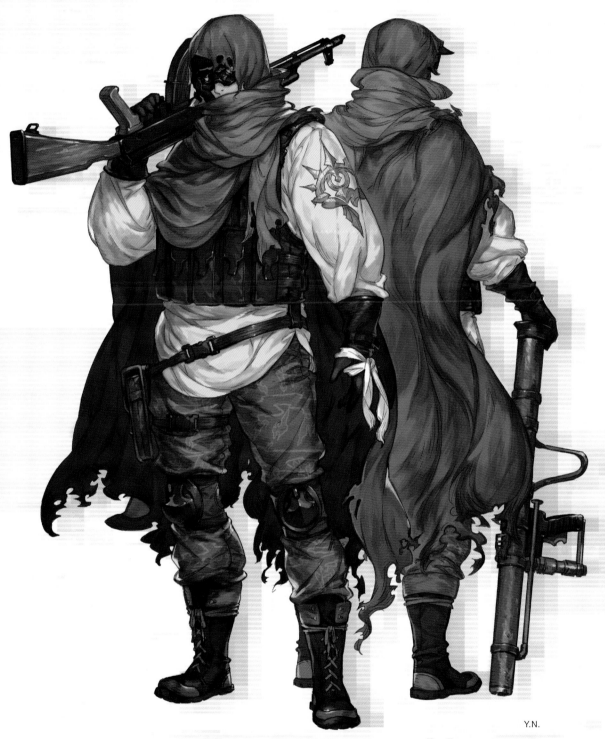

Y.N.

Resistance Members

Feature: Ranged combat	Height: —	Weight: —	Bust: —	Waist: —	Hips: —	Eye color: —	Hair color: —

Androids who descended to the surface before YoRHa and have been battling the machine lifeforms ever since. They developed guerrilla warfare tactics to continue the long battle against the machines. Not only do they support the surface-deployed YoRHa squadron in their operations, but they also recover broken machines for repair and reconstruction. They're also in charge of helping with supply shortages. The Resistance is divided into groups of roughly twenty to thirty individuals who have deployed to various regions. Many of them wear white clothing that bears the symbol of the Resistance.

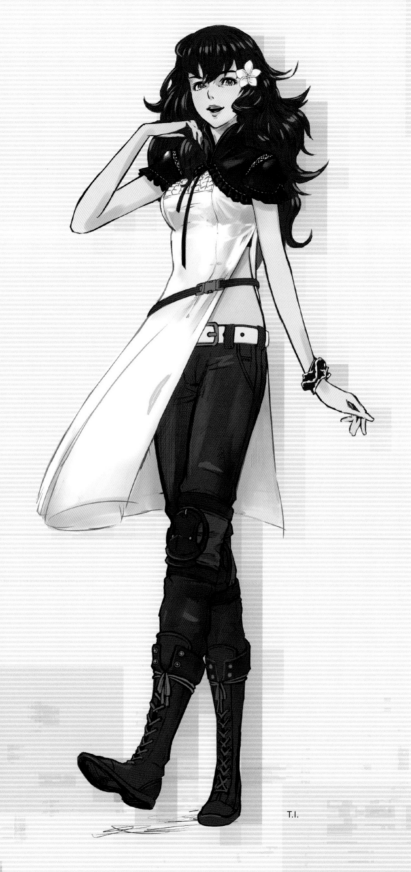

T.I.

Devola

| Feature: Repair management | Height: 173 cm (with boots) | Weight: 159.6 kg | Bust: 79 cm | Waist: 56 cm | Hips: 85 cm | Eye color: Green | Hair color: Violet red |

An old-style twin android manufactured over seven thousand years ago. She can really hold her liquor, which is rare for androids. Devola has a lively and cheerful personality, different from Popola's. Androids of Devola's type and model have a history of going berserk, and most of the others were destroyed and disposed of. Only some of them remain, and there are a few in each area to observe progress, but many around them fear the emergence of the model's chaotic behavior.

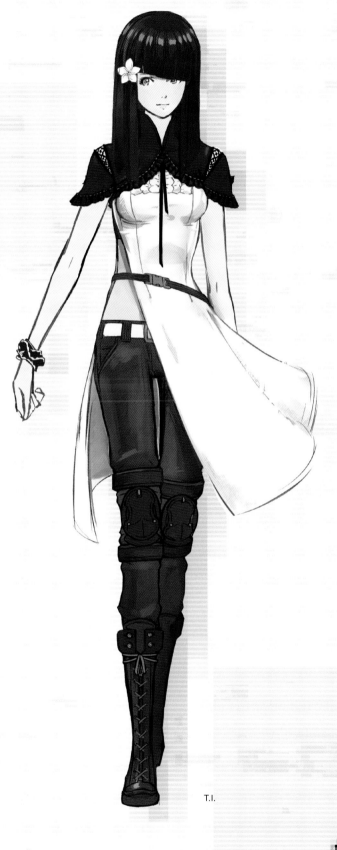

T.I.

Popola

Feature: Repair management	Height: 173 cm (with boots)	Weight: 163.2 kg	Bust: 81 cm	Waist: 54 cm	Hips: 86 cm	Eye color: Green	Hair color: Violet red

The android model who is Devola's twin. She and Devola have spent a very long time on the surface together. Currently, they work in the Resistance camp and are responsible for such things as supplies and the medical treatment of androids. Compared to Devola, Popola is introverted and mild mannered. It's said that she becomes cheerful when she drinks, but almost nobody in the Resistance camp has seen her like that.

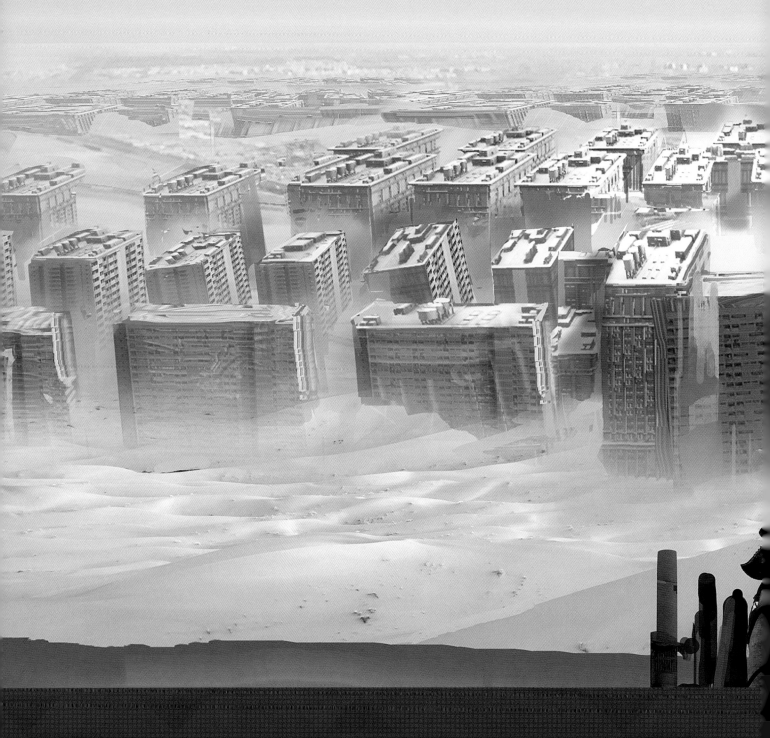

DESERT AREA REPORT

54686f73652077686f206174652074686520666f7262696464656e206170706c652e

00084

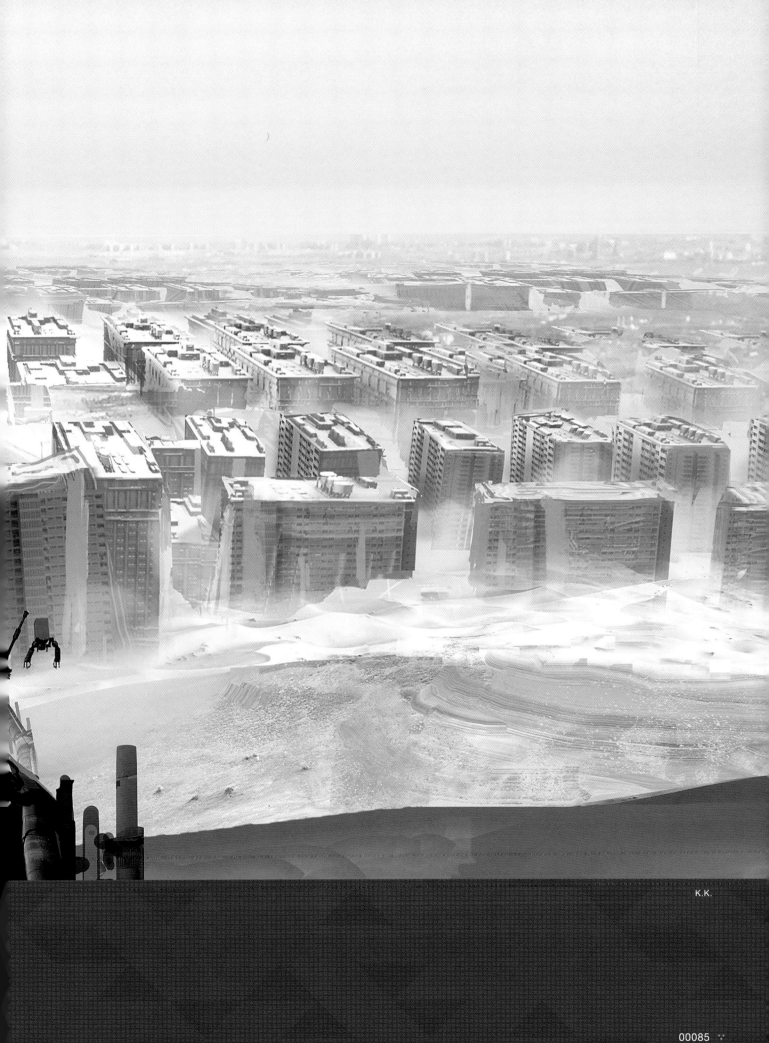

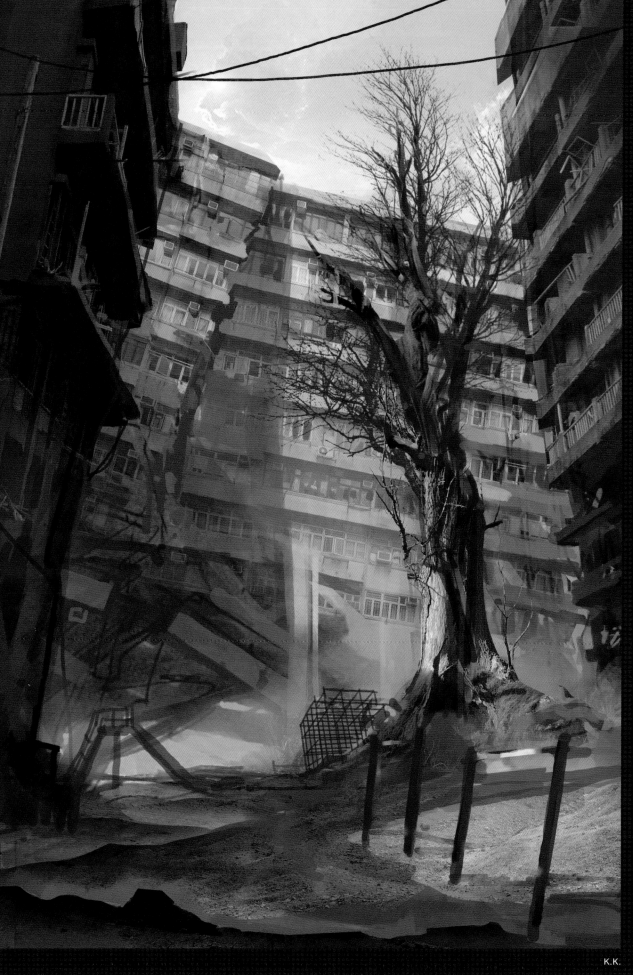

K.K.

Record of Reclamation Management of Mankind's Legacy:

Mammoth Apartments is in the foreground. We have established that human

children lived here, because there's a large amount of playground equipment.

Residential environments from the old world are a low priority for preservation

and aren't surveyed very often; however, recent surveys have shown there is

a great deal of precious heritage to be found in these locations, so we plan to

revise the preservation priority.

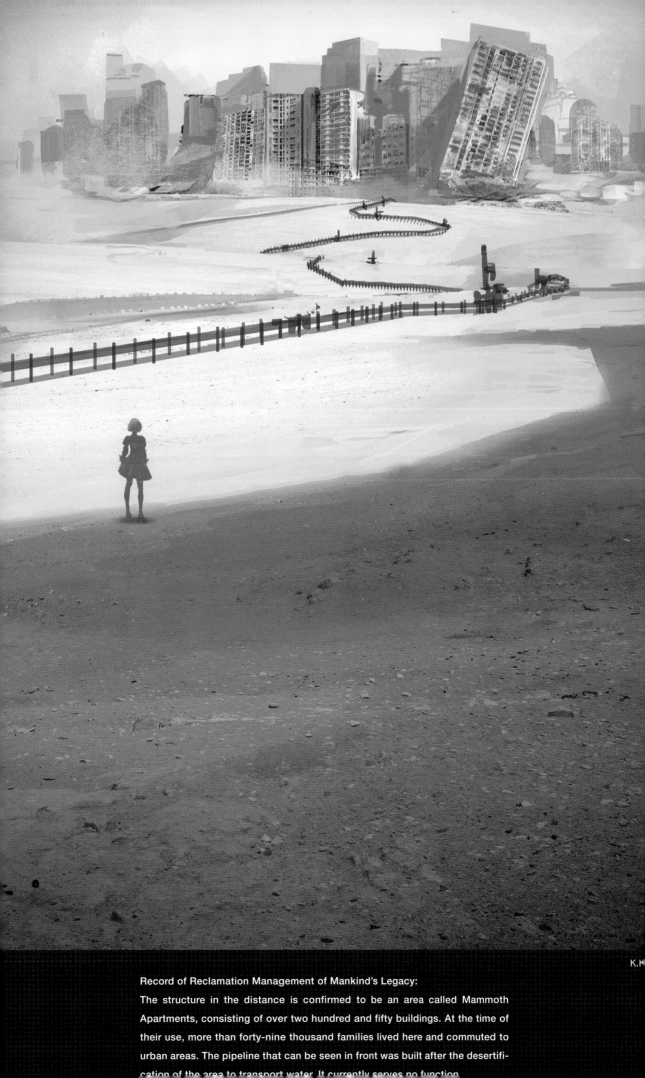

K.K

Record of Reclamation Management of Mankind's Legacy:

The structure in the distance is confirmed to be an area called Mammoth Apartments, consisting of over two hundred and fifty buildings. At the time of their use, more than forty-nine thousand families lived here and commuted to urban areas. The pipeline that can be seen in front was built after the desertification of the area to transport water. It currently serves no function.

Desert Area

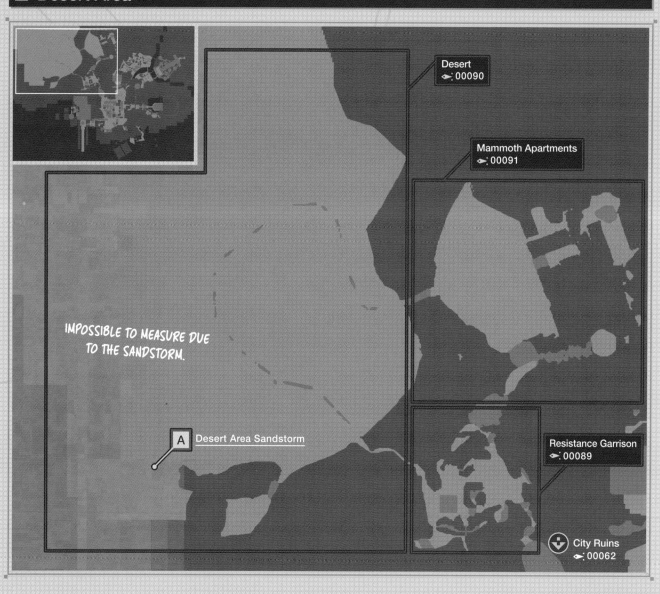

Desert
00090

Mammoth Apartments
00091

IMPOSSIBLE TO MEASURE DUE
TO THE SANDSTORM.

A Desert Area Sandstorm

Resistance Garrison
00089

City Ruins
00062

A Desert Area Sandstorm

Report: The occurrence of a powerful sandstorm has been confirmed in one part of the desert. There is a lack of information on this particular area due to the storm's impact.

Alert: Not only is there poor visibility in this area but there is also danger of android parts breaking down during a survey.

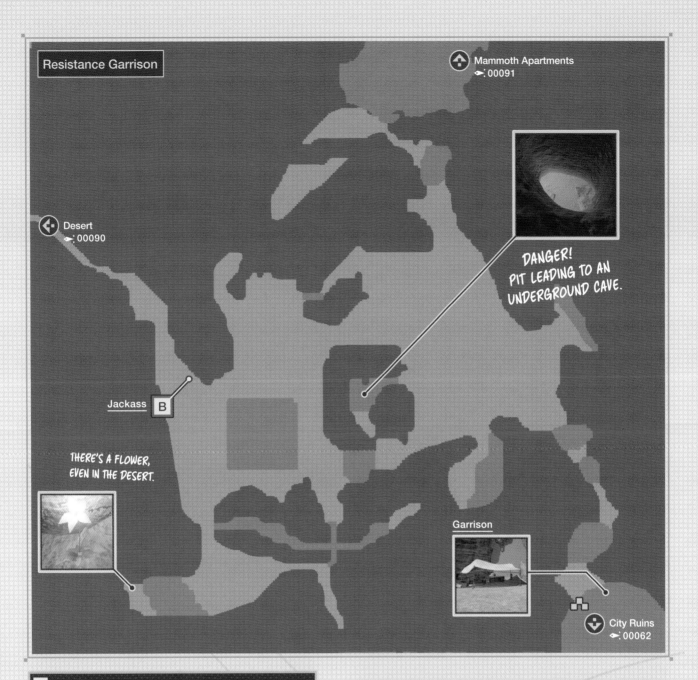

Resistance Garrison

Mammoth Apartments
🗫: 00091

Desert
🗫: 00090

DANGER!
PIT LEADING TO AN
UNDERGROUND CAVE.

Jackass **B**

THERE'S A FLOWER,
EVEN IN THE DESERT.

Garrison

City Ruins
🗫: 00062

B Jackass

Jackass is a female Resistance member in the desert who carries out research related to machine lifeforms and androids. Her curious and energetic nature, and the fact that she studies everything she can about subjects that catch her eye, would make her a good scanner model. However, she makes a big show of blowing up barricades and tidying warehouses with bombs. This extreme behavior creates problems. Nevertheless, the results of her research certainly seem to benefit the android forces.

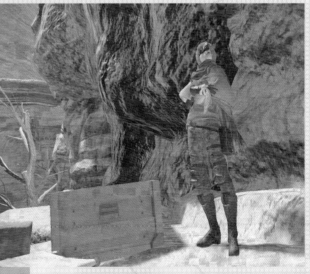

HELP ME GET DATA!
↑
HER CATCH PHRASE?

Desert

REMAINS OF A PIPELINE

Mammoth Apartments
00091

POD SPOTTED!
IT'S EASY TO GET LOST,
SO USE THE PIPELINE
AS A LANDMARK WHILE
SEARCHING.

Resistance Garrison
00089

ITEMS OBTAINABLE BY
FISHING IN THE OASIS:

• BEETLE FISH
• CARP
• AROWANA

ITEMS OBTAINABLE BY
FISHING IN THE OIL FIELD:

• OIL SARDINE
• BLOWFISH MACHINE
• KOI CARP MACHINE

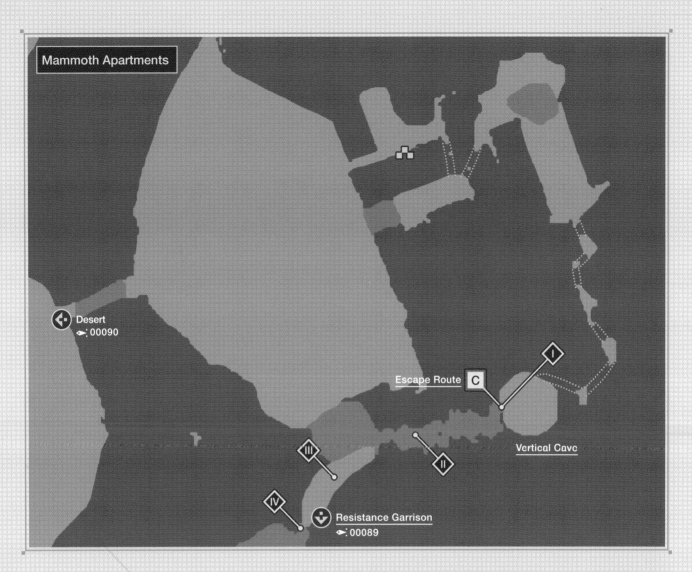

Mammoth Apartments

Desert
00090

Escape Route C

Vertical Cave

Resistance Garrison
00089

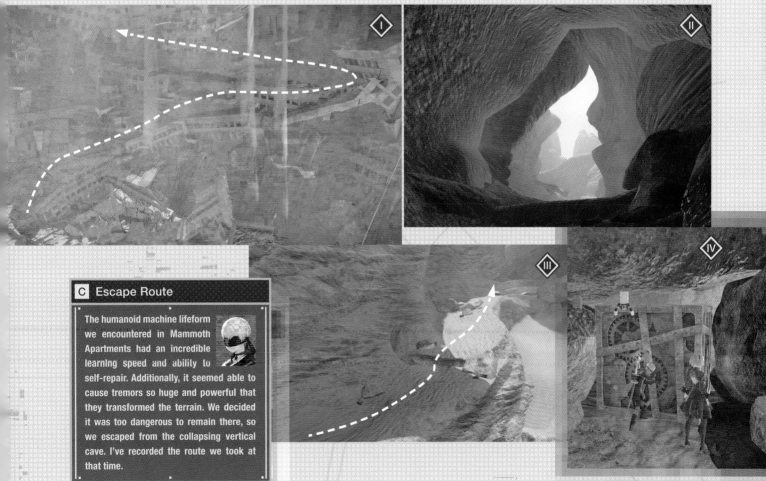

C Escape Route

The humanoid machine lifeform we encountered in Mammoth Apartments had an incredible learning speed and ability to self-repair. Additionally, it seemed able to cause tremors so huge and powerful that they transformed the terrain. We decided it was too dangerous to remain there, so we escaped from the collapsing vertical cave. I've recorded the route we took at that time.

K.K.

K.K.

Extensive Underground Passage

Without sunlight, the temperature in the desert underground is quite low compared to the surface. Furthermore, not only are there sand and rocks everywhere, but the terrain is also complex, making thorough investigation difficult. There's an artificial gate at the center of the cave. Using this as a landmark, our search confirmed the four points below from which one can return to the surface.

Resistance Garrison

a

b

c
d

DROP DOWN FROM HERE.

e

Underground Passage

THESE PATHS CONNECT TO THE SURFACE.

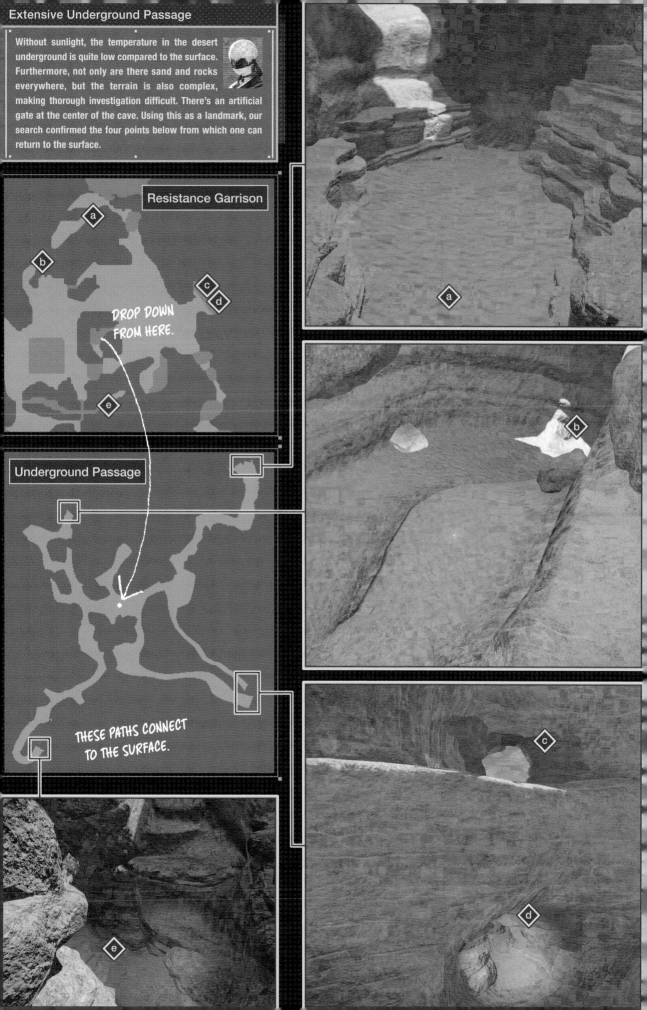

-WARNING-

Adam/Eve

These machines are named Adam and Eve, respectively, and they have achieved a singular evolution. They were born from a large number of machine lifeforms swarming into what looked like a cocoon, and their outward appearance resembles that of an android. They wore no clothes when they first came into being, and their movements were unsteady, but they learned and grew with an incredible speed, mastering attack types and language.

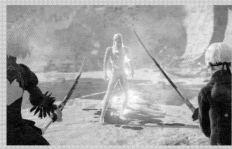

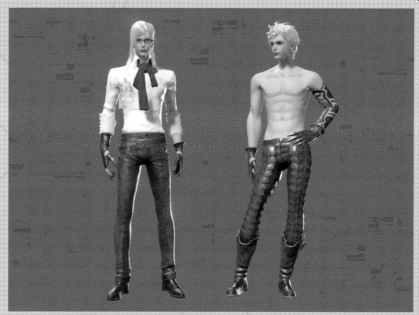

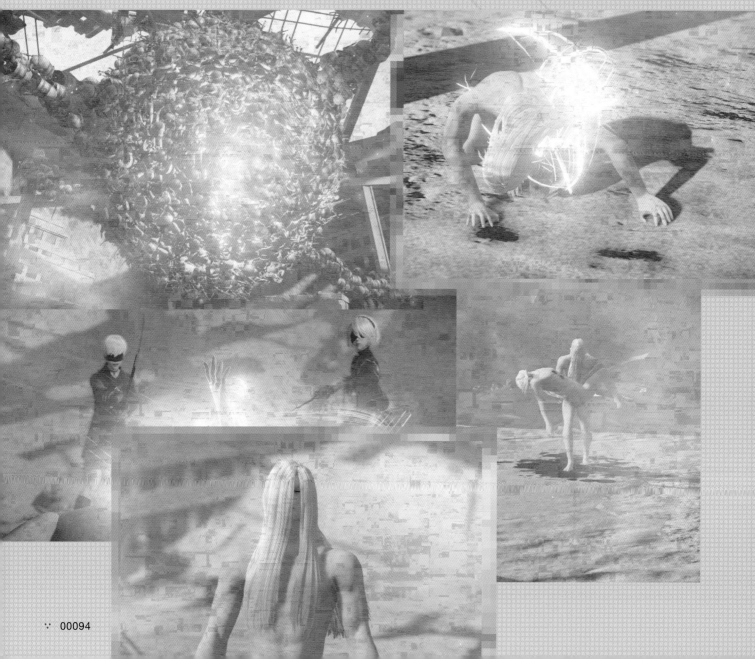

Special Machine Report | Hegel

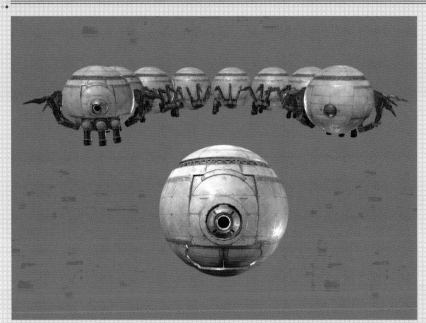

Hegel is a unit formed through the linking of several multilegged Goliath-class machine lifeforms. Because it gathers the energy generated from each machine, it boasts a huge energy output. It has floating, detached, and connected transfigurations, as well as a variety of attacks, so it is essential to confirm the current sequence during combat.

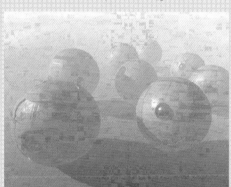

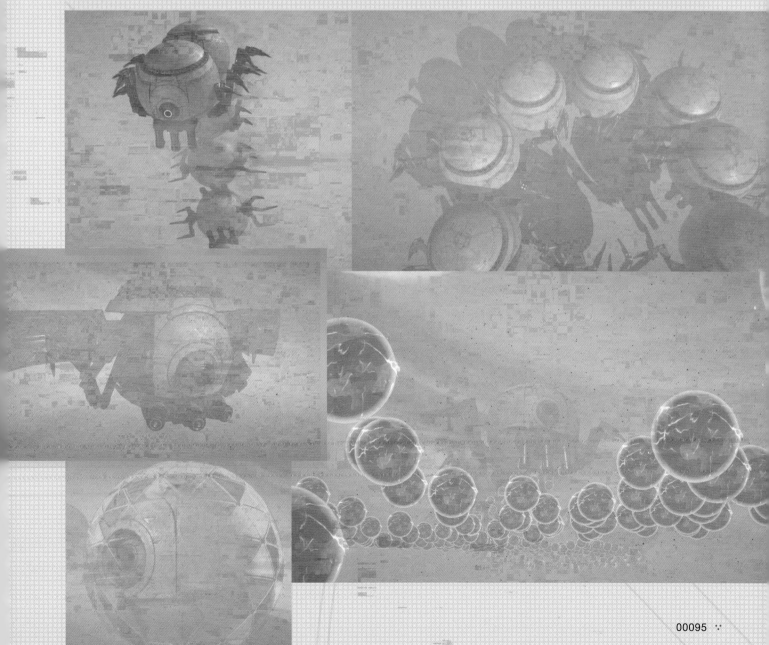

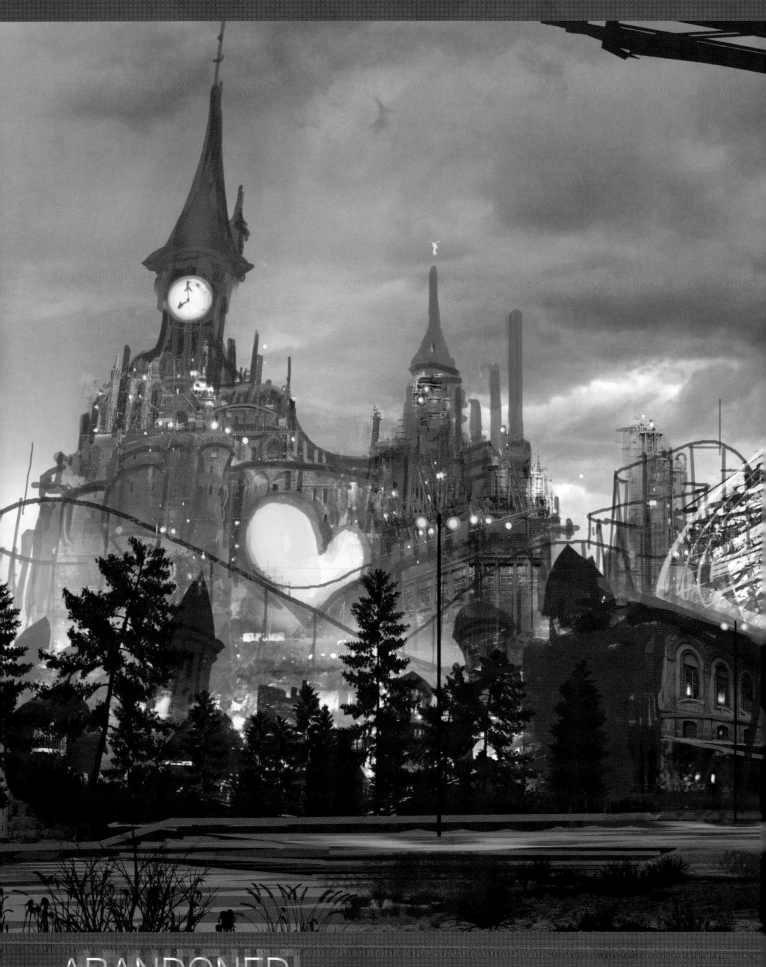

ABANDONED
AMUSEMENT PARK REPORT

48617070696e65737320616e64206d61646e6573732e

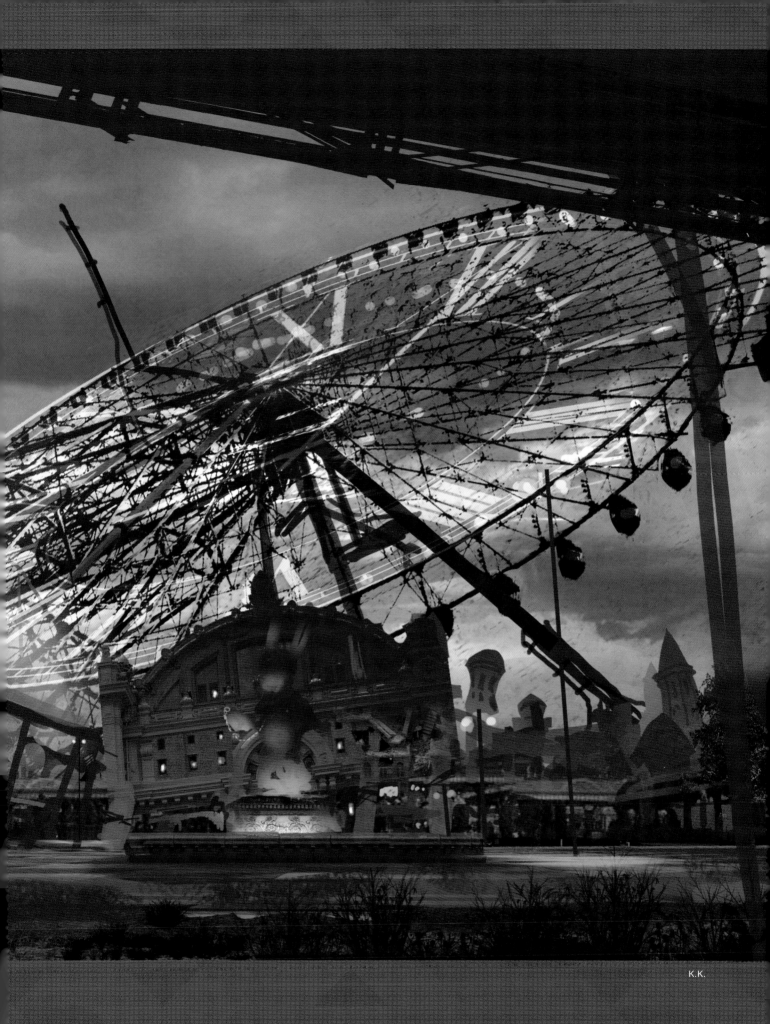

K.K.

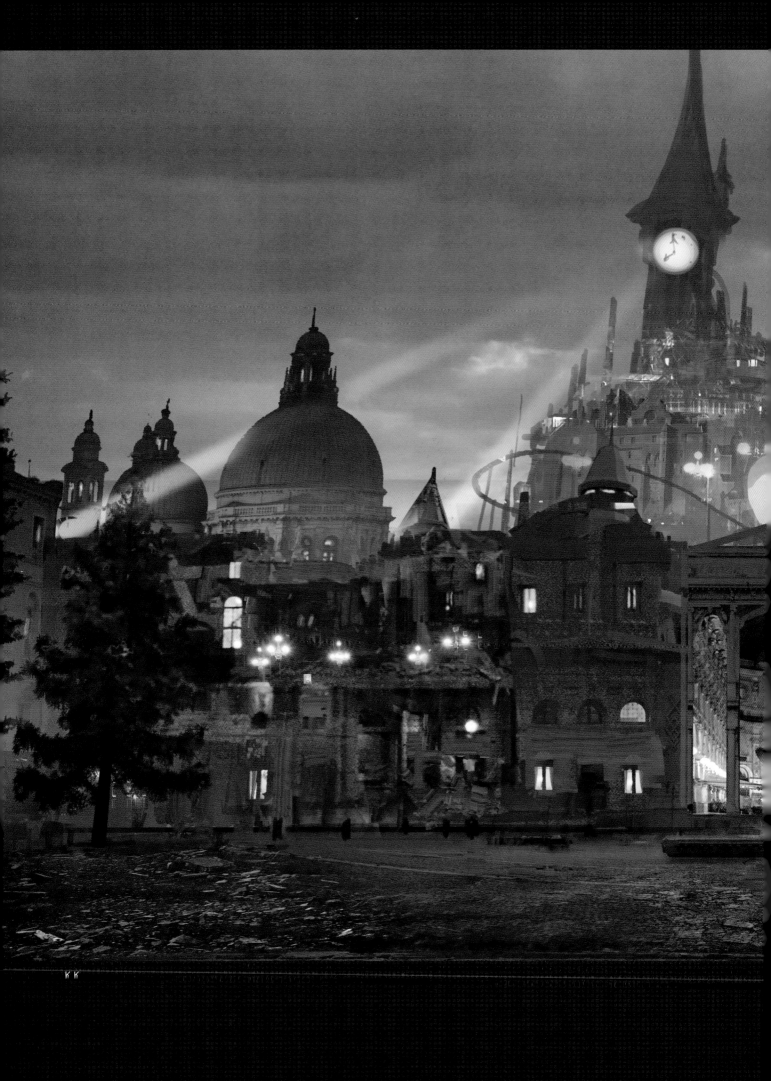

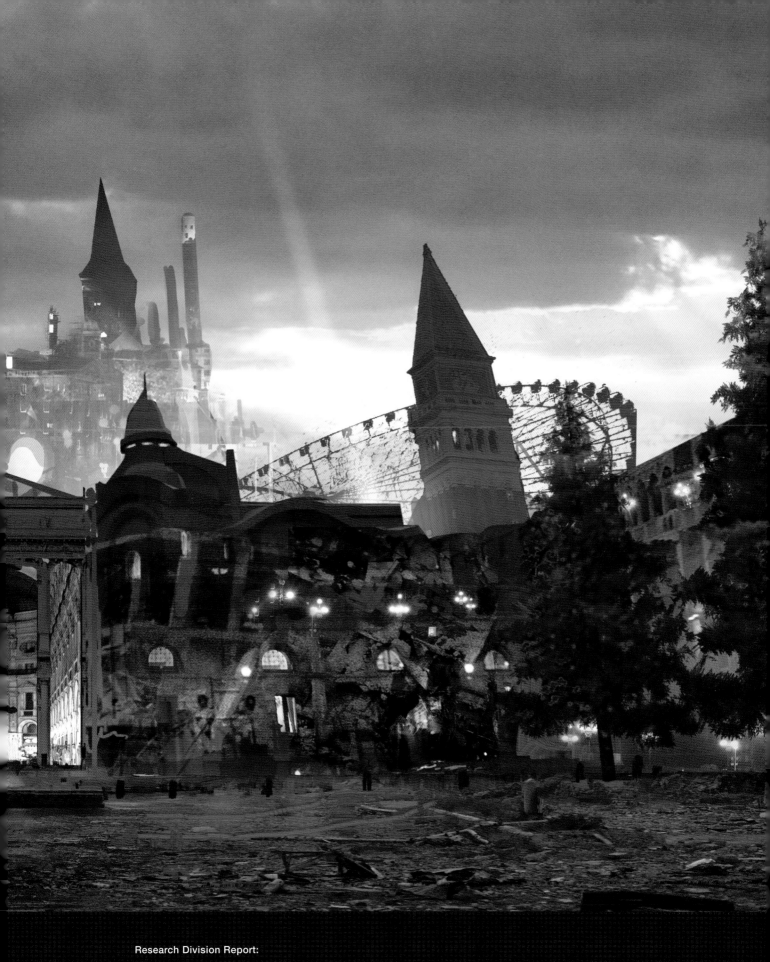

Research Division Report:

There are many nonaggressive machine lifeforms inhabiting the ruins of the amusement park. Machine lifeforms repaired the equipment inside the park and use it in their own unique way. Our research teams have several hypotheses for the reasons behind this. Among those, the most likely is that the park is a test site to ensure weapon diversity.

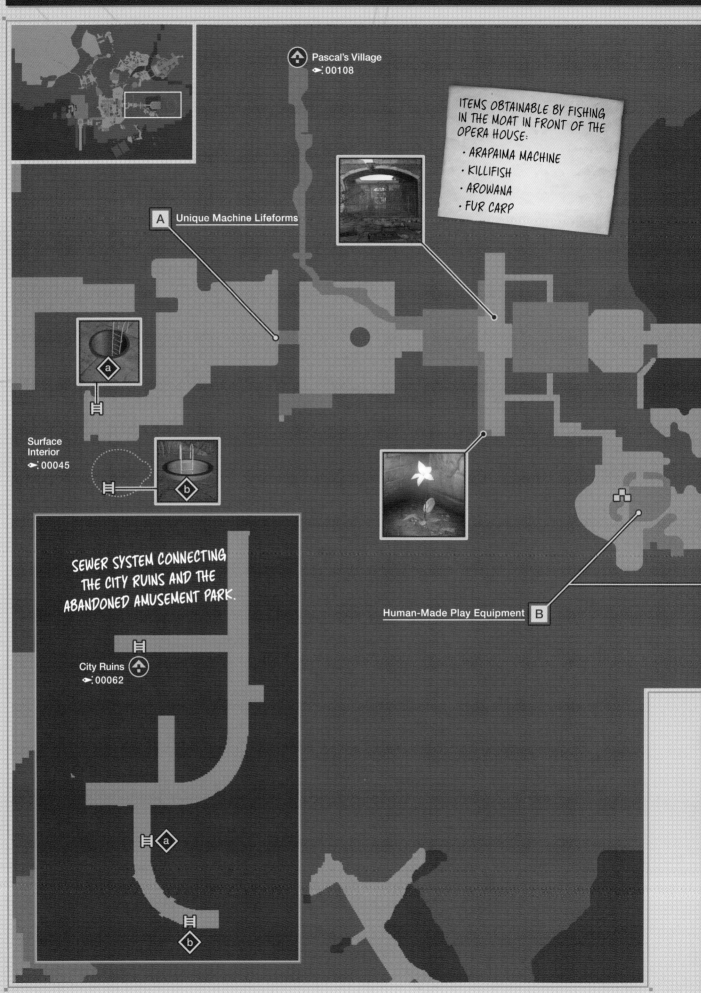

Pascal's Village
✎ 00108

ITEMS OBTAINABLE BY FISHING
IN THE MOAT IN FRONT OF THE
OPERA HOUSE:

- ARAPAIMA MACHINE
- KILLIFISH
- AROWANA
- FUR CARP

A Unique Machine Lifeforms

a

Surface
Interior
✎ 00045

b

SEWER SYSTEM CONNECTING
THE CITY RUINS AND THE
ABANDONED AMUSEMENT PARK.

City Ruins
✎ 00062

Human-Made Play Equipment **B**

a

b

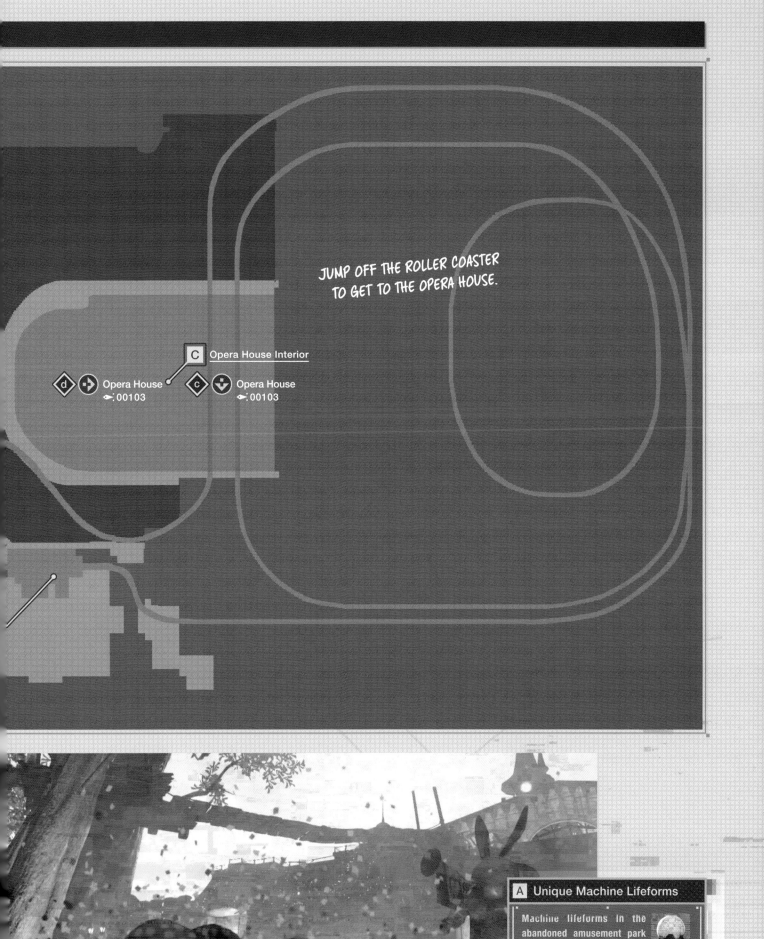

JUMP OFF THE ROLLER COASTER
TO GET TO THE OPERA HOUSE.

C Opera House Interior

d ➡ Opera House
🖊:00103

c ⬍ Opera House
🖊:00103

A Unique Machine Lifeforms

Machine lifeforms in the abandoned amusement park harbor no animosity toward androids, so it seems you won't be in danger if you don't attack them. They are welcoming to those visiting the park, and it seems like they are imitating the actions of the humans who used to be here.

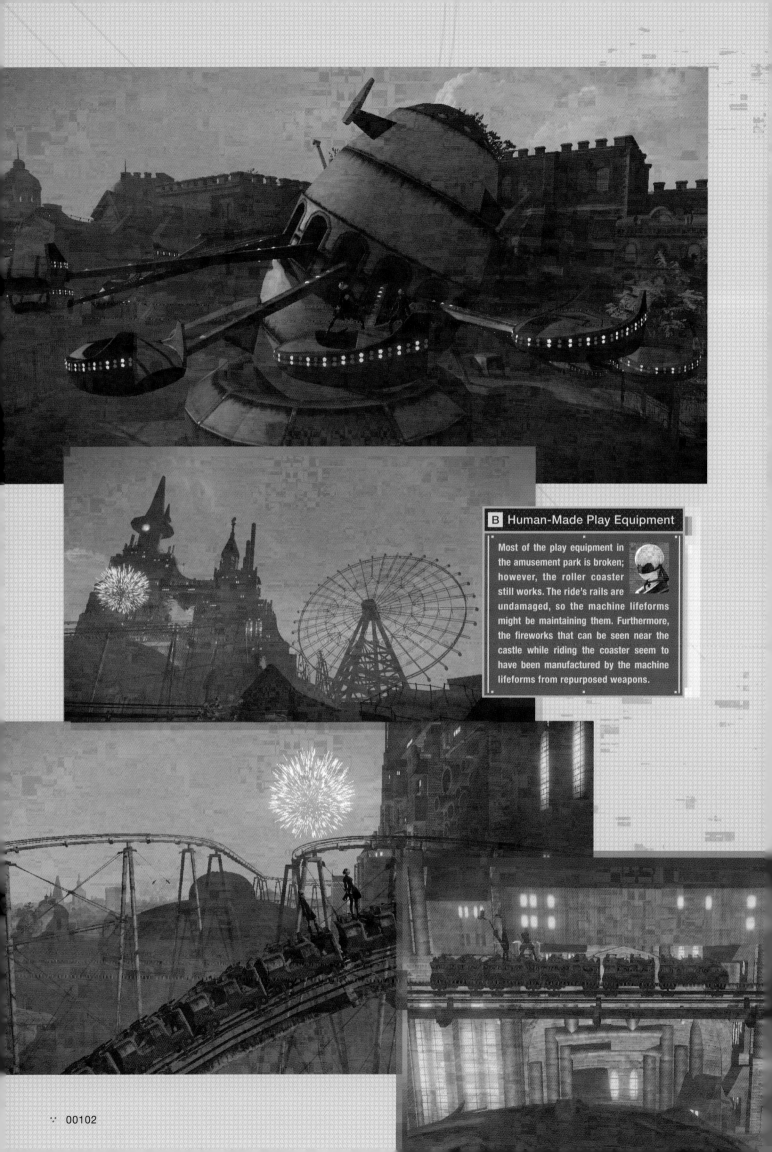

B **Human-Made Play Equipment**

Most of the play equipment in the amusement park is broken; however, the roller coaster still works. The ride's rails are undamaged, so the machine lifeforms might be maintaining them. Furthermore, the fireworks that can be seen near the castle while riding the coaster seem to have been manufactured by the machine lifeforms from repurposed weapons.

C Opera House Interior

Report: A huge theater has been discovered on this side of the castle. The interior is crumbling, and most of the passageways are blocked by rubble.

Analysis: The elevator to the underground area is currently operational. Old-fashioned monitors are piled up and are thought to have been gathered by machine lifeforms.

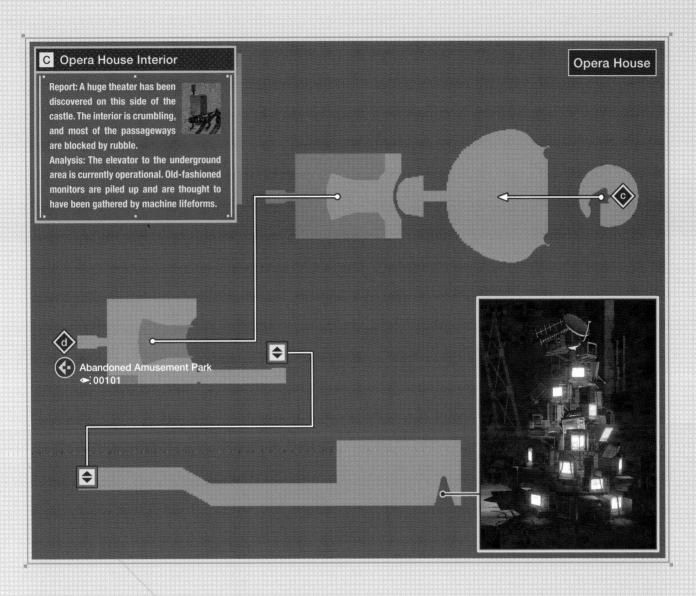

d

← Abandoned Amusement Park
⌐ 00101

-WARNING-

| Special Machine Report | **Amusement Park Goliath Tank (Pythagoras)** |

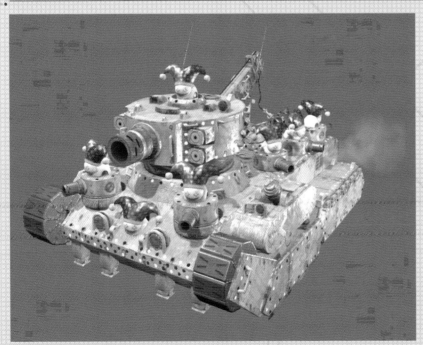

Goliath-class tanks are dangerous machines with overwhelming firepower from nine separate cannons and high mobility due to their continuous tracks. However, this particular machine identified in the amusement park fires confetti and decorative shots, which are not generally considered to be harmful. Nevertheless, when we recognized its hostile nature, it replaced its harmless arsenal with lethal shells and demonstrated its original specifications and peerless abilities.

Special Machine Report | **Simone**

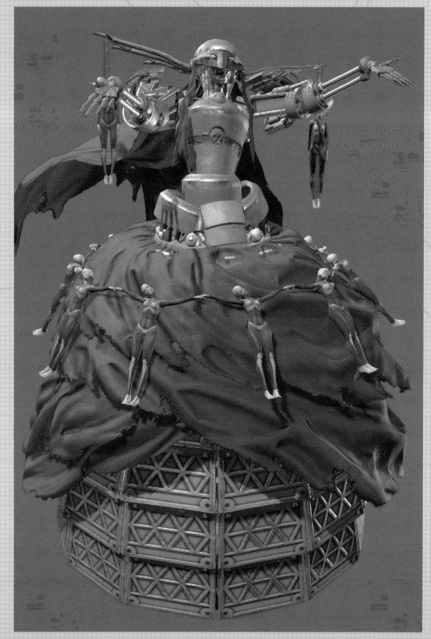

Simone is a Goliath-class machine lifeform with the appearance of an opera singer and an obsession with beauty. She dresses herself with parts from other machine lifeforms and android corpses. Living androids are used as reconstructed weapons for hacking attacks, and there are countless weapons built into her skirt. She's considered to have evolved uniquely in a way not seen in other machines.

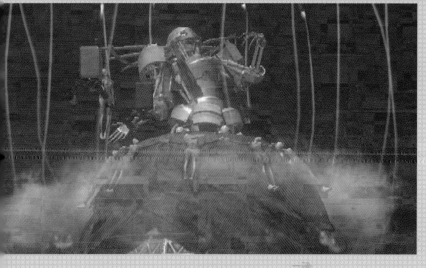

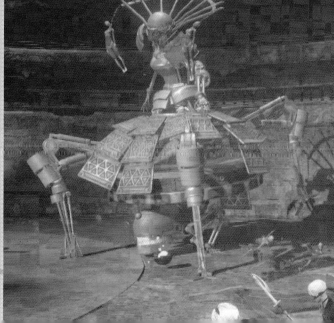

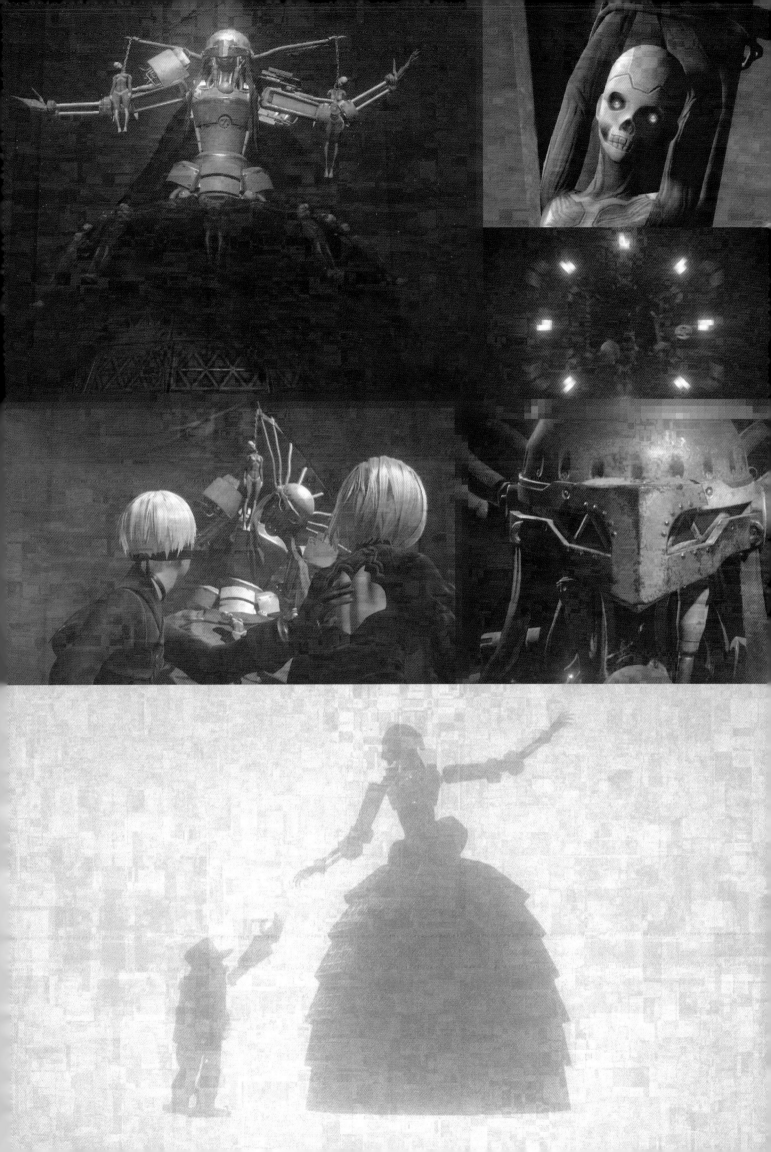

PASCAL'S VILLAGE REPORT

5468652066696e616c2064617973206f6620746865206f66206c732077686f206162616e646f6e656420636f6e666c6963742e

K.K.

Pascal's Village

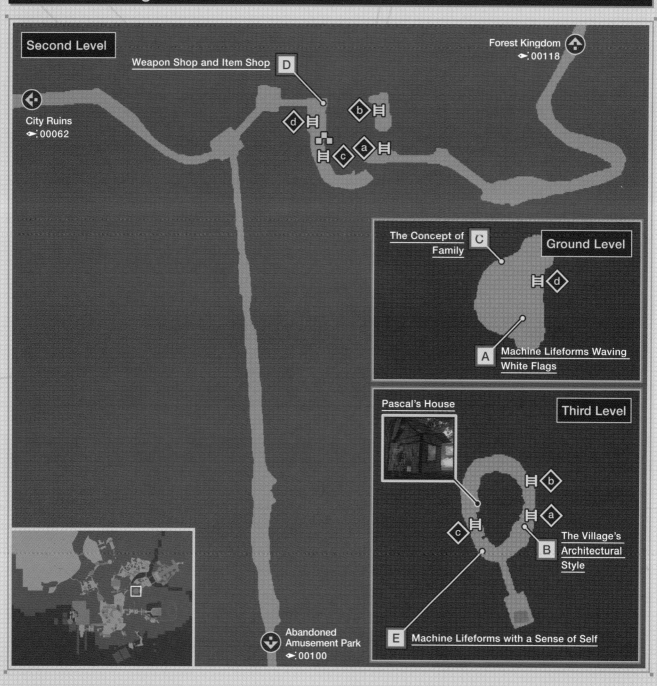

Second Level

Weapon Shop and Item Shop — D

Forest Kingdom
➤ 00118

City Ruins
➤ 00062

d 🛏
b 🛏
c a 🛏

The Concept of Family — C
Ground Level
🛏 d
A — Machine Lifeforms Waving White Flags

Pascal's House
Third Level
🛏 b
🛏 a
c 🛏
B — The Village's Architectural Style
E — Machine Lifeforms with a Sense of Self

Abandoned Amusement Park
➤ 00100

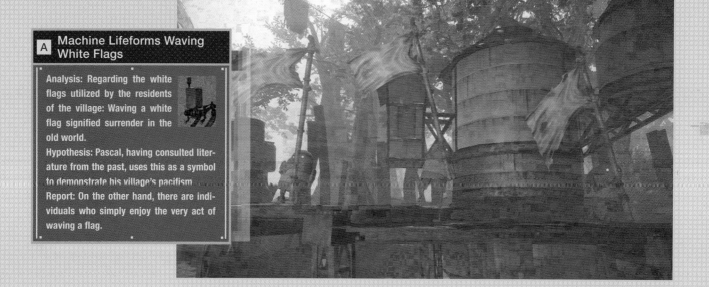

A Machine Lifeforms Waving White Flags

Analysis: Regarding the white flags utilized by the residents of the village: Waving a white flag signified surrender in the old world.

Hypothesis: Pascal, having consulted literature from the past, uses this as a symbol to demonstrate his village's pacifism.

Report: On the other hand, there are individuals who simply enjoy the very act of waving a flag.

B The Village's Architectural Style

Analysis: Chimneys are installed in the village houses, but heating and ventilation facilities are unnecessary for machine lifeform dwellings.

Hypothesis: Such unneeded equipment is thought to be installed for the purpose of mimicking mankind's culture. The layered structure that makes use of the large tree at the center of the village may also be imitating mankind's architectural techniques from the old world.

Report: While they may be copying mankind's architectural style, the machine lifeforms move between the structures' levels with ladders, by hitching to small flying-type machines, or by utilizing their own flight functionality.

LITTLE SISTER MACHINE

BIG SISTER MACHINE

C The Concept of Family

Sisters, parent, and child . . . Through interacting with the inhabitants of Pascal's Village, my impression is that the concept of family exists even among machine lifeforms. They may even worry about a runaway son or a lost sister. I wonder how the definition of a machine family is decided? The answer might have something to do with having similar serial numbers or coming from the same factory.

SISTER?

MOM?

I LOVE YOU

BROTHER?

FATHER MACHINE

MOTHER MACHINE

CHILD MACHINE

D Weapon Shop and Item Shop

Report: A weapon shop and an item shop operating as village facilities have been confirmed. They utilize machine parts as currency. The item shop offers wares like plug-in chips that are usable by androids, while the weapon shop offers armaments used by machine lifeforms.

Query: Why do the individuals of Pascal's Village possess a particular fixation with weapons of war, despite seeking peace?

INDOOR MACHINE AND OUTDOOR MACHINE

E Machine Lifeforms with a Sense of Self

The village inhabitants are very different from the image of machine lifeforms I've harbored up to now. Separated from the network and possessing a sense of self, they copy the history of mankind that Pascal teaches them, and considering its significance allows them to further develop their self-awareness. Individuals with different ideas coexist. The situation in this village is like that of androids . . . No, it's given me a sense of humans' daily existence, which up until now, I'd only known through documents.

WEIRD MACHINE

← OVERPROTECTIVE MACHINE WORRIED ABOUT HER RECLUSIVE SON

PLAYFUL!
CHEERFUL!
TOO PLAYFUL!
MACHINES

JEAN PAUL
LIKES PHILOSOPHY.

MACHINE WITH MAKEUP
SEEMS TO BE A FAN OF JEAN PAUL.

SCIENTIST MACHINE

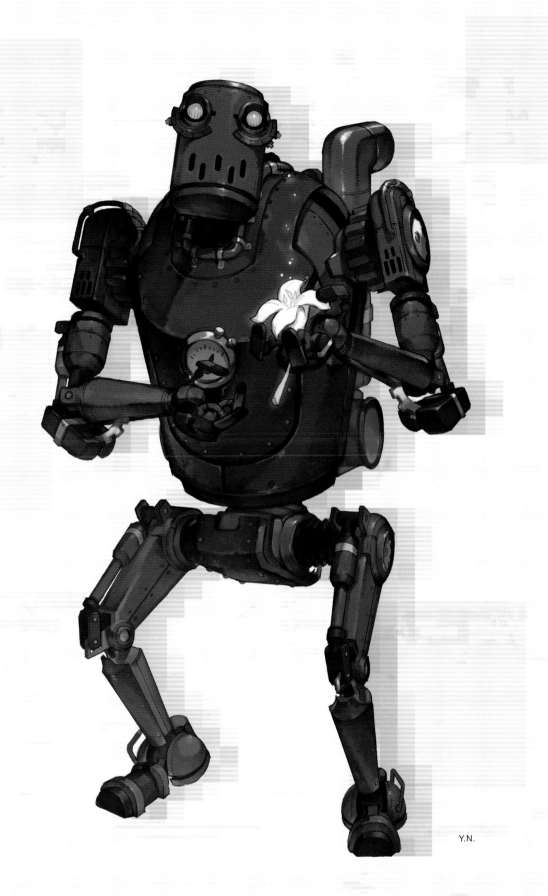

Y.N.

Pascal

| Feature: Leadership function | Height: 250 cm | Weight: 360.1 kg | Bust: 247 cm | Waist: 166 cm | Hips: 201 cm | Eye color: — | Hair color: — |

A unique, peace-loving machine lifeform who attained independence from the machine network and built a village with his comrades. Pascal is substantially more intelligent than a typical machine lifeform and shows interest in data from the old world and in the history of machines. He's searching for a way to make peace with the androids, so we conjecture that he's harmless. Despite having a female voice, he calls himself "Uncle" as a result of forming a sense of self and having absorbed a variety of information. His hobbies include reading philosophy books and composing haiku poetry.

FOREST KINGDOM REPORT

5765616b6c696e67732077686f20636f756c646e2774206265636f6d652070617274206f6620612066616d696c792e

K.K.

K K

00114

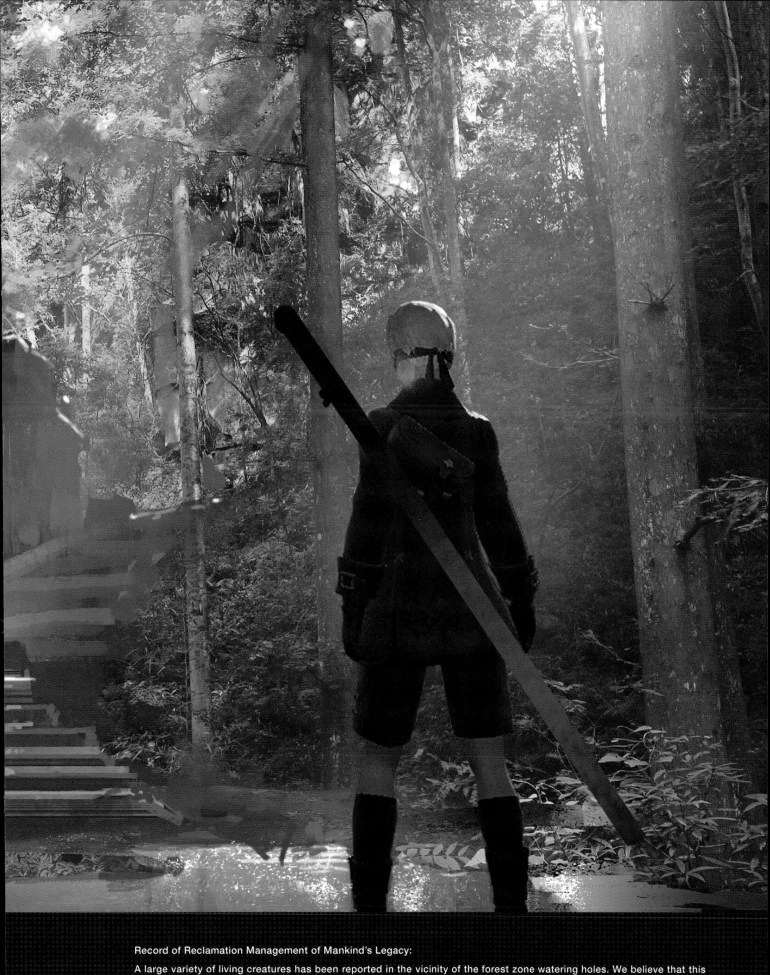

Record of Reclamation Management of Mankind's Legacy:

A large variety of living creatures has been reported in the vicinity of the forest zone watering holes. We believe that this is because of the abundance of food from the vegetation. However, many of the machine lifeforms in this area act in groups, and caution is required due to their belligerence. Be particularly careful near the ruins of the old castle, where a Goliath-class machine lifeform has been confirmed to reside.

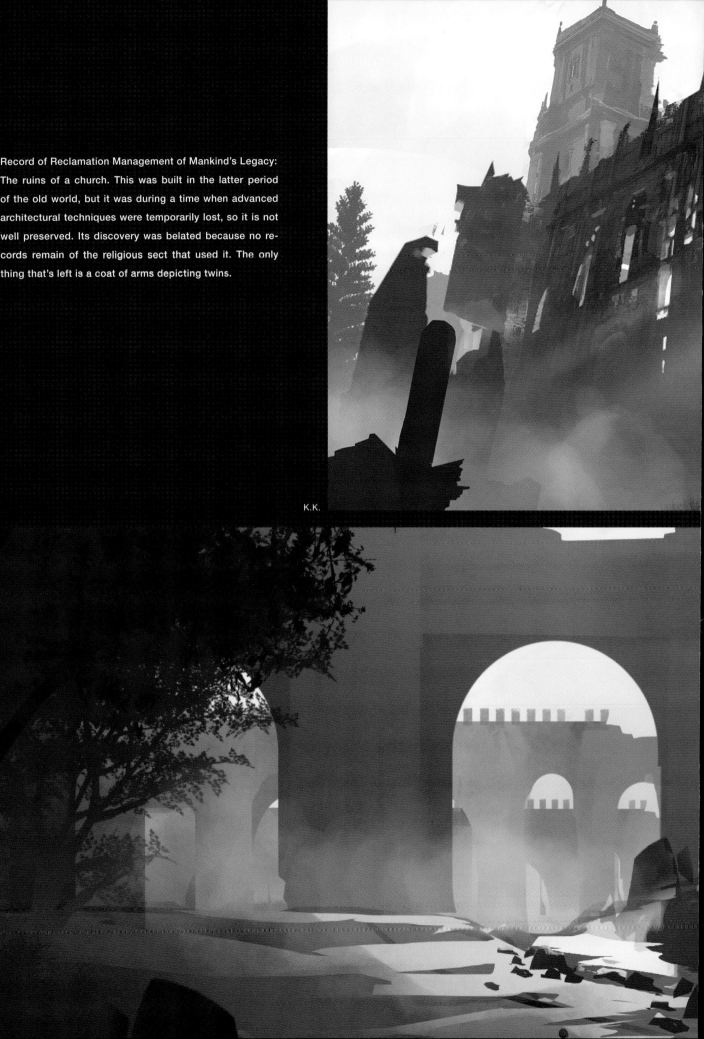

Record of Reclamation Management of Mankind's Legacy: The ruins of a church. This was built in the latter period of the old world, but it was during a time when advanced architectural techniques were temporarily lost, so it is not well preserved. Its discovery was belated because no records remain of the religious sect that used it. The only thing that's left is a coat of arms depicting twins.

K.K.

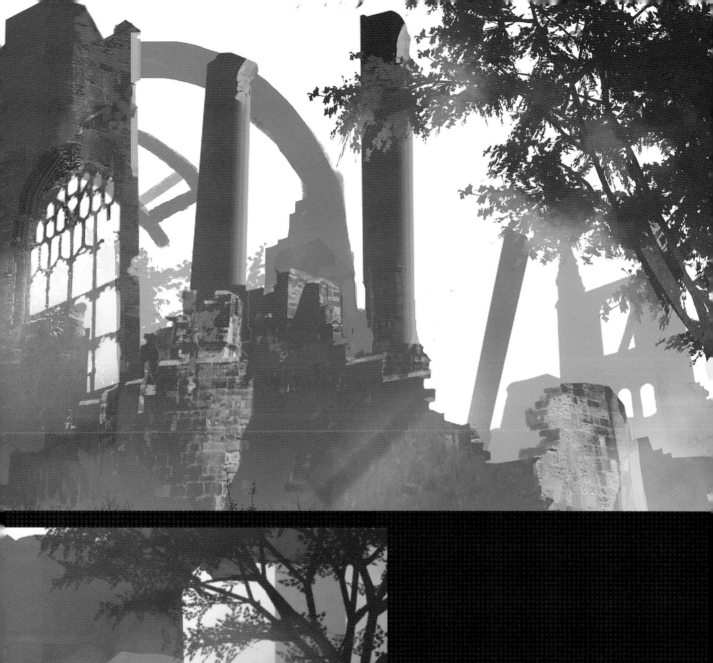

Record of Reclamation Management of Mankind's Legacy
Not much of the forest zone's environment has changed
since the time of the old world. This place flourished as a
human sightseeing area, with the long suspension bridge
and large castle both serving as tourism destinations. Re-
cords also remain of the use of a hot spring, and we've
confirmed that it erupted prior to the year 2000.

Forest Kingdom

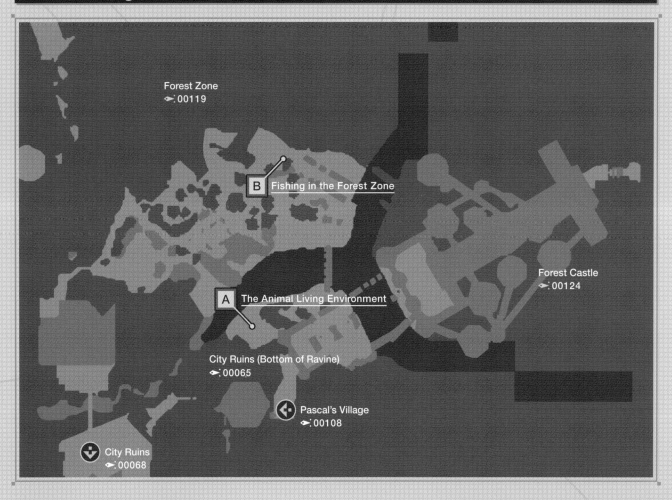

Forest Zone
�

 00119

B Fishing in the Forest Zone

Forest Castle
�

 00124

A The Animal Living Environment

City Ruins (Bottom of Ravine)
�

 00065

Pascal's Village
�

 00108

City Ruins
�

 00068

A The Animal Living Environment

Analysis: The forest zone is a suitable environment for plants and animals. It is possible to observe animals in great numbers. Rare albino individuals have been confirmed when observing deer, wild boars, and the like.

Hypothesis: Because animals and machine lifeforms have different requirements to survive, they have established a coexistence where each ignores the other. As a result, it's thought that the appearance of the machine lifeforms has altered the ecosystem very little.

B Fishing in the Forest Zone

Report: Regarding the living conditions of marine life in the forest zone: This area possesses many bodies of water produced from the abundance of nature. Hence, it is possible to observe a rich variety of freshwater fish. Furthermore, we have confirmed that their propagation has increased in recent years.

Hypothesis: This is due to the influence of the fish-shaped machine lifeforms that were modeled after native species. The forest zone was naturally a living environment suitable to propagation, but there is a possibility that an even more favorable environment has been created by establishing a symbiotic relationship with the now-wild fish-shaped machine lifeforms.

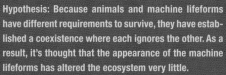

ITEMS OBTAINABLE BY FISHING IN THE FOREST ZONE:

- AROWANA
- KOI CARP
- CARP
- KILLIFISH

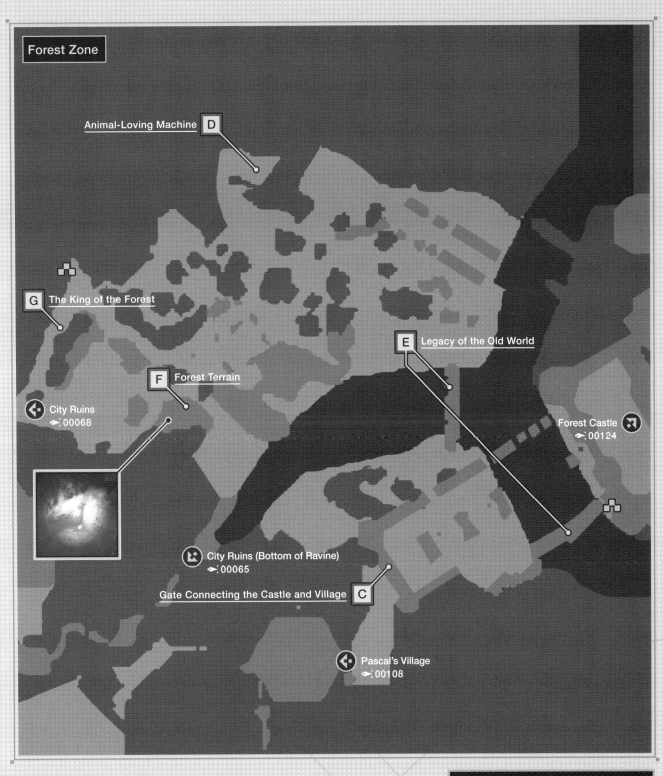

Forest Zone

Animal-Loving Machine **D**

G The King of the Forest

E Legacy of the Old World

F Forest Terrain

City Ruins
🔄 00068

Forest Castle
🔄 00124

City Ruins (Bottom of Ravine)
🔄 00065

Gate Connecting the Castle and Village **C**

Pascal's Village
🔄 00108

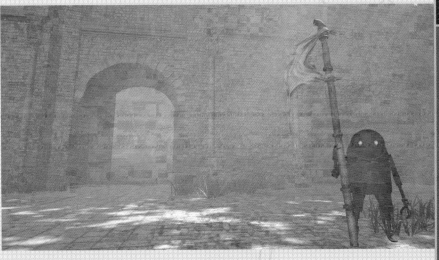

C | Gate Connecting the Castle and Village

The gate here seems to connect to Pascal's Village, but it's usually closed to protect against enemy invasions. The machine lifeforms in the forest kingdom are extremely exclusive, so Pascal believes that building an amicable relationship with them through dialogue would be difficult.

On the other hand, the machines in the forest kingdom are increasingly wary of the village. It seems like some of them want to make a preemptive strike . . . Two groups, separated from the network and possessing a sense of self. Despite similar circumstances and the fact that they're all machines, their relationship is considerably strained.

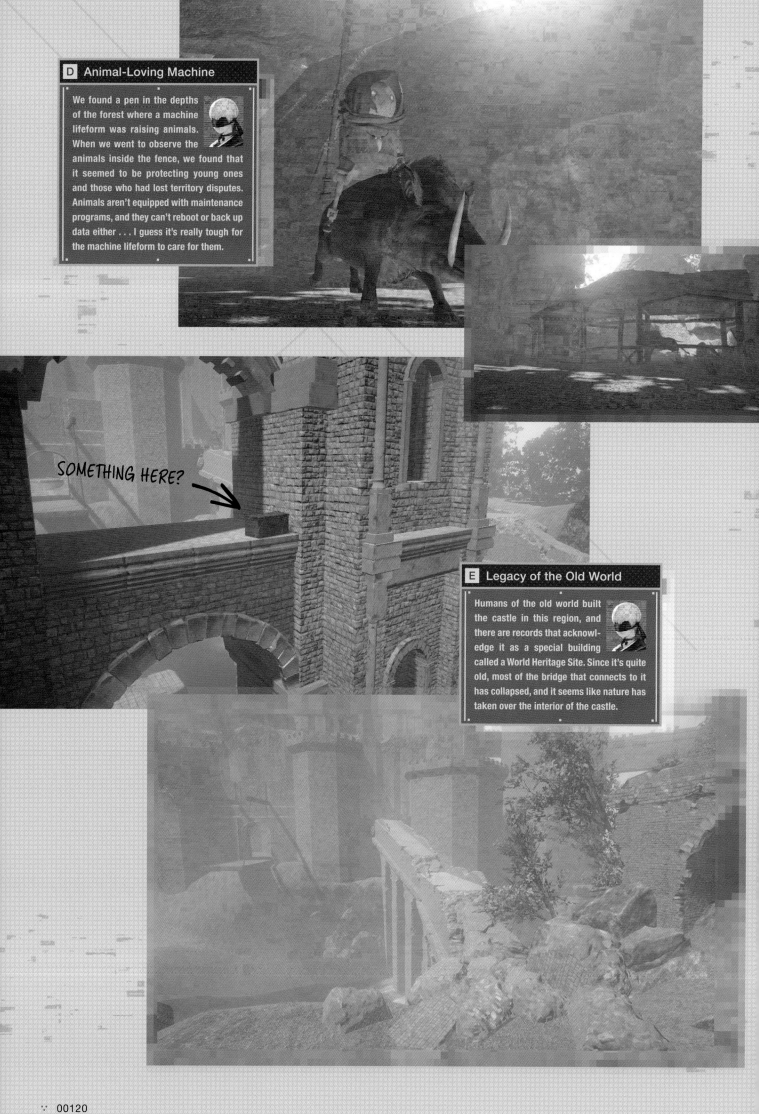

D Animal-Loving Machine

We found a pen in the depths of the forest where a machine lifeform was raising animals. When we went to observe the animals inside the fence, we found that it seemed to be protecting young ones and those who had lost territory disputes. Animals aren't equipped with maintenance programs, and they can't reboot or back up data either . . . I guess it's really tough for the machine lifeform to care for them.

SOMETHING HERE?

E Legacy of the Old World

Humans of the old world built the castle in this region, and there are records that acknowledge it as a special building called a World Heritage Site. Since it's quite old, most of the bridge that connects to it has collapsed, and it seems like nature has taken over the interior of the castle.

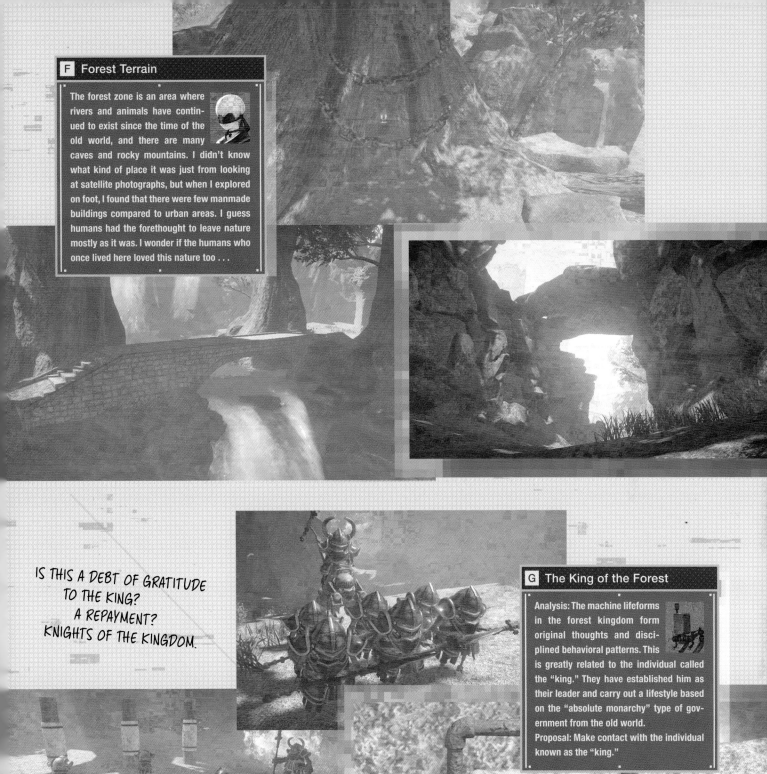

F Forest Terrain

The forest zone is an area where rivers and animals have continued to exist since the time of the old world, and there are many caves and rocky mountains. I didn't know what kind of place it was just from looking at satellite photographs, but when I explored on foot, I found that there were few manmade buildings compared to urban areas. I guess humans had the forethought to leave nature mostly as it was. I wonder if the humans who once lived here loved this nature too . . .

IS THIS A DEBT OF GRATITUDE TO THE KING?
A REPAYMENT?
KNIGHTS OF THE KINGDOM.

G The King of the Forest

Analysis: The machine lifeforms in the forest kingdom form original thoughts and disciplined behavioral patterns. This is greatly related to the individual called the "king." They have established him as their leader and carry out a lifestyle based on the "absolute monarchy" type of government from the old world.
Proposal: Make contact with the individual known as the "king."

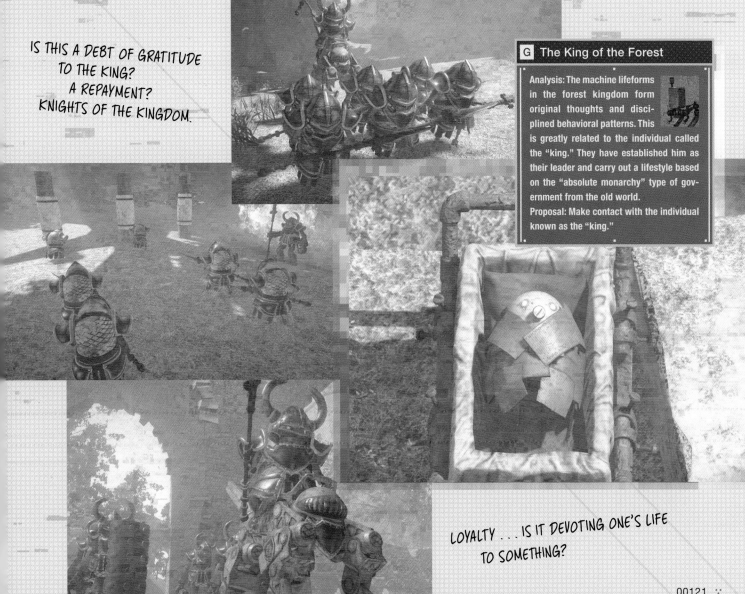

LOYALTY . . . IS IT DEVOTING ONE'S LIFE TO SOMETHING?

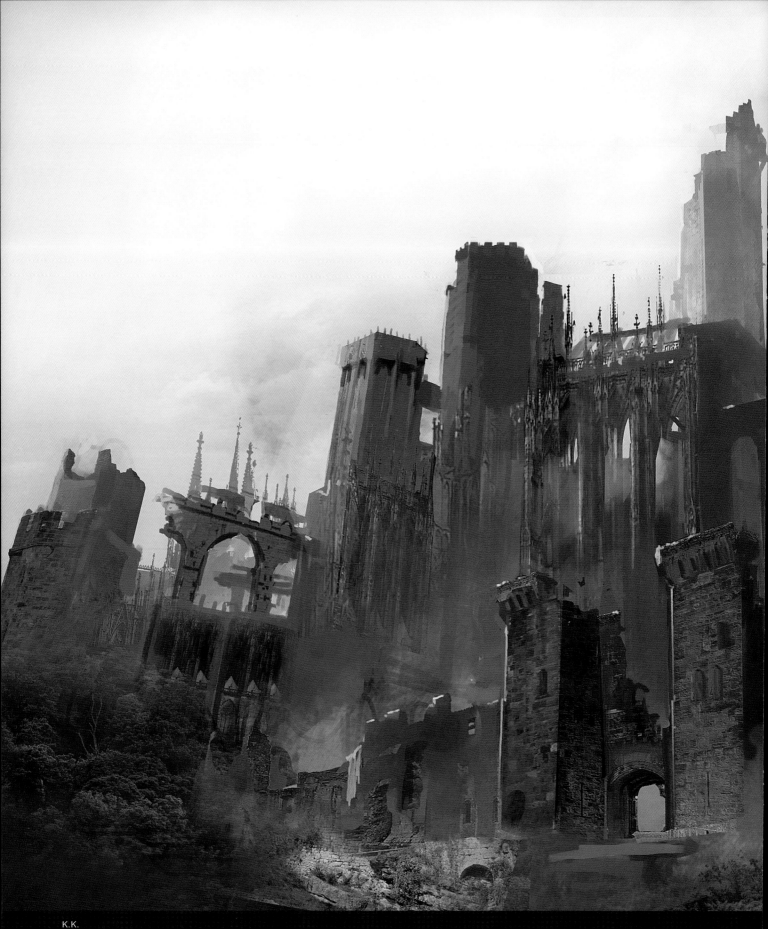

K.K.

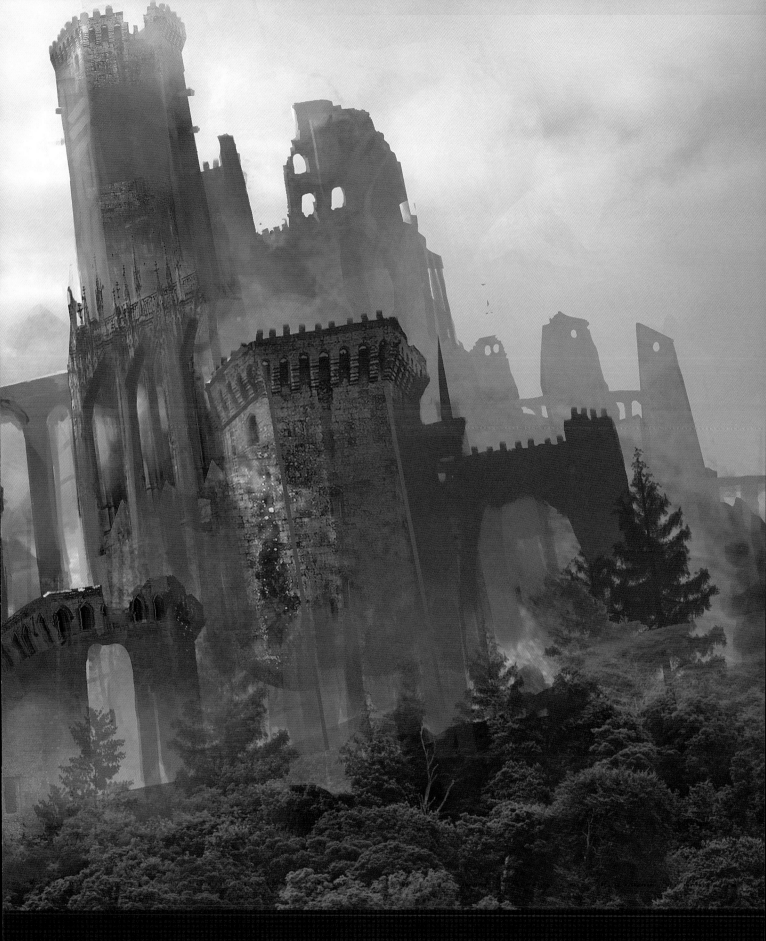

Record of Reclamation Management of Mankind's Legacy:

This huge fortress was built before the area became a tourist attraction. The feudal lord who controlled this land at the time lived here, but in the end, he died by the hands of the people who were suffering under his tyrannical rule. Research into such negative aspects of human history still hasn't made much progress, and we can assume that any documents stored in the castle interior are a valuable legacy.

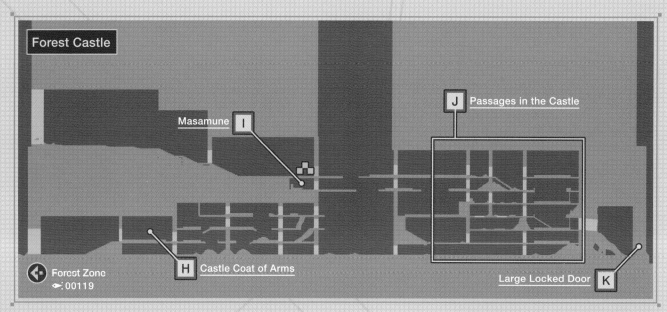

Forest Castle

Masamune | I |

| J | Passages in the Castle

| H | Castle Coat of Arms

Forest Zone
00119

Large Locked Door | K |

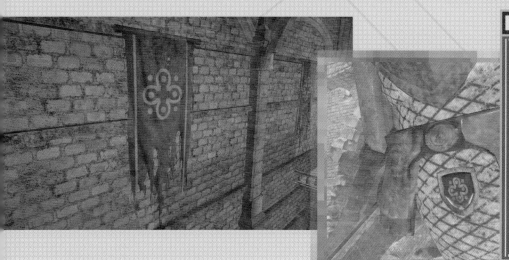

H Castle Coat of Arms

Report: A coat of arms has been discovered on flags inside the castle and on the equipment of some machine lifeforms. It is a type of symbol that was used in the old world.

Hypothesis: It is used as a symbol of the machine lifeforms in this area in order to unify them. It is unknown whether this mark showing the machine lifeforms' affiliation was carved by an individual beforehand, or whether it was done after they attained a sense of self in order to show that they were a community.

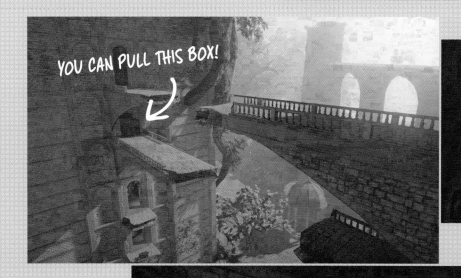

YOU CAN PULL THIS BOX!

HIS SKILL IS THE REAL DEAL!

I Masamune

We met a machine lifeform named Masamune who's a blacksmith and runs a shop. He separated himself from the network due to an internal malfunction. Because of this, he gained a sense of self and is cooperative with androids. He also seemingly had a teacher who trained him in the art of blacksmithing, and he showed strong feelings toward the weapons his teacher honed. Furthermore, it appears he's taken the weapons dealer in Pascal's Village as his apprentice and is passing down his own techniques.

DISCOVERED AN ENTRANCE TO THE TOP FLOOR OF THE LIBRARY!

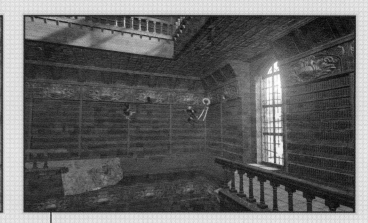

J Passages in the Castle

Alert: The interior of the castle is in an advanced state of deterioration, and collapsed passages exist.

Hypothesis: There is a possibility that these cave-ins will have an effect on the route one can take during exploration of the castle.

Analysis: The library added after the castle was built shows comparatively few signs of crumbling, and the ladders may be used for direct ascent and descent.

Proposal: Use the library ladders to move between the levels of the castle.

Library

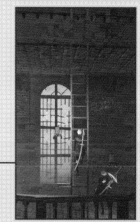

a

K

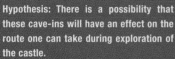

THE SOLDIERS' COUNCIL ROOM

K Large Locked Door

We found a large locked door deep inside the library. Through the door lay the tomb of a two-legged Goliath-class machine . . . It seemed like the first king to rule over the machine lifeforms was buried here. The unsanitary and humid environment of this region is harsh for machines. If we assume that the king commanded and inspired machine lifeforms at this scale under such circumstances, he was probably quite a remarkable individual.

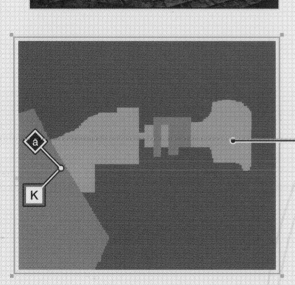

a

K

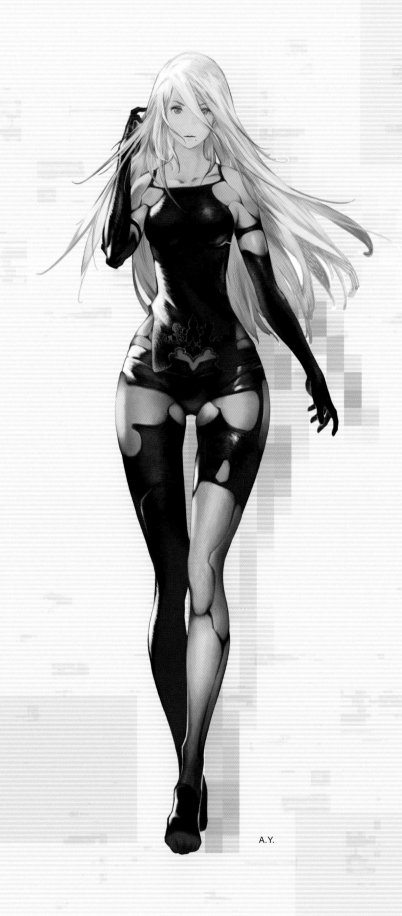

A.Y.

A2

| Feature: Melee combat | Height: 168 cm (with heels) | Weight: 139.2 kg | Bust: 73 cm | Waist: 54 cm | Hips: 82 cm | Eye color: Cloudy blue | Hair color: Yellowish white |

Her official name is YoRHa Type A No. 2. An attacker-type model no longer in use who specializes in melee combat, she is a prototype of the current official YoRHa units, such as 2B and 9S. A models and G models were abolished due to the introduction of the pod system in current YoRHa troops, and they were integrated into the B models. A2 is the sole surviving A model, but she's wanted as a deserter from back when the experimental YoRHa force was in use. After her encounter and battle with 2B and 9S, who were investigating the forest castle, her whereabouts are once again unknown.

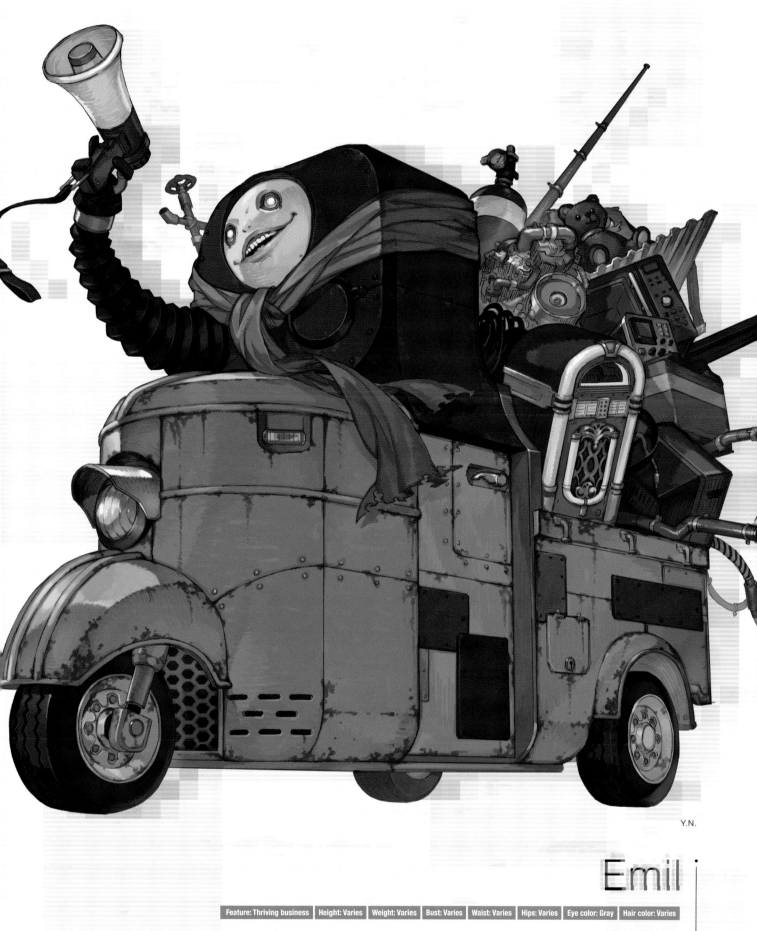

Y.N.

Emil

| Feature: Thriving business | Height: Varies | Weight: Varies | Bust: Varies | Waist: Varies | Hips: Varies | Eye color: Gray | Hair color: Varies |

A mysterious lifeform who appeared from the head of a machine. After meeting 2B and 9S, only his head escaped. He was created as a weapon long ago, but after many years, most of his memories seem to be missing. Nowadays, he's acquired a vehicle-like body and plays unfathomable music as he speeds around the city ruins. The dissonance of the song he plays has prompted a flood of complaints from Resistance members to their leader, Anemone, but since she doesn't even know where he lives, she's at her wits' end.

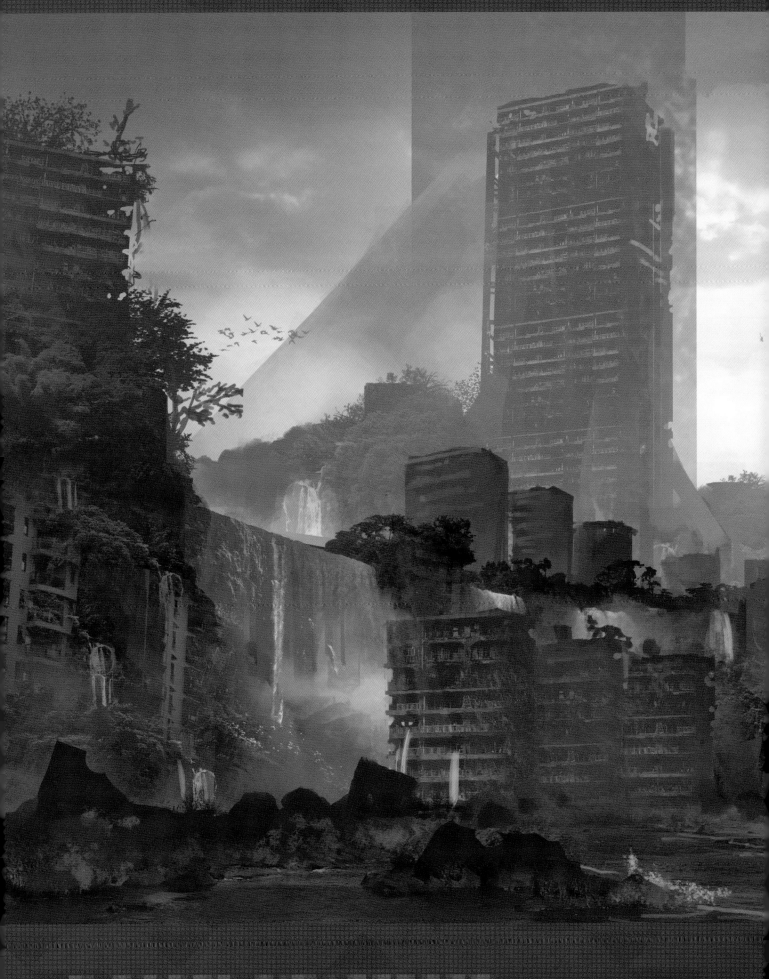

FLOODED CITY REPORT

546865206162616e646f6e6564206368696c642e

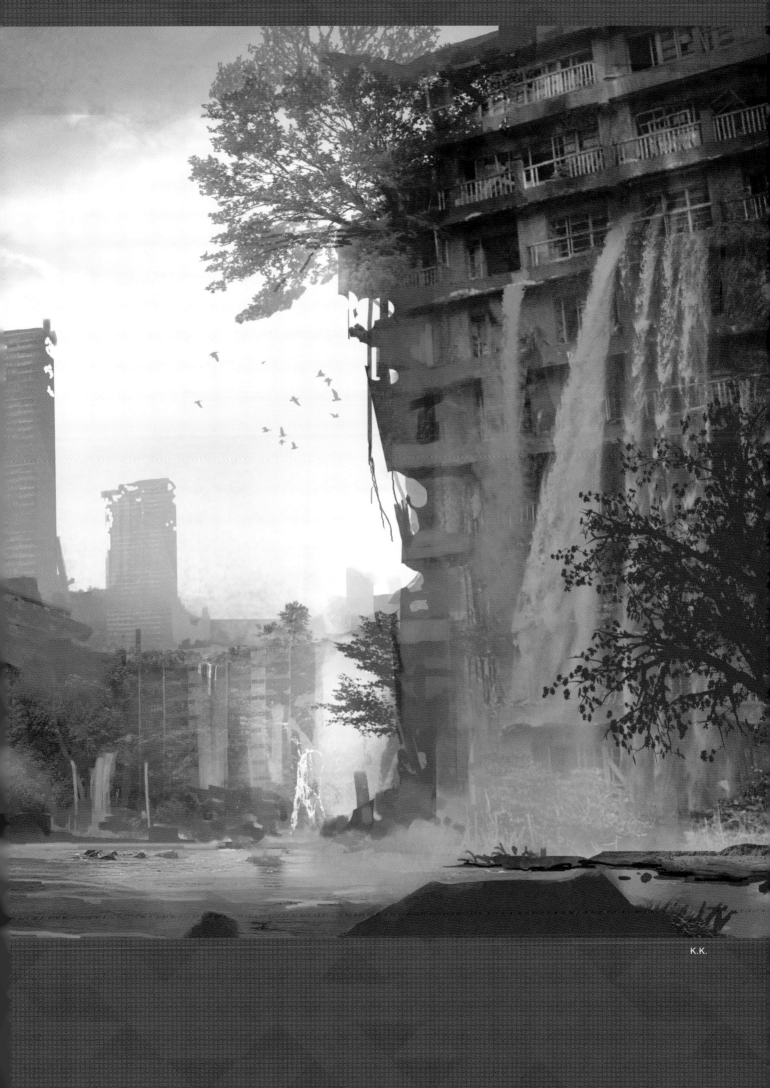

K.K.

Research Division Report:

This city became submerged as a result of frequent changes in the earth's crust. Because the fault at the boundary sank several dozen meters, a large quantity of water flows in from the surrounding areas.

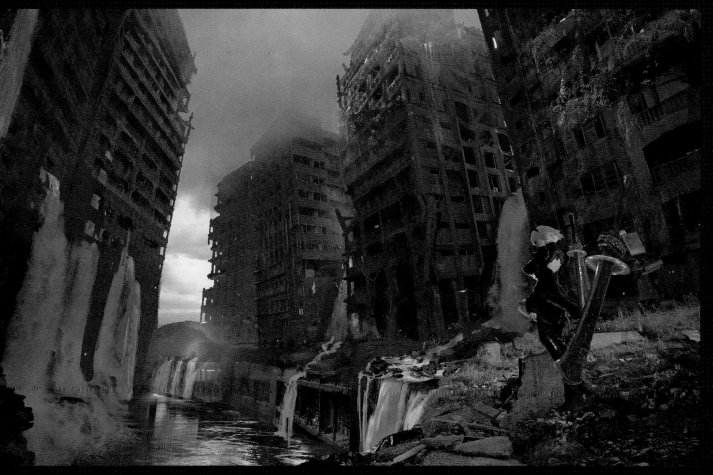

K.K.

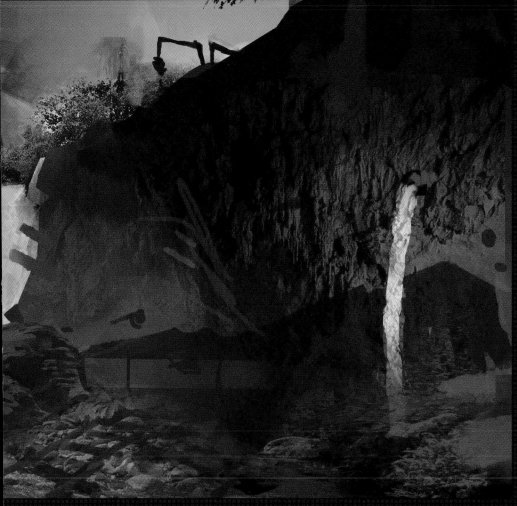

K.K.

The existence of an underwater machine lifeform has been previously identified, but investigation into it hasn't made any progress. There are few records regarding the environment of the sea in the first place, and it is not currently understood how that environment has changed.

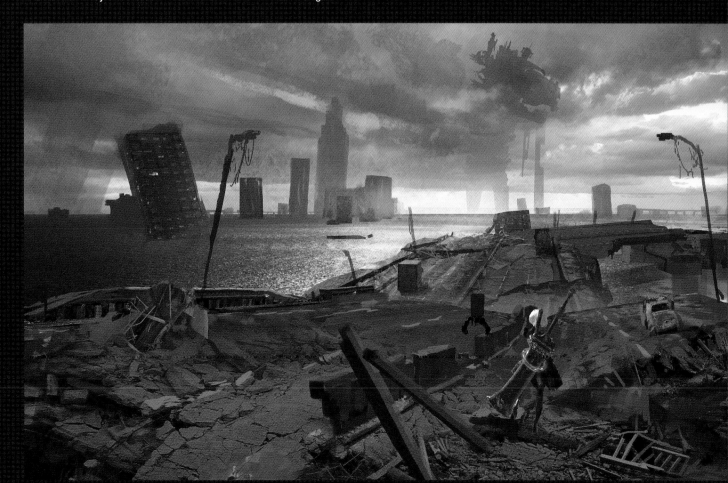

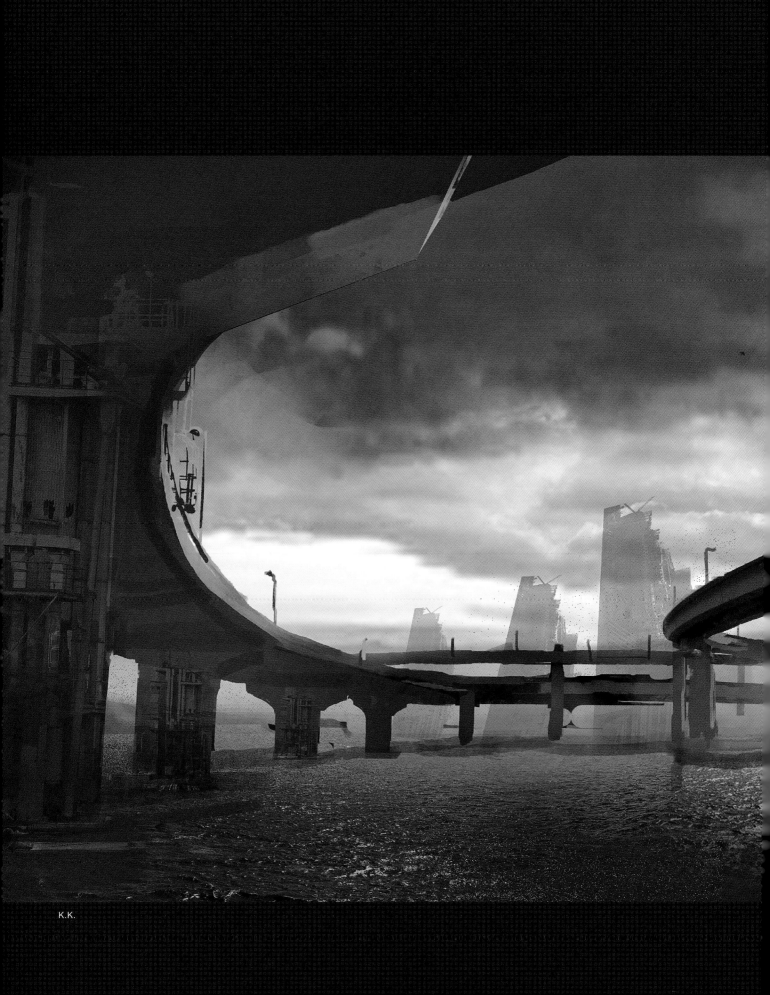

K.K.

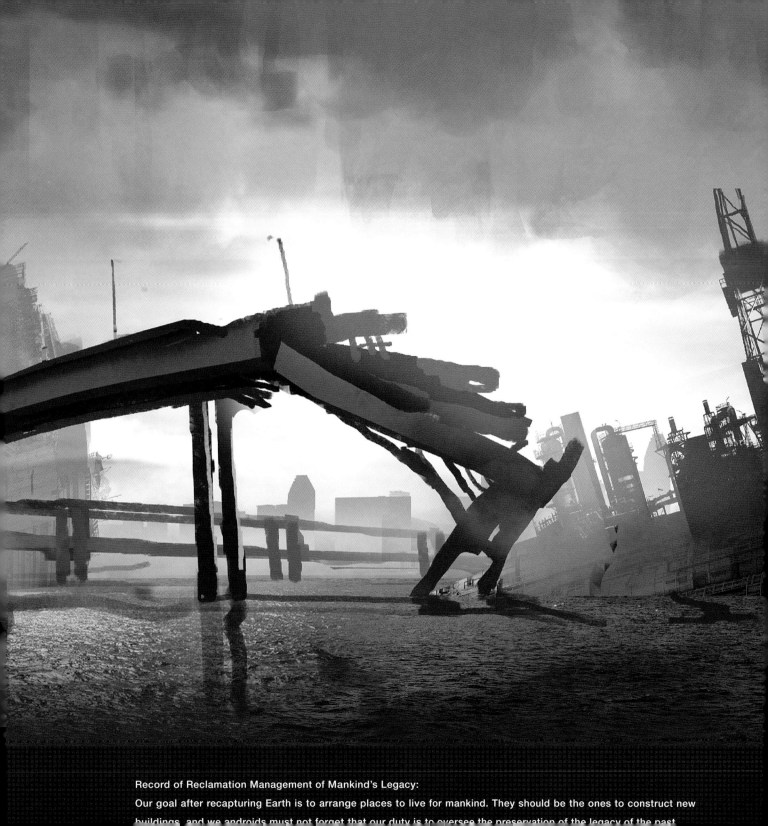

Record of Reclamation Management of Mankind's Legacy:

Our goal after recapturing Earth is to arrange places to live for mankind. They should be the ones to construct new buildings, and we androids must not forget that our duty is to oversee the preservation of the legacy of the past.

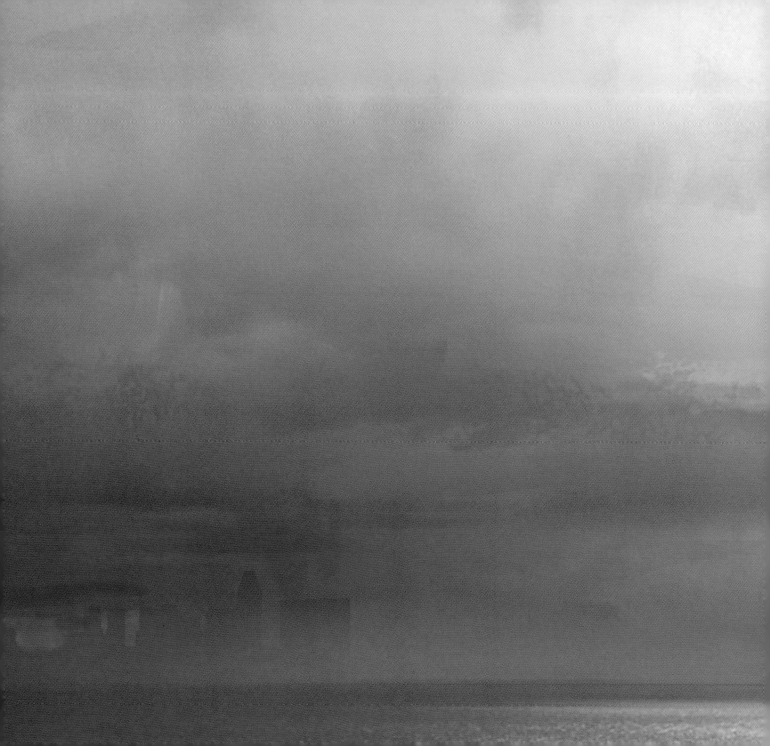

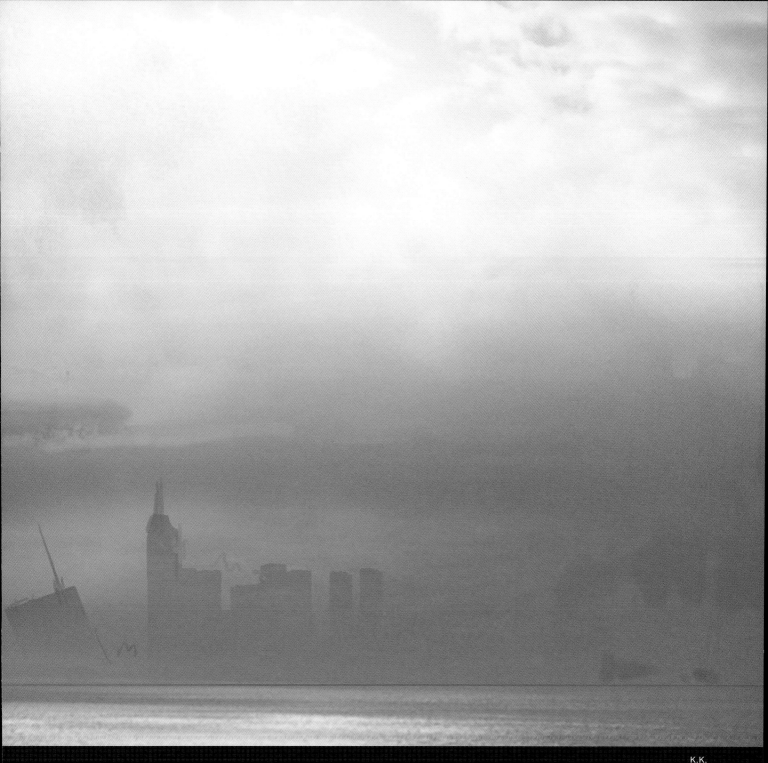

Flooded City

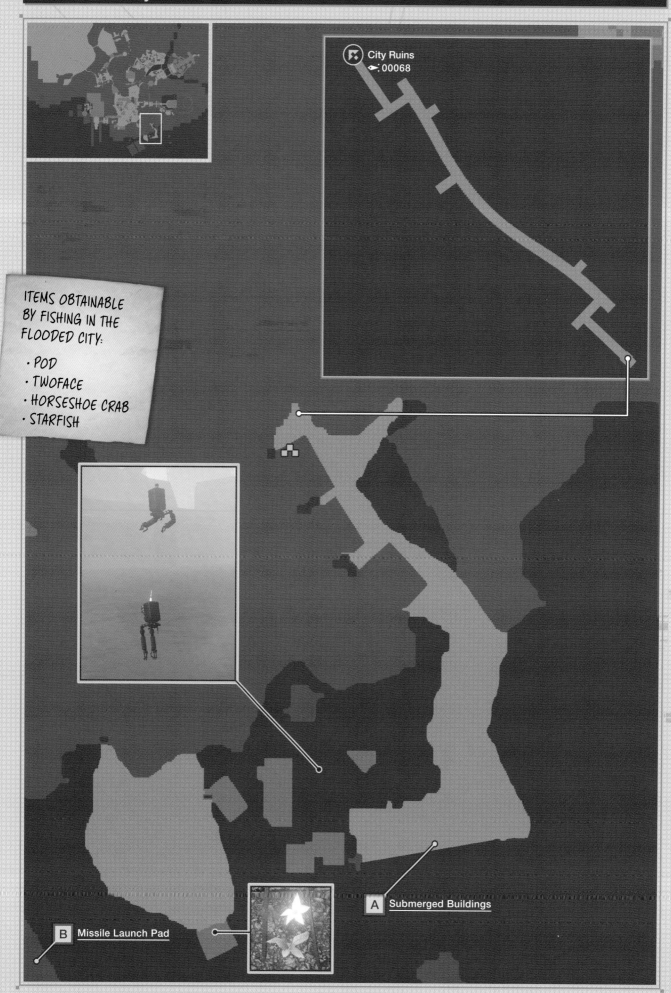

City Ruins
🐟 00068

ITEMS OBTAINABLE
BY FISHING IN THE
FLOODED CITY:

· POD
· TWOFACE
· HORSESHOE CRAB
· STARFISH

A Submerged Buildings

B Missile Launch Pad

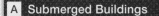

A Submerged Buildings

Report: Due to the effects of the previous Machine War, the ground in this entire area appears to be sinking. Water cascades from the gaps between buildings in mimicry of waterfalls as a result of hydraulic pressure. At present, the sinking still has not stopped, and it is hypothesized that the buildings will be completely underwater in the near future.

B Missile Launch Pad

A missile launch pad from mankind's armies is installed in the flooded city. According to information from headquarters, the deployed missiles are planned to be reproduced in the aircraft carrier *Blue Ridge II*. The eventual applications of the missiles haven't been disclosed, but what would be the impact of such gigantic weapons on the environment?

| Special Machine Report | **Grun** |

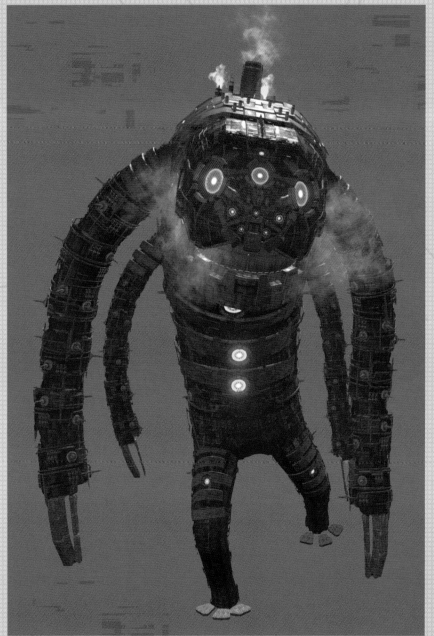

Grun is a machine lifeform reaching over one thousand meters in height that was developed to annihilate androids. It seemed to have been sealed in the sea due to the violent attacks on its own kind. Not only does every part of its body serve as a weapon but it's also covered in thick armor and ordinary weapons can't damage it. Also, it has an EMP attack that can cause a variety of disruptions to android functionality.

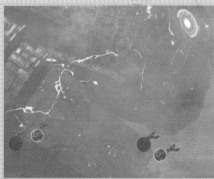

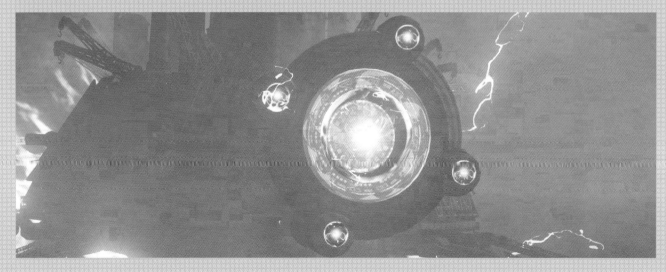

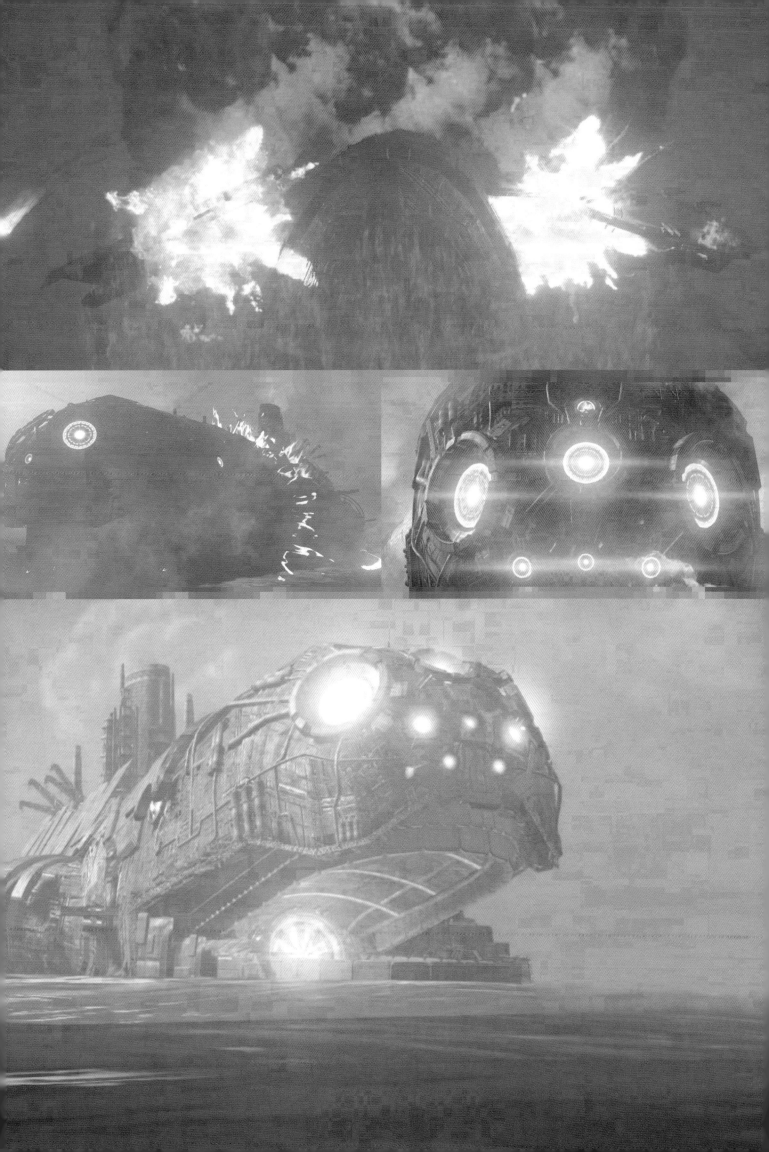

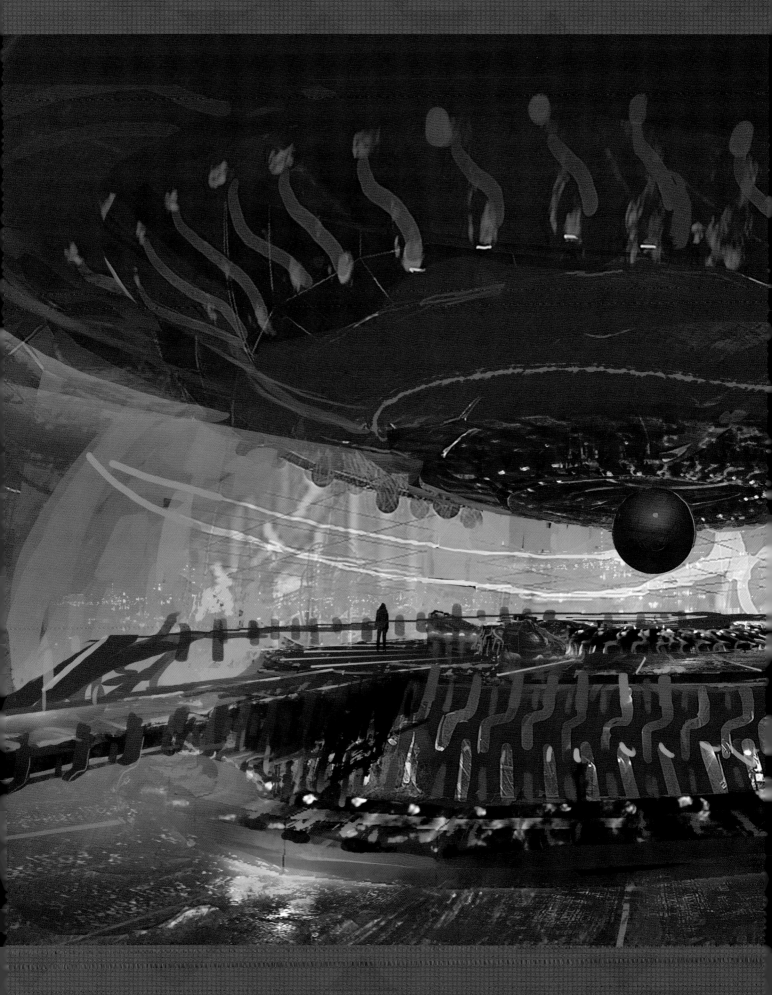

ALIEN SHIP REPORT

546865206772617665796172642e06f66206f757220637265617466f72732e

00140

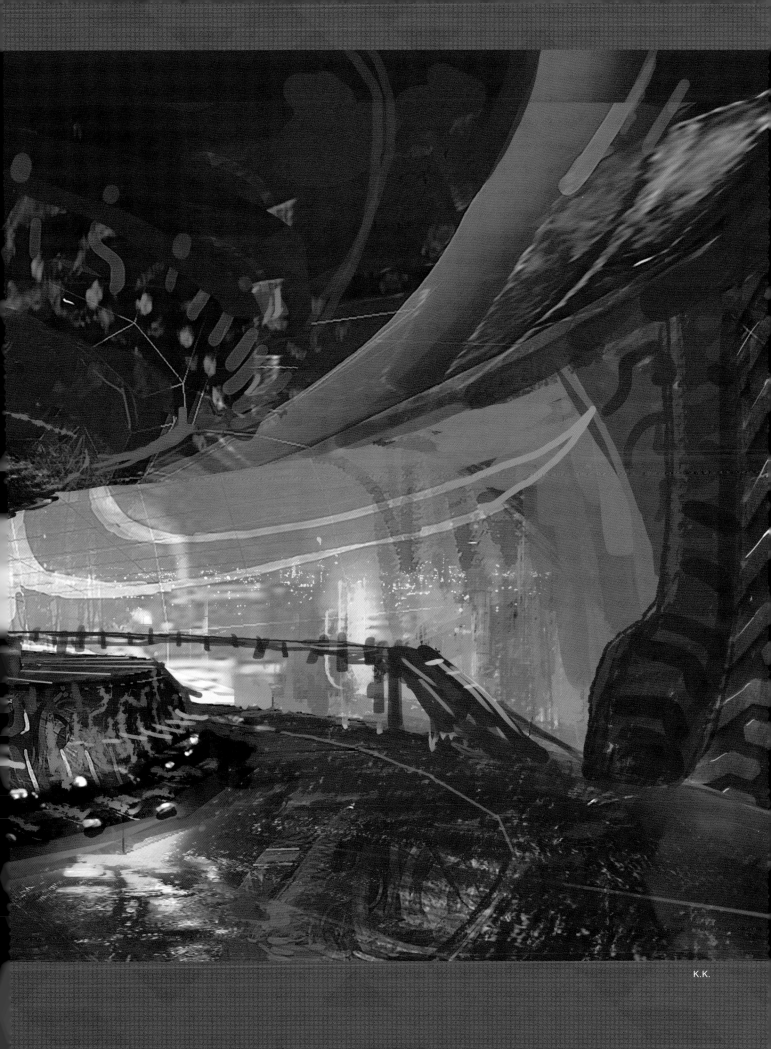

K.K.

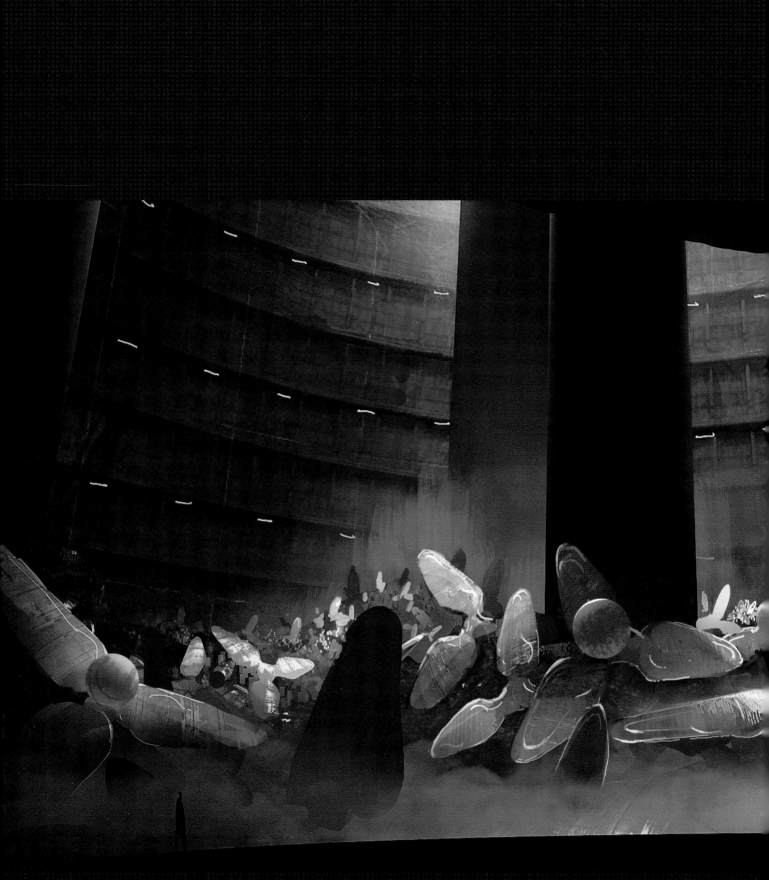

K.K.

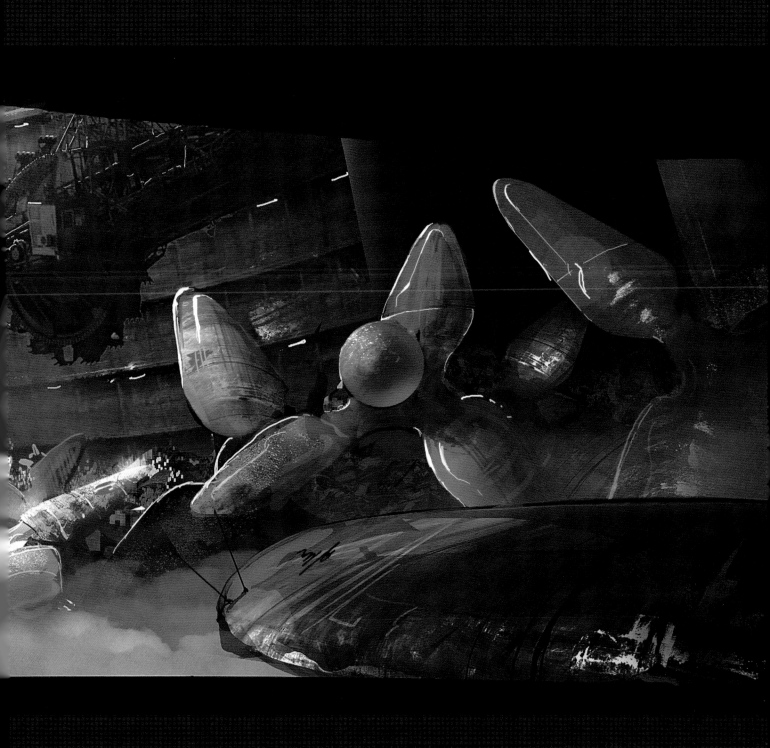

Research Division Report:

A mother ship was deployed in every city during the time of the alien invasion, but in the latter half of the 11000s, after six thousand years, sightings have greatly decreased. Also, there have been no attacks on the orbital satellite base of mankind's armies, but the reason for this is still unknown.

■ Alien Ship

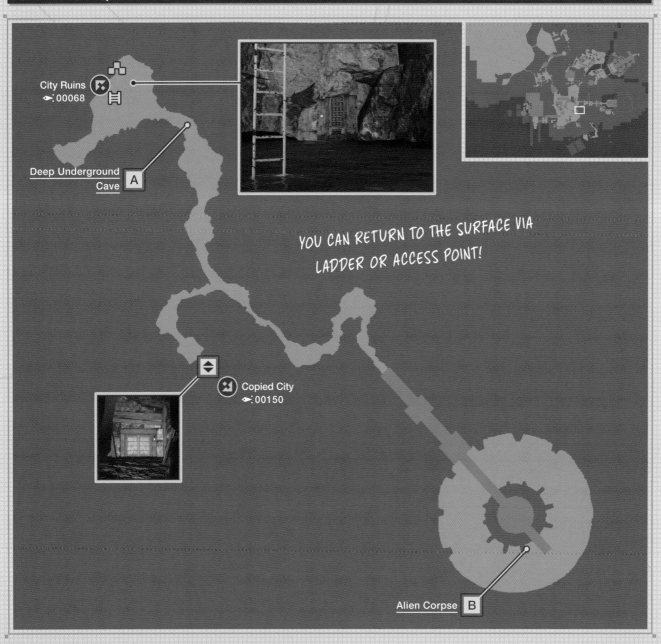

City Ruins
🦶 00068

Deep Underground
Cave [A]

YOU CAN RETURN TO THE SURFACE VIA LADDER OR ACCESS POINT!

Copied City
🦶 00150

Alien Corpse [B]

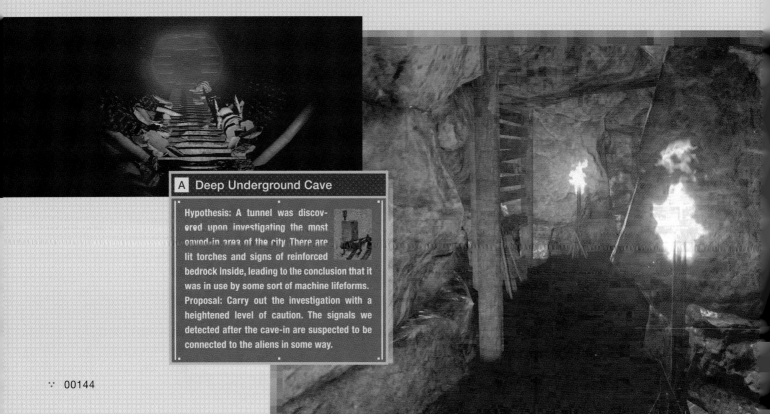

[A] Deep Underground Cave

Hypothesis: A tunnel was discovered upon investigating the most caved-in area of the city. There are lit torches and signs of reinforced bedrock inside, leading to the conclusion that it was in use by some sort of machine lifeforms.
Proposal: Carry out the investigation with a heightened level of caution. The signals we detected after the cave-in are suspected to be connected to the aliens in some way.

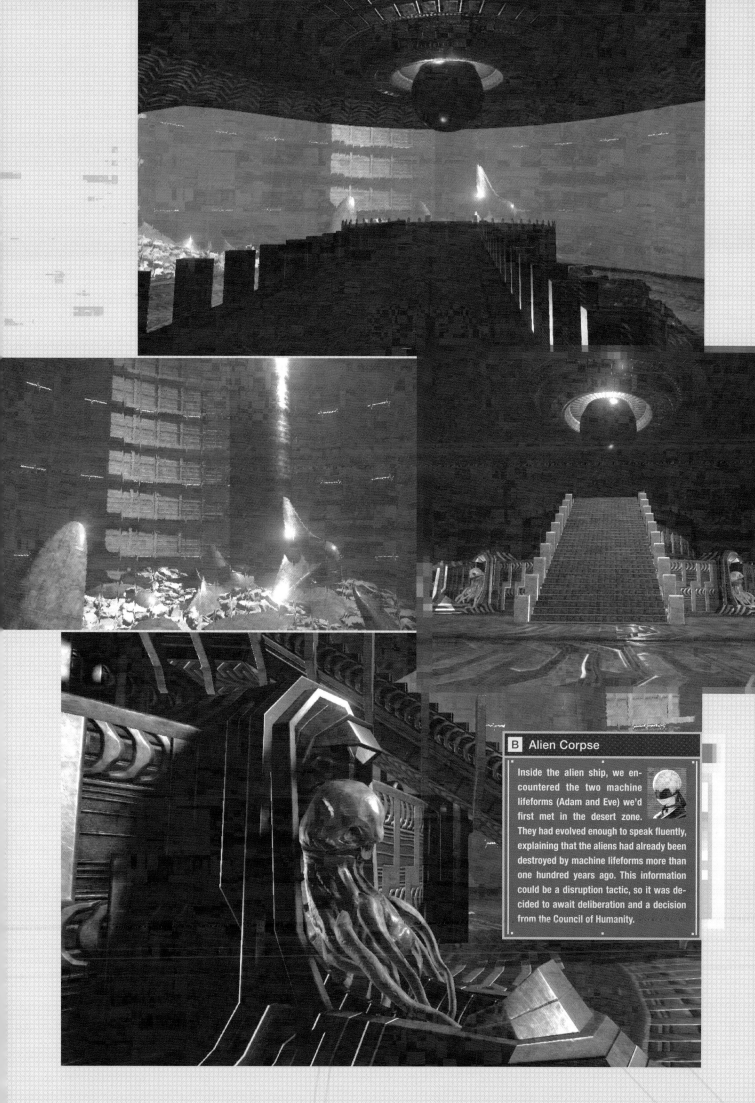

B Alien Corpse

Inside the alien ship, we encountered the two machine lifeforms (Adam and Eve) we'd first met in the desert zone. They had evolved enough to speak fluently, explaining that the aliens had already been destroyed by machine lifeforms more than one hundred years ago. This information could be a disruption tactic, so it was decided to await deliberation and a decision from the Council of Humanity.

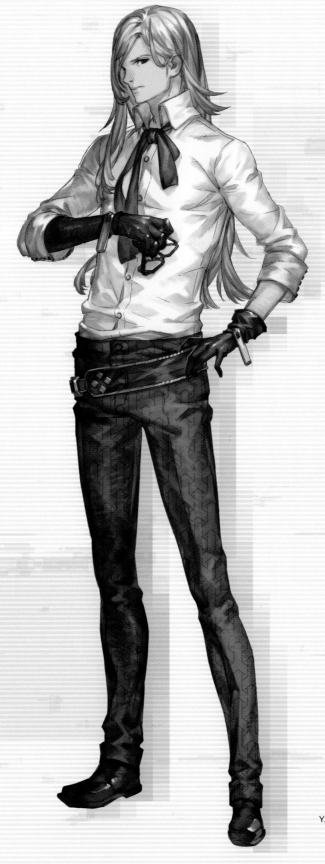

Y.N.

Adam

| Feature: Network function | Height: 188 cm | Weight: 998.6 kg | Bust: 100 cm | Waist: 74 cm | Hips: 94 cm | Eye color: Brownish red | Hair color: Bluish white |

A machine lifeform with the outward appearance of an android. Born in the desert zone, he's composed of a special material that consists mainly of silicon, and his appearance is completely different from other machine lifeforms. He is hostile toward 2B and 9S. He has achieved an astounding evolution that allows him to study attacks used against him and learn how to counter each one. Brimming with curiosity, he has a zeal for learning. He shows a particularly strong interest in humanity and has an extraordinary tenacity of purpose toward the humans who escaped to the moon.

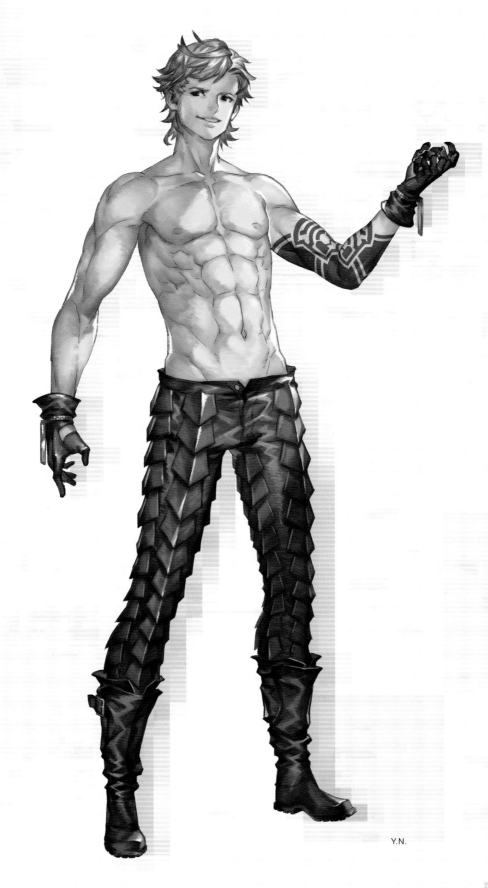

Y.N.

Eve

| Feature: Network function | Height: 188 cm | Weight: 228.6 kg | Bust: 100 cm | Waist: 74 cm | Hips: 94 cm | Eye color: Brownish red | Hair color: Bluish white |

A machine lifeform resembling an android who was born at the same time as Adam. He relies on his brother and basically is capable of doing very little on his own. He doesn't care about his appearance, but he reluctantly wears briefs and trousers due to the influence of his brother, who learned from the records of mankind. Unlike his sibling, he has no interest in reading books or eating, but he'll obediently do anything that Adam commands.

COPIED CITY REPORT

506c6179696e6720696e2061206d696e696174757265206761726465e2e

506c6179696e6720696e2061206d696e696e69617475726520676172e4656e2e

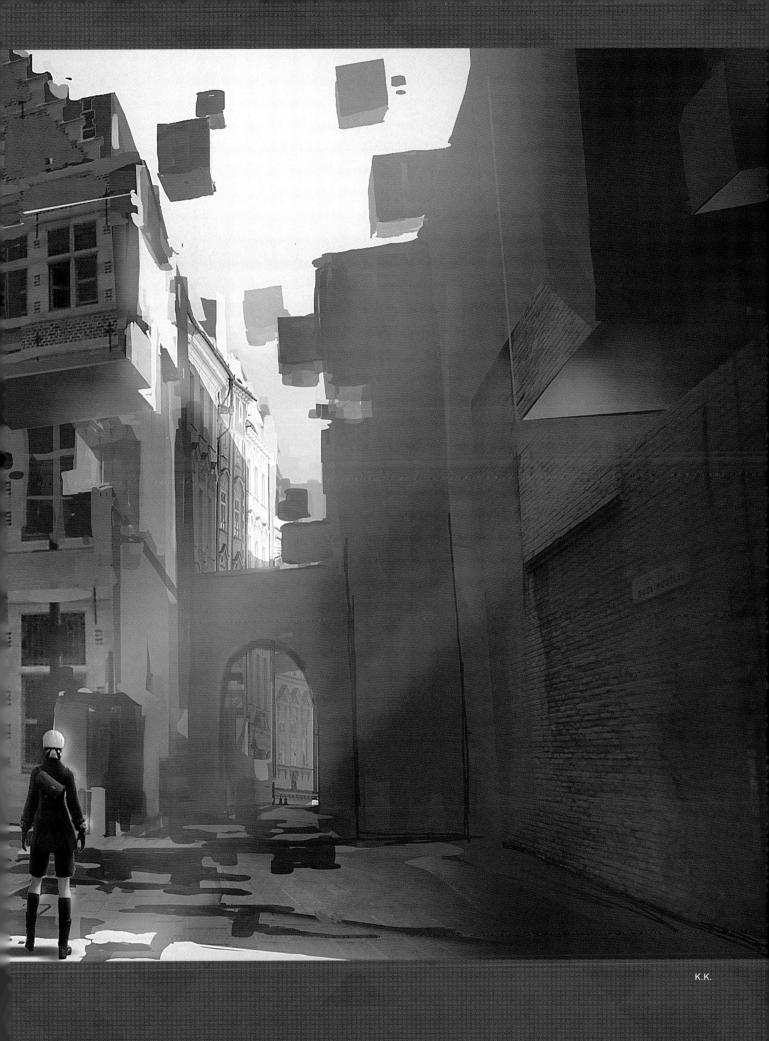

K.K.

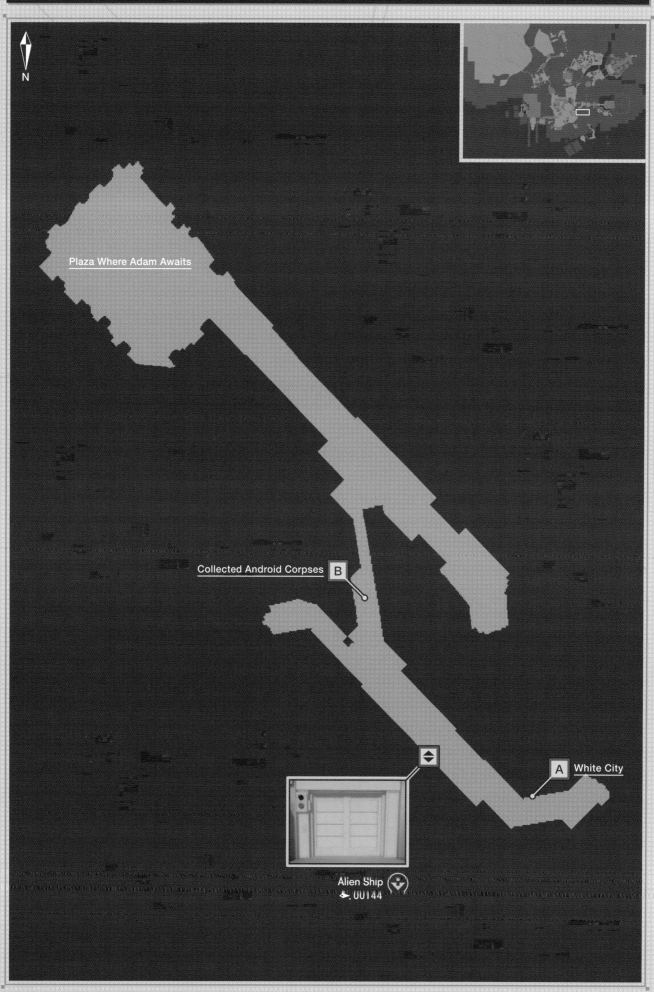

Plaza Where Adam Awaits

Collected Android Corpses B

A White City

Alien Ship

00144

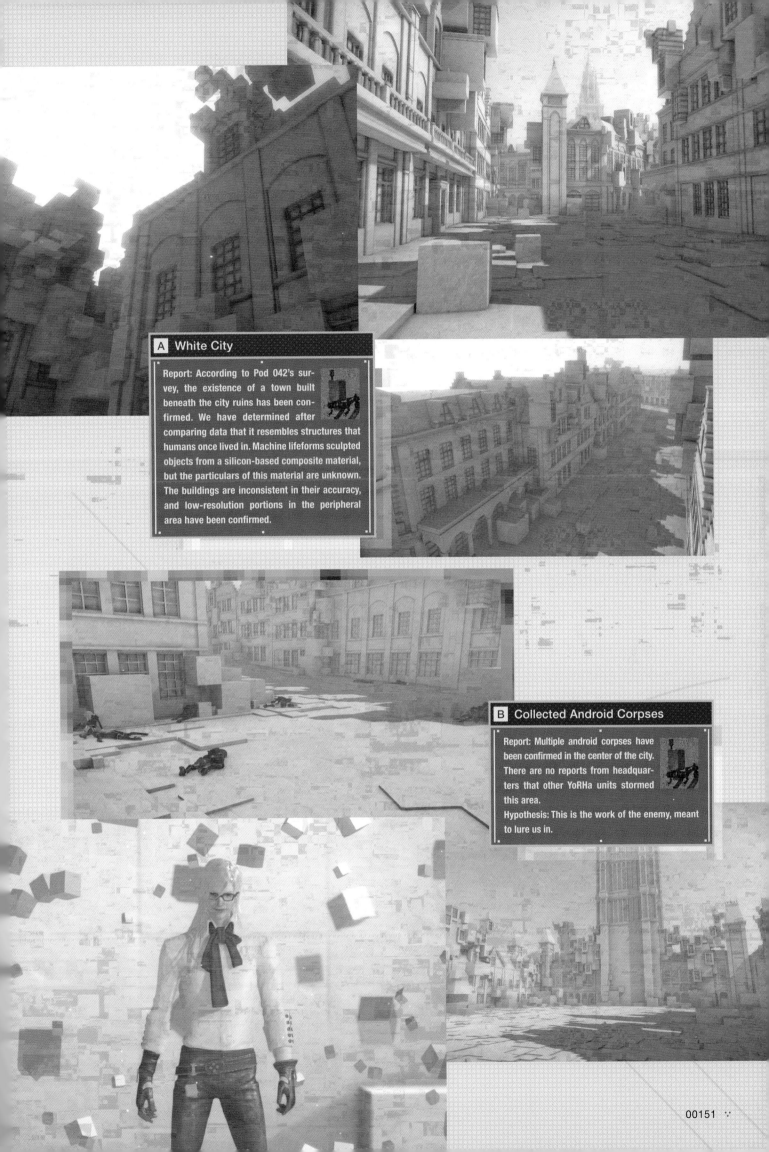

A White City

Report: According to Pod 042's survey, the existence of a town built beneath the city ruins has been confirmed. We have determined after comparing data that it resembles structures that humans once lived in. Machine lifeforms sculpted objects from a silicon-based composite material, but the particulars of this material are unknown. The buildings are inconsistent in their accuracy, and low-resolution portions in the peripheral area have been confirmed.

B Collected Android Corpses

Report: Multiple android corpses have been confirmed in the center of the city. There are no reports from headquarters that other YoRHa units stormed this area.

Hypothesis: This is the work of the enemy, meant to lure us in.

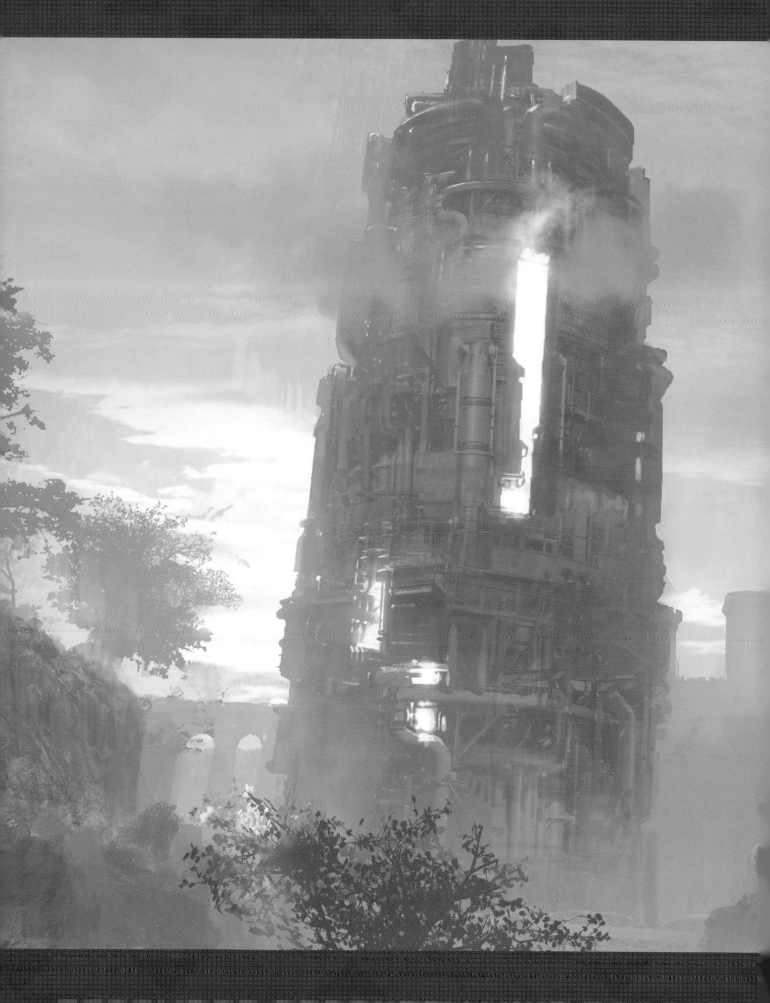

RESOURCE RECOVERY UNIT REPORT

49742077696c6c206265617220757320746f20746865206e6578742077f726c642e

K.K.

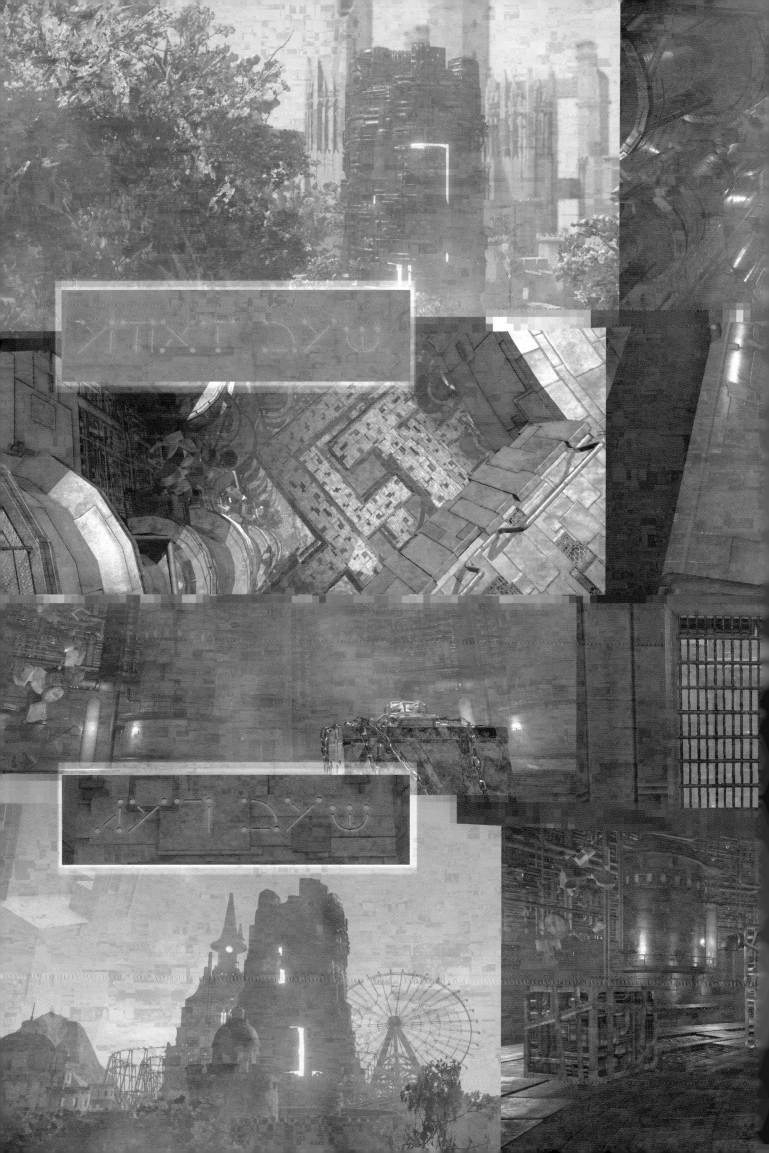

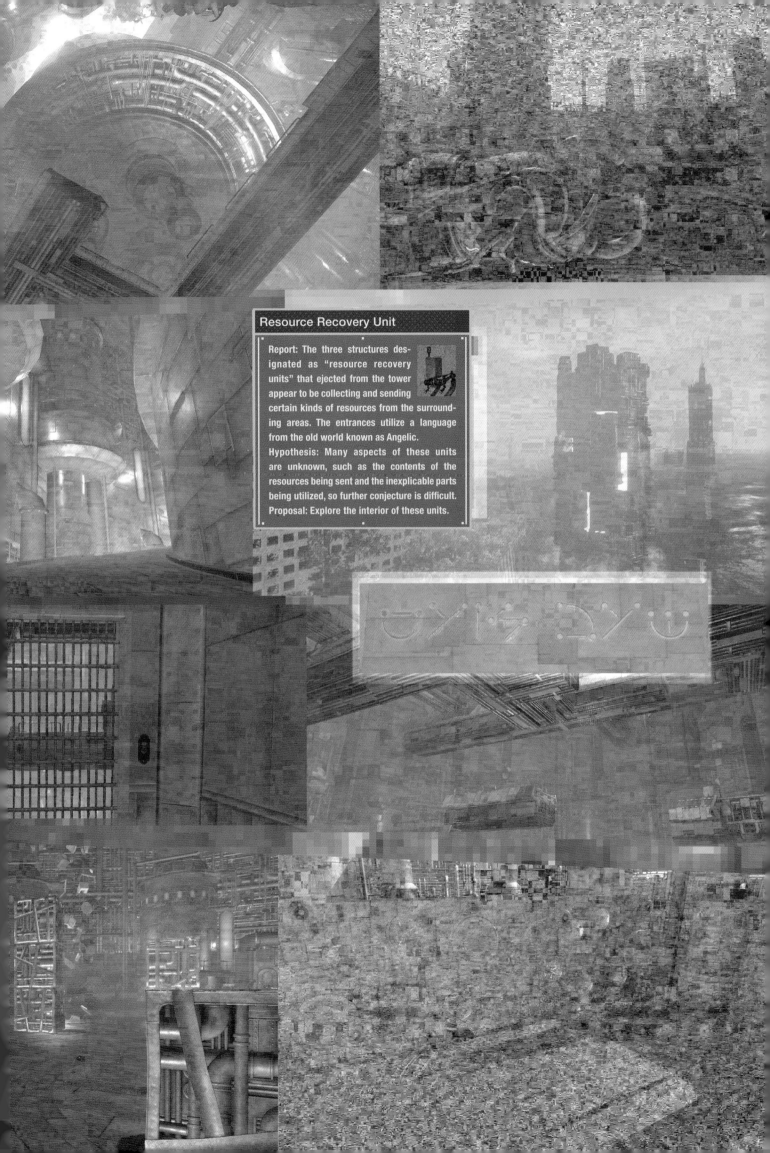

Resource Recovery Unit

Report: The three structures designated as "resource recovery units" that ejected from the tower appear to be collecting and sending certain kinds of resources from the surrounding areas. The entrances utilize a language from the old world known as Angelic.

Hypothesis: Many aspects of these units are unknown, such as the contents of the resources being sent and the inexplicable parts being utilized, so further conjecture is difficult.

Proposal: Explore the interior of these units.

TOWER REPORT

46696e616c20776973682e

Y.N.

Red Girl

Unknown Unknown Unknown Unknown Unknown Unknown Unknown Unknown

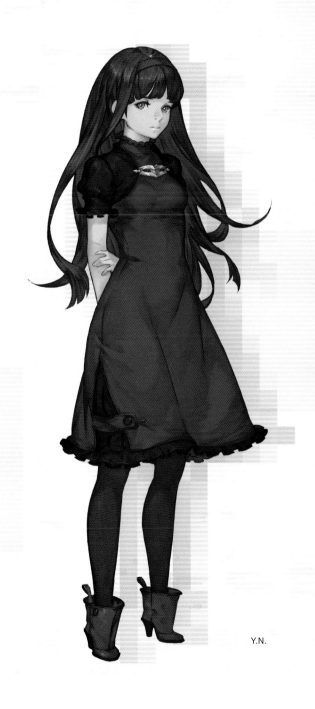

Y.N.

5765206172652061616c6f6e652e205765206172652061726520696e66696e6974652e205765206578697937420696e207468652070726573656e742e205765206578697374420696e2074686520706173742e205765206578697337420696e207468652070617374742e205765206578697337420696e207468652066757475726572652e

W452041RE20534d4l4c4c20414e442046524147494c452c204255542057E ARE MA4e5920414e4420494e56494e4349424c452e2057452057494c4c20CONTINUE TO FIGHT20554e54494c205745204445STROY ALL ANDROI44532e

FOO4c49534820414e44524fIDS2e20464f4c49534820414cIE4e532e20464f4f4cIS482048554d41NS.

574520415245204d414e5920414e4420574520415245204f4e452e20574520415245204
55445524e414c2e

MACHINE RECORDS : EXTRACT

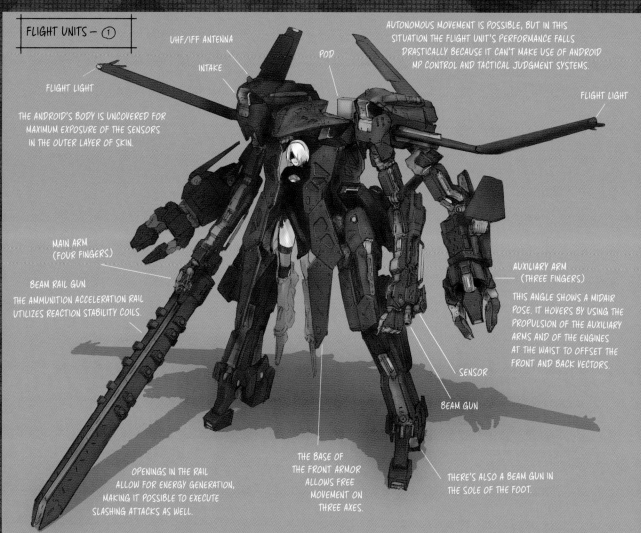

FLIGHT UNITS — ①

AUTONOMOUS MOVEMENT IS POSSIBLE, BUT IN THIS SITUATION THE FLIGHT UNIT'S PERFORMANCE FALLS DRASTICALLY BECAUSE IT CAN'T MAKE USE OF ANDROID MP CONTROL AND TACTICAL JUDGMENT SYSTEMS.

UHF/IFF ANTENNA

INTAKE

POD

FLIGHT LIGHT

FLIGHT LIGHT

THE ANDROID'S BODY IS UNCOVERED FOR MAXIMUM EXPOSURE OF THE SENSORS IN THE OUTER LAYER OF SKIN.

MAIN ARM (FOUR FINGERS)

AUXILIARY ARM (THREE FINGERS)

BEAM RAIL GUN
THE AMMUNITION ACCELERATION RAIL UTILIZES REACTION STABILITY COILS.

THIS ANGLE SHOWS A MIDAIR POSE. IT HOVERS BY USING THE PROPULSION OF THE AUXILIARY ARMS AND OF THE ENGINES AT THE WAIST TO OFFSET THE FRONT AND BACK VECTORS.

SENSOR

BEAM GUN

OPENINGS IN THE RAIL ALLOW FOR ENERGY GENERATION, MAKING IT POSSIBLE TO EXECUTE SLASHING ATTACKS AS WELL.

THE BASE OF THE FRONT ARMOR ALLOWS FREE MOVEMENT ON THREE AXES.

THERE'S ALSO A BEAM GUN IN THE SOLE OF THE FOOT.

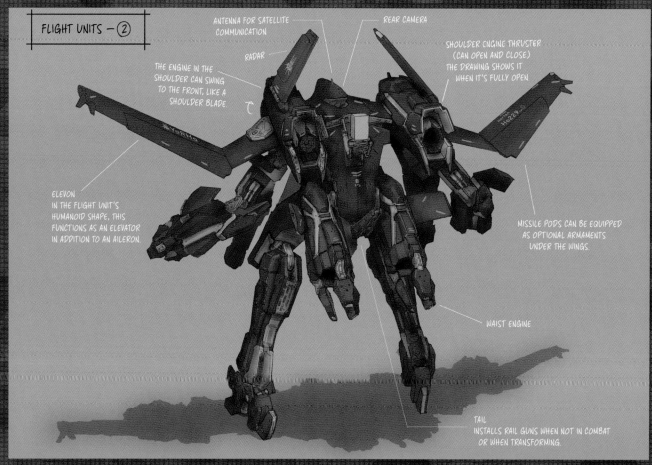

FLIGHT UNITS — ②

ANTENNA FOR SATELLITE COMMUNICATION

REAR CAMERA

RADAR

SHOULDER ENGINE THRUSTER (CAN OPEN AND CLOSE)
THE DRAWING SHOWS IT WHEN IT'S FULLY OPEN

THE ENGINE IN THE SHOULDER CAN SWING TO THE FRONT, LIKE A SHOULDER BLADE.

ELEVON
IN THE FLIGHT UNIT'S HUMANOID SHAPE, THIS FUNCTIONS AS AN ELEVATOR IN ADDITION TO AN AILERON.

MISSILE PODS CAN BE EQUIPPED AS OPTIONAL ARMAMENTS UNDER THE WINGS.

WAIST ENGINE

TAIL
INSTALLS RAIL GUNS WHEN NOT IN COMBAT OR WHEN TRANSFORMING.

FLIGHT UNITS — ③

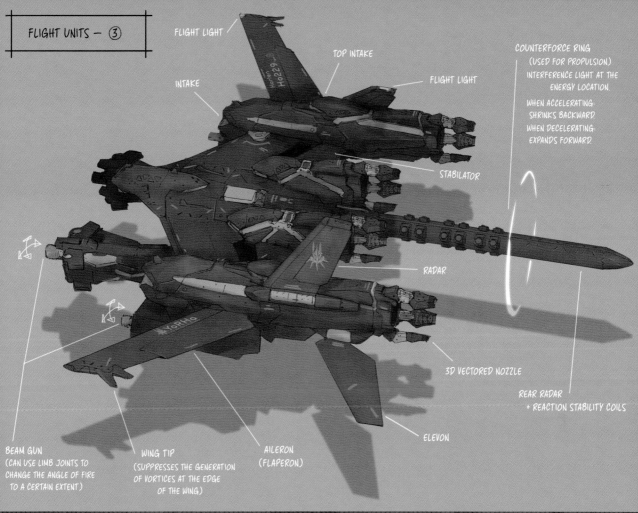

FLIGHT LIGHT

TOP INTAKE

INTAKE

FLIGHT LIGHT

STABILATOR

COUNTERFORCE RING
(USED FOR PROPULSION)
INTERFERENCE LIGHT AT THE
ENERGY LOCATION.

WHEN ACCELERATING:
SHRINKS BACKWARD

WHEN DECELERATING:
EXPANDS FORWARD

RADAR

3D VECTORED NOZZLE

REAR RADAR
+ REACTION STABILITY COILS

ELEVON

BEAM GUN
(CAN USE LIMB JOINTS TO
CHANGE THE ANGLE OF FIRE
TO A CERTAIN EXTENT)

WING TIP
(SUPPRESSES THE GENERATION
OF VORTICES AT THE EDGE
OF THE WING)

AILERON
(FLAPERON)

FLIGHT UNITS — DETAILS ①

BEAM MISSILES

A WEAPON THAT GUIDES THE MP PARTICLE BEAM TO ITS TARGET TO ATTACK WITH MICROMINIATURE MISSILES.

THE MISSILE AMMUNITION IS PROTECTED FROM THE MP PARTICLE BEAM BY AN MP-RESISTANT BARRIER. THIS BARRIER IS REMOVED AT THE TIME OF IMPACT, AND THE BEAM IS DISCHARGED ON THE TARGET.

SMALL QUANTITIES OF REAGENT AND TUNGSTEN PELLETS ARE STORED IN THE MISSILE WARHEADS. THE REAGENT REACTS WITH THE BEAM AT THE TIME OF IMPACT TO CAUSE AN MP PARTICLE EXPLOSION, ENHANCING THE DAMAGING EFFECT.

WHEN IT'S DETERMINED THAT A DIRECT HIT IS IMPOSSIBLE, IT'S CHANGED TO A PROXIMITY FUSE, AND THE TUNGSTEN PELLETS WILL INFLICT DAMAGE WITH AN MP PARTICLE EXPLOSION WHEN THEY EXPLODE NEAR THE TARGET.

IT'S AN EFFECTIVE WEAPON AGAINST ARMOR WITH AN MP-RESISTANT BARRIER. AT THE TIME OF IMPACT, THE TARGET'S BARRIER IS NEUTRALIZED BY THE WARHEAD'S OWN MP-RESISTANT BARRIER, AND THEN IT'S DISABLED BY CREATING A HOLE IN THE BARRIER'S SURFACE.

EVEN WHEN THE PROXIMITY FUSE IS RUNNING, IT'S POSSIBLE TO INFLICT DAMAGE WITH A PHYSICAL ATTACK FROM THE TUNGSTEN PELLETS.

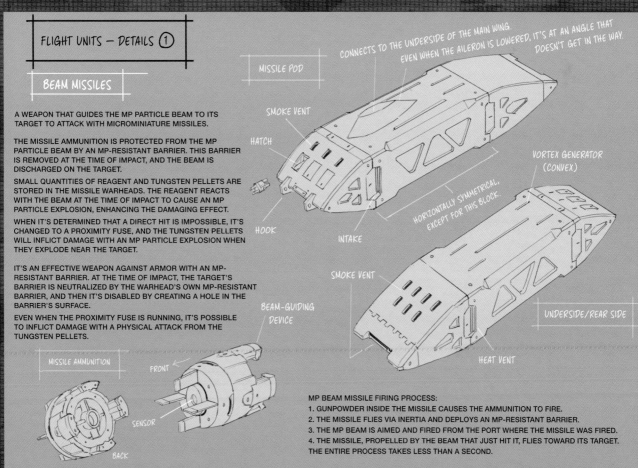

MISSILE POD

CONNECTS TO THE UNDERSIDE OF THE MAIN WING.
EVEN WHEN THE AILERON IS LOWERED, IT'S AT AN ANGLE THAT DOESN'T GET IN THE WAY.

SMOKE VENT

HATCH

HOOK

INTAKE

HORIZONTALLY SYMMETRICAL, EXCEPT FOR THIS BLOCK.

VORTEX GENERATOR
(CONVEX)

SMOKE VENT

UNDERSIDE/REAR SIDE

HEAT VENT

BEAM-GUIDING DEVICE

MISSILE AMMUNITION

FRONT

SENSOR

BACK

MP BEAM MISSILE FIRING PROCESS:
1. GUNPOWDER INSIDE THE MISSILE CAUSES THE AMMUNITION TO FIRE.
2. THE MISSILE FLIES VIA INERTIA AND DEPLOYS AN MP-RESISTANT BARRIER.
3. THE MP BEAM IS AIMED AND FIRED FROM THE PORT WHERE THE MISSILE WAS FIRED.
4. THE MISSILE, PROPELLED BY THE BEAM THAT JUST HIT IT, FLIES TOWARD ITS TARGET.
THE ENTIRE PROCESS TAKES LESS THAN A SECOND.

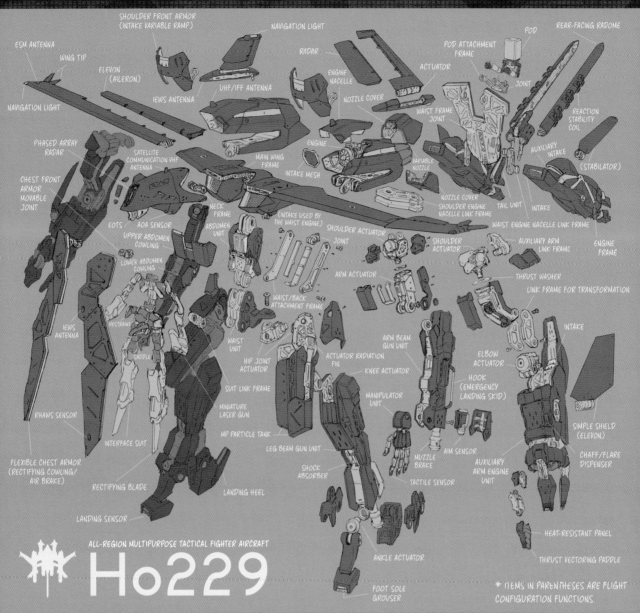

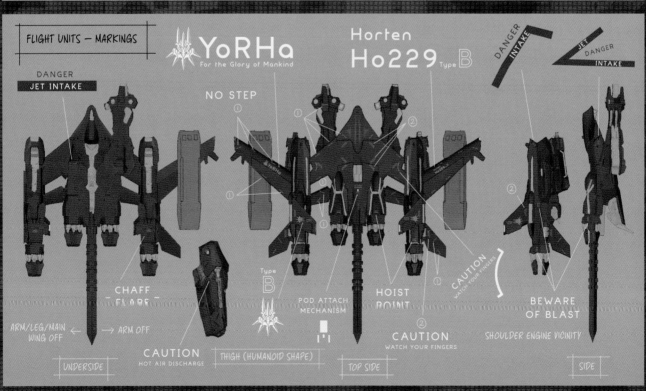

AIRCRAFT CARRIERS

H.K.

AIRCRAFT CARRIERS — DETAILS

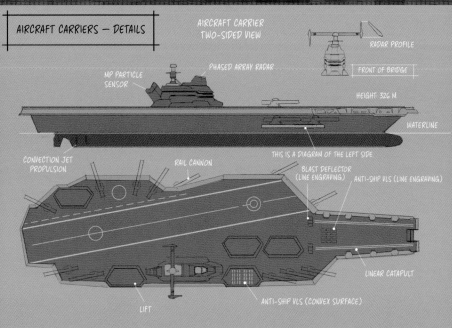

AIRCRAFT CARRIER
TWO-SIDED VIEW

RADAR PROFILE

MP PARTICLE
SENSOR

PHASED ARRAY RADAR

FRONT OF BRIDGE

HEIGHT: 326 M

WATERLINE

THIS IS A DIAGRAM OF THE LEFT SIDE

CONVECTION JET
PROPULSION

RAIL CANNON

BLAST DEFLECTOR
(LINE ENGRAVING)

ANTI-SHIP VLS (LINE ENGRAVING)

LINEAR CATAPULT

LIFT

ANTI-SHIP VLS (CONVEX SURFACE)

H.K.

INTERCEPTION GUNS — DETAILS

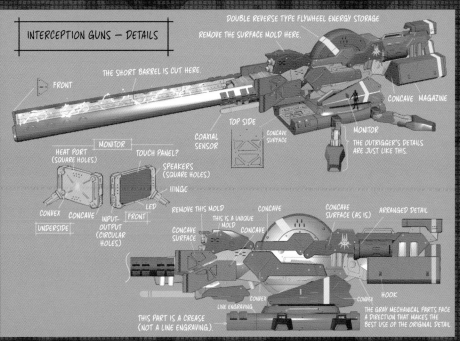

DOUBLE REVERSE TYPE FLYWHEEL ENERGY STORAGE

REMOVE THE SURFACE MOLD HERE.

THE SHORT BARREL IS CUT HERE.

FRONT

CONCAVE MAGAZINE

TOP SIDE

COAXIAL
SENSOR

CONCAVE
SURFACE

MONITOR

THE OUTRIGGER'S DETAILS
ARE JUST LIKE THIS.

HEAT PORT
(SQUARE HOLES)

MONITOR

TOUCH PANEL?

SPEAKERS
(SQUARE HOLES)

HINGE

CONVEX CONCAVE

INPUT-
OUTPUT
(CIRCULAR
HOLES)

LED

FRONT

UNDERSIDE

REMOVE THIS MOLD

CONCAVE

CONCAVE
SURFACE (AS IS)

ARRANGED DETAIL

THIS IS A UNIQUE
MOLD

CONCAVE
SURFACE

CONCAVE

CONVEX

HOOK

THE GRAY MECHANICAL PARTS FACE
A DIRECTION THAT MAKES THE
BEST USE OF THE ORIGINAL DETAIL.

LINE ENGRAVING

CONVEX

THIS PART IS A CREASE
(NOT A LINE ENGRAVING).

H.K.

ENEMY MACHINES — COMMON

WHEELED TYPE
KUGELPANZER

SMALL STUBBY
(SPRING-ACTION MACHINE)

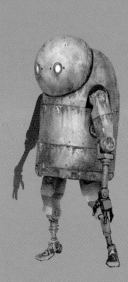

SMALL BIPED

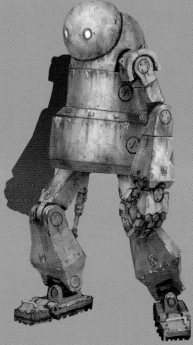

MEDIUM BIPED

H.K.

COMMON FLYERS (SMALL)

COLEOPTER TYPE
(DUCTED FAN)

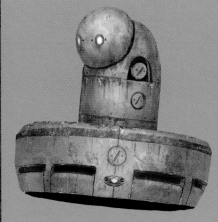

PLEASE REFER TO THE MINISTRY OF DEFENSE'S
SPHERICAL FLYING OBJECTS FOR HOW THEY FLY.

ADJUST THE HEIGHT HERE DEPENDING ON THE INTERFERENCE OF,
AND AIRS PUT ON BY, THE MACHINE LIFEFORM.

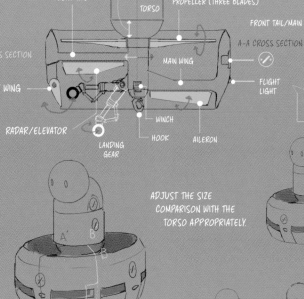

FRONT TAIL

TORSO

PROPELLER (THREE BLADES)

FRONT TAIL/MAIN WING CROSS-SECTIONAL SHAPE

B-B CROSS SECTION

A-A CROSS SECTION

ALL KINDS OF
FLIGHT CONTROL
SURFACES

DUCT WING

MAIN WING

FLIGHT
LIGHT

LEFT: GREEN RIGHT: RED
FRONT AND BACK: WHITE

RADAR/ELEVATOR

WINCH

LANDING
GEAR

HOOK

AILERON

WINCHES CAN
BE USED
TO CARRY
OBJECTS,
ETC.

ADJUST THE SIZE
COMPARISON WITH THE
TORSO APPROPRIATELY.

0° (90°) 0° (90°) 45° (135°)
* THE CROSS SECTION OF THE LOWER
HALF HAS BEEN SHIFTED FOR THE
DUCT WING EXPLANATION.

IT'S POSSIBLE TO TAXI BY ROTATING THE
PROPELLERS CLOSE TO THE GROUND

H.K.

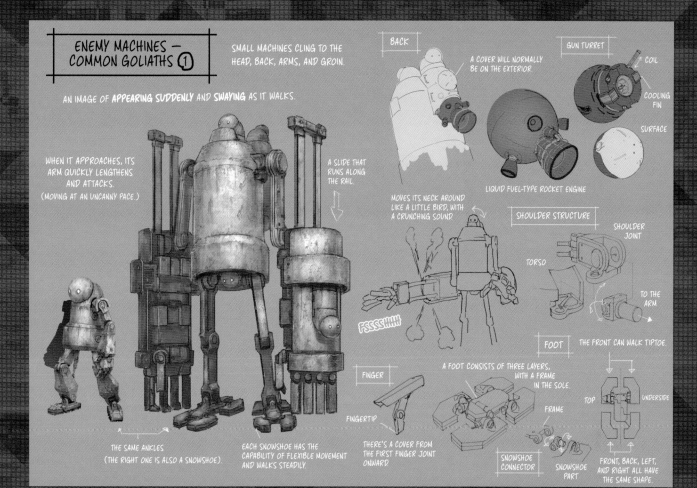

ENEMY MACHINES — COMMON GOLIATHS ①

SMALL MACHINES CLING TO THE HEAD, BACK, ARMS, AND GROIN.

AN IMAGE OF **APPEARING SUDDENLY** AND **SWAYING** AS IT WALKS.

WHEN IT APPROACHES, ITS ARM QUICKLY LENGTHENS AND ATTACKS. (MOVING AT AN UNCANNY PACE.)

A SLIDE THAT RUNS ALONG THE RAIL.

BACK

A COVER WILL NORMALLY BE ON THE EXTERIOR.

GUN TURRET

COIL

COOLING FIN

SURFACE

LIQUID FUEL-TYPE ROCKET ENGINE

MOVES ITS NECK AROUND LIKE A LITTLE BIRD, WITH A CRUNCHING SOUND

FSSSSHHH

SHOULDER STRUCTURE

SHOULDER JOINT

TORSO

TO THE ARM

FOOT

THE FRONT CAN WALK TIPTOE.

FINGER

A FOOT CONSISTS OF THREE LAYERS, WITH A FRAME IN THE SOLE.

TOP

UNDERSIDE

FINGERTIP

THERE'S A COVER FROM THE FIRST FINGER JOINT ONWARD.

FRAME

THE SAME ANKLES (THE RIGHT ONE IS ALSO A SNOWSHOE).

EACH SNOWSHOE HAS THE CAPABILITY OF FLEXIBLE MOVEMENT AND WALKS STEADILY.

SNOWSHOE CONNECTOR

SNOWSHOE PART

FRONT, BACK, LEFT, AND RIGHT ALL HAVE THE SAME SHAPE.

H.K.

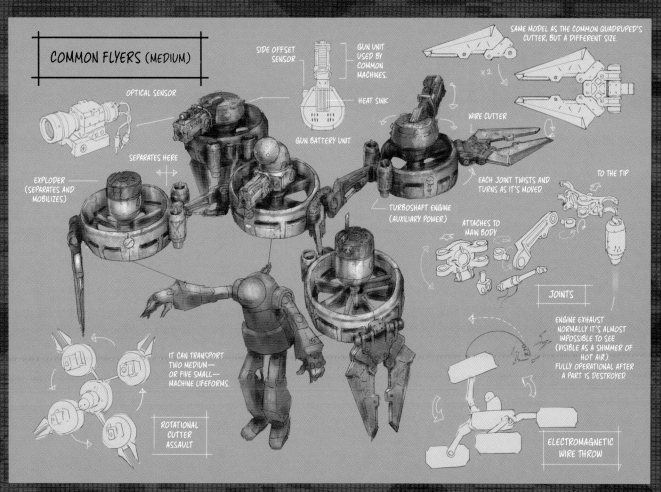

COMMON FLYERS (MEDIUM)

OPTICAL SENSOR

SIDE OFFSET SENSOR

GUN UNIT USED BY COMMON MACHINES.

HEAT SINK

GUN BATTERY UNIT

SAME MODEL AS THE COMMON QUADRUPED'S CUTTER, BUT A DIFFERENT SIZE.

×2

WIRE CUTTER

SEPARATES HERE

EXPLODER (SEPARATES AND MOBILIZES)

EACH JOINT TWISTS AND TURNS AS IT'S MOVED

TO THE TIP

TURBOSHAFT ENGINE (AUXILIARY POWER)

ATTACHES TO MAIN BODY

JOINTS

IT CAN TRANSPORT TWO MEDIUM— OR FIVE SMALL— MACHINE LIFEFORMS.

ENGINE EXHAUST NORMALLY IT'S ALMOST IMPOSSIBLE TO SEE (VISIBLE AS A SHIMMER OF HOT AIR). FULLY OPERATIONAL AFTER A PART IS DESTROYED

ROTATIONAL CUTTER ASSAULT

ELECTROMAGNETIC WIRE THROW

H.K.

ENEMY MACHINES — COMMON TYPE HEADS ①

ZZZ

THIS INTERVAL IS ONLY 0.6 OF A SECOND!
ROUGHLY...?

1. CLOSED CAMERA COVER 2. THE CAMERA COVER OPENS 3. THE CAMERA ROTATES AS IT'S PUSHED OUT 4. THE CAMERA IS FLUSH WITH THE FACE

CAMERA COVER OPENING/CLOSING GIMMICK (FOR REFERENCE) THE OPENING AND CLOSING (BLINKING) OF THE COVER CLEANS THE LENSES.

THESE SCREWS HOLD THE INTERNAL STRUCTURE IN PLACE.

SCREW HOLES
FOR EXTENSIONS.

HEAD CLOSE-UP DAMAGE REFERENCE INTERIOR

H.K.

ENEMY MACHINES — COMMON TYPE HEADS ②

FOR TEXTURE INFORMATION, REFER TO
"COMMON TYPE HEADS ①."
FOR SHAPE INFORMATION, REFER TO THIS SECTION.

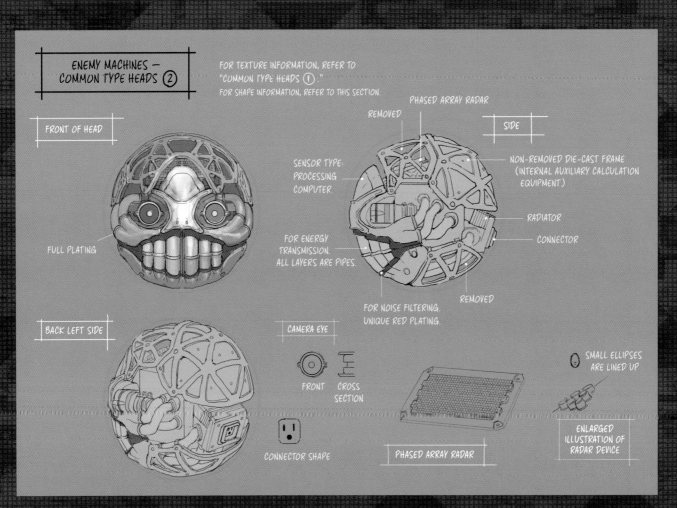

FRONT OF HEAD

PHASED ARRAY RADAR

REMOVED

SIDE

SENSOR TYPE:
PROCESSING
COMPUTER.

NON-REMOVED DIE-CAST FRAME
(INTERNAL AUXILIARY CALCULATION
EQUIPMENT)

FULL PLATING

FOR ENERGY
TRANSMISSION.
ALL LAYERS ARE PIPES.

RADIATOR

CONNECTOR

REMOVED

FOR NOISE FILTERING.
UNIQUE RED PLATING.

BACK LEFT SIDE

CAMERA EYE

SMALL ELLIPSES
ARE LINED UP

FRONT CROSS
SECTION

CONNECTOR SHAPE PHASED ARRAY RADAR

ENLARGED
ILLUSTRATION OF
RADAR DEVICE

H.K.